In *The Rhetoric of Purity*, Mark A. Cheetham explores the historical and theoretical relations between early abstract painting in Europe and the notion of purity. For Gauguin, Sérusier, Mondrian, and Kandinsky – the pioneering abstractionists whose written and visual works Cheetham discusses in detail – purity is the crucial quality that painting must possess. Purity, however, was itself only a password for what Cheetham defines as an "essentialist" philosophy inaugurated by Plato's vision of a perfect, non-mimetic art form and practiced by the founders of abstraction.

The essentialism of late nineteenth-century French discussions of "abstraction," Cheetham argues, also infects the work of Mondrian and Kandinsky. These visions of abstraction are central to the development of Modernism and are closely tied to the philosophical traditions of Plato, Hegel, and Schopenhauer. As a conclusion, Cheetham provides a postmodern reading of Klee's rejection of the rhetoric of purity and claims that Klee's refusal speaks to contemporary concerns in visual theory and culture. By acting as an antidote to the seductive appeal of purity in art and society, Cheetham's final critique of the trope of purity seeks to preserve the possibility of visual discourse itself.

THE RHETORIC OF PURITY

The Rhetoric of Purity

Essentialist Theory and the Advent of
Abstract Painting

MARK A. CHEETHAM

The right of the
University of Cambridge
to print and publish
all kinds of books
was granted by law
in 1534.
The University has printed
and published continuously
since 1584.

CAMBRIDGE UNIVERSITY PRESS

Cambridge
New York Port Chester Melbourne Sydney

Published by the Press Syndicate of the University of Cambridge
The Pitt Building, Trumpington Street, Cambridge CB2 1RP
40 West 20th Street, New York, NY 10011, USA
10 Stamford Road, Oakleigh, Melbourne 3166, Australia

© Cambridge University Press 1991

First published 1991

Printed in the United States of America

Library of Congress Cataloging-in-Publication Data
Cheetham, Mark A. (Mark Arthur), 1954–
The rhetoric of purity : essentialist theory and the advent of
abstract painting / Mark A. Cheetham.
p. cm. – (Cambridge new art history and criticism)
Includes bibliographical references and index.
ISBN 0-521-38546-6
1. Painting, Abstract – Philosophy. 2. Purity (Philosophy)
I. Title. II. Series.
ND 196.A2C4 1991
750'.1 – dc20
90-48593
CIP

British Library Cataloguing in Publication Data
Cheetham, Mark A.
The rhetoric of purity : essentialist theory and the
advent of abstract painting. – (Cambridge new art history
and criticism)
1. Abstract Paintings History
I. Title
759.065

ISBN 0-521-38546-6 hardback

for Elizabeth D. Harvey

CONTENTS

ILLUSTRATIONS

PREFACE

THIS BOOK is about the historical, conceptual, and theoretical relations between the advent of abstract painting in Europe and the notion of purity that attends this radical innovation in remarkably constant and crucial ways. When we read texts by the pioneers of abstraction, the term purity, or a cognate such as purification, is habitually used to describe and indeed to define the work that they have achieved or that they envision. Purity is for these artists nothing less than *the* quality that abstract painting must possess, and they go to great material and conceptual ends to achieve it. If the ubiquity of references to purity in this context stands out for us now and invites investigation, however, this same pervasiveness must also be evidence for the unchallenged normality of the term for those who used it to portray and legitimate abstract painting, a sign, in other words, of its naturalization. In addition, the ideas that we render with the word "purity" must also have had a widely accepted range of connotations across Europe at this time. Although the foundational texts of abstraction were written in languages as different as Russian, Dutch, French, German, and Czech, "purity" remains common despite the nuances of translation. My first aim in this study is to upset the naturalness of the linkage between purity and abstraction, to make this conceptual twinship stand out in order to understand why it was such a potent part of what was arguably the most daring change in (and challenge to) Western painting since the Renaissance.

My claim is that purity managed to seem innocent because it was itself only a shibboleth, a seemingly unproblematic and compact surface that nonetheless enclosed a complex and extensive essentialist metaphysics that powered the initiation of abstract painting to a very considerable, but not exclusive, extent. By essentialism I mean the search for immutable es-

sence or truth and the concomitant ontological division between reality and mere appearance.[1] Plato inaugurates this discourse, and it has remained fundamental to Western philosophical thought. It is this distinction that underlies his rejection of mimesis in art and that leads him to banish its practitioners from the ideal state. As I will argue more fully as I articulate the characteristics of essentialism throughout the chapters that follow, Plato's insistence that we have access to truth rather than appearance is also an important basis for *defenses* of art, both in the *Republic* itself (the site of banishment) and, more explicitly, in the writings of subsequent thinkers like Plotinus, Hegel, and Schopenhauer. I argue that Plato himself – and those who construct apologies for art in reaction to his ideas – hypothesized a perfect art form that would escape the charges of inadequacy by being nonmimetic. I claim in addition that the founders of abstraction from Gauguin to Mondrian quite unambiguously answered Plato with their new art. For these philosophers and painters alike, purity is the touchstone for what art must become if it is to be valid metaphysically and therefore functional within society.[2]

In the essentialist tradition embraced by Gauguin, Sérusier, Mondrian, and Kandinsky, purity as the image of and vehicle to absolute, universal truth is a very serious matter. Why then do I give the notion of rhetoric – commonly seen as mere wordplay[3] – equal voice and emphasize its relation to purity with the spatial propinquity of these terms in my title? For Plato, rhetoric and the Sophists who employ it stand in dangerous opposition to the silent wisdom of pure knowledge that Socrates embodies but is loath to speak let alone write, since purity is by definition immaterial. My strategy in consciously bringing these traditionally opposed ideas together is to create a new set of tensions between them in the context of early abstract painting and thereby to unsettle the normality of purity. For the essentialist, rhetoric is appearance, it is transient and untruthful and thus exactly the mode of discourse that civilization should evolve away from. In abstract painting as in the philosophical tradition on which it drew, purity strove – in the face of paradox – for absolute and *immaterial* values that were by definition beyond the grasp of mere rhetoric. Rhetoric deals with the quotidian and changing aspects of experience, and again, purity in abstraction sought to transcend such contingency. Yet purity in this context is indeed a rhetoric in the classical, pejorative sense: its repetition seeks to persuade, it longs impossibly for the

immaterial in the material, it is attracted to the promise of ahistorical security for decidedly historical reasons. Like Socrates and Plato, then, the artists on whom I focus became rhetoricians in spite of themselves by pleading art's case both plastically and theoretically. Art is thus at best a *way to* purity, but where does this leave art once perfection is achieved? Put another way, I will argue that the abstractionists inadvertently constructed an inverted hierarchy between purity and rhetoric by making the pure rhetorical. In trying to escape the danger of this impurity in the self-transcendence of art, they sought silence, the pure transparency and presence of the non-mimetic ideal. But here an even less savory plateau is reached, since art's purity now entails art's loss of its definitive freedom, autonomy, and potential to effect change.

Rhetoric works in another way in this book, a way that opposes purity but not from the negative vantage of our ruling philosophical conventions. Rhetoric points to the metaphorical and ideological dimensions of visual and written language; where purity was in the discourse of early abstract painting quite literally a way to close down the material practice of all art, rhetoric exposes the ever-changing tropology of a term like purity. My invocation of this sort of rhetoric is thus not in the least negative. As I will suggest in the Postscript, a postmodern, rhetorical investigation is in fact a much-needed antidote to the perenially seductive appeal to purity in art and society. In the four chapters that follow, I elaborate this reading in ways that are at once traditional and unconventional within the discipline of art history, so in previewing the steps in my arguments here I also want to characterize my methodology. Given the present flux and controversy within art history, some will no doubt see this move as "defensive," but my aim is more to suggest what readers may expect (and not expect) from this study.

In the first chapter, "Out of Plato's Cave: 'Abstraction' in Late Nineteenth-Century France," I establish an essentialist frame of reference for Gauguin's and then Sérusier's discussions of "abstraction." My point of entry is the crucial Platonic and Neoplatonic* notion of memory as an eidetic faculty that yields access to Reality, a notion that is central to Synthetism. These analyses work against several conventions in art history. In taking artists like Gauguin seriously as theorists and offering detailed readings of their texts, I seek not only to revise the received wisdom about their intellectual

*See note 3 in Chapter 1.I for an explanation of this terminology.

abilities but also (and more significantly) to begin an argument against the frequent division of artists' labors into "theory" and "practice." This bifurcation is hierarchical and usually puts practice on top, with theory relegated to the lowly status of a second-order parasite. My claim here and throughout the book is that this distinction will not hold historically or "in theory" when we examine the beginnings of abstract painting. In discussing abstraction and purification in France before the turn of the twentieth century, I do not make the attempt to be exhaustive. This is partly a practical consideration, since the terms come up with tremendous frequency. But my more pressing reason is that I do not wish to present a survey but, on the contrary, a paradigm, a model of a set of issues whose greatest critical success would be the recognition that these questions apply to other artists and thinkers. My thematic focus entails other emphases and exclusions. When I discuss Gauguin's participation in a tradition of Neoplatonic thinking, for example, I might seem to be neglecting his "work," his paintings. But this distinction goes beyond being untenable to obstruct our comprehension of Gauguin's plastic production as well as his prolific writing. By analyzing Sérusier's reliance on Derrida's deconstructed Plato, as I do in the second part of this chapter, I aim to augment recent trends towards non-formalist readings in the study of abstraction, but again this means that I do not dwell on the spiritual and mystical dimension of such artists' concerns.[4] As a final example of this sort of exclusion, in my examination of memory here and in Chapters 2 and 3, I do not discuss Bergson, because in spite of his tremendous interest in memory and his influence in modern painting (especially Futurism), he was overtly anti-Platonic in his theorizing and so did not affect artists like Kandinsky and Mondrian to nearly the extent that the essentialist equation of memory with noetic access did. These exclusions are the result of conscious choices of emphasis, and I hope that what I do offer far outweighs any omission: a new reading of the entire inception of abstract painting, coeval reinterpretations of already canonized works of art, and attention to the implications of abstraction's rhetoric of purity for present concerns.

Chapters 2 and 3, "The Mechanisms of Purity," I and II, extend the terms of reference established in Chapter 1 to the work of Mondrian and then Kandinsky. As further evidence for my contention that theoretical texts and paintings are for these artists equal partners in a common enterprise, I present

detailed analyses of both their textual and visual production.
Again, my arguments also bear on (and are borne out by)
other pioneering abstractionists, especially Malevich and
Kupka, who remain unexamined in this book, but whose
work is so intricately involved with the notion of purity that
we can safely see this rhetoric as foundational to the entire
edifice of early twentieth-century abstraction. Notions of pu-
rity are also central to Cubism and Orphism, as Apollinaire
makes clear, and Mondrian and Kandinsky were closely in-
volved with the first and second of these predominantly
French directions respectively. My practical reason for doing
little more than alluding to this attention to purity is again
the frequency with which such references are made and my
desire to look at the rhetoric of purity intensively rather than
extensively. It is also true, as Mondrian claimed, that Cubism
itself didn't produce abstract art. This is not true of Orphism,
however, and its reliance on metaphors of purity would cer-
tainly repay detailed analysis. By maintaining my emphasis
on Mondrian and Kandinsky, however, I am able to present
a pattern in the advent of abstraction of sufficient clarity that
it can work as an example for what I believe is an overdue
evaluation of this phenomenon, to which I turn in Chapter 4,
"Purity as Aesthetic Ideology."

Here I take up ramifications of abstract art's purity in four
areas, the philosophical, the art historical, the social, and the
political. Pure abstraction has, I argue, committed itself to
each of these domains by adopting an essentialist position.
This stance is important philosophically in part because it
claims absolute and universal status: I offer an historical and
theoretical critique of this attempt to colonize a would-be
Archimedean point. Plato's hypothetical demand for a non-
mimetic art form also requires that art be capable of affect-
ing social and political change, and we find in Mondrian and
Kandinsky an art that tries to meet this challenge. I argue,
however, that abstraction's obsession with purity seeks the
perfection of stasis through processes of purification that are
so relentlessly exclusive – of the diagonal principle, if we take
an example from art's plastic means, or more significantly,
of the "female element," in Mondrian's Neoplasticism – that
the only hope for "evolution" lies in the direction of art's
absorption into a very male authoritarianism. In this chapter
I also address the important question of purity as an ingredient
of Modernism. If abstract painting is to a considerable degree
inspired and molded by the notion of a transcendental purity,
and if this new painting is to be considered as central to our

understanding of Modernism, then the rhetoric of purity should, I hold, figure centrally in our view of that problematic designation. I claim that the purity model augments in important ways the two most common paradigms of the Modern, its material self-reflexivity (as championed most notably by Clement Greenberg), and its political engagement through the avant-garde.

In a concluding Postscript, I offer what I define as a postmodern[5] reading of Paul Klee's rejection of the rhetoric of purity in abstract art. I do not claim Klee as a prize winner in a hypothetical race to be the first postmodern, nor do I suggest that he ends the quest for purity in art. This search in fact continued somewhat cyclically with the transcendental aspirations of much Abstract Expressionism – only to be countered by the impurities of Pop – and it is still an open possibility addressed to and not infrequently adopted by the "men of the future," to borrow Mondrian's loaded words. What I see and want to display in Klee's work is a rhetorical move in the positive sense I have alluded to, a move that refuses the closure of purity and thus preserves the possibility of artistic discourse itself. In self-consciously reading Klee through a postmodern filter, I am suggesting both the positive potential of this much-maligned term in relation to Modernism's now often forgotten nostalgia for purity *and* that the keeping open of interpretive possibilities, the *discursiveness* that Klee demonstrates, is – as Paul de Man suggests with respect to Nietzsche – "the very model of philosophical rigor,"[6] a model that is much preferable to that of purity.

I see this study as a contribution to what is more and more widely known as "new art history."[7] But just as I work against the empiricism and the expectation for exhaustive presentation of evidence that characterize traditional work in this field, so too my relation with the very welcome and increasingly institutionalized recent developments that go by the name "new art history" is somewhat unconventional and therefore deserving of comment. Thomas Crow has aptly deemed the widespread practice of one or another version of the social history of art as the "new orthodoxy" in the discipline.[8] Social history conventionally focuses on economies of class and gender, and – whether overtly or not – relegates discussions of (other) "theory" – whether historical or contemporary – to the now epistemologically and even morally inferior status of intellectual history. It is my contention, however, that such "intellectual" pursuits are just as "social" in their foundations and manifestations as are economic de-

terminates. This is especially true in the case of an essentialist abstract painting like Mondrian's, where his confessed reliance on Schopenhauer, for example, is causally related to his articulation of an explicitly revolutionary form of art that nonetheless excludes all women on principle. It is also the case that the rhetoric of purity in abstract painting had at its very center the avoidance of historical specificity. In trying to understand this rhetoric, my own analyses thus often focus on arguments and influences that are not immediately historical in the senses currently validated by most social historians of art. It is my hope, however, that a critical examination of abstract painting's yearning for purity can nonetheless be seen as part of its continuing social reality and can thereby serve to keep open the reference points of the discipline and make moments in its history more visible to present concerns.

ACKNOWLEDGMENTS

THIS BOOK is about the metaphor of purity, but through writing it I have come to understand and even enjoy the impurity of the scholarly process. If I was ever at all persuaded by the rhetoric of purity that attends the beginnings of abstract painting in Europe, this faith was quickly displaced by my appreciation for the eclectic range of intellectual inspirations, institutional encouragement, and most importantly, personal support, without which this study would never have been completed.

It is a great pleasure to acknowledge the inspiration I have received from many people as this book took shape. For comments on my first chapter in its earliest forms, I would like to thank Reed Dasenbrock, Nancy Troy, and especially Linda Henderson. William Vaughan has been for me a model of generosity, both scholarly and personal. The initial ideas for this book were developed in graduate and undergraduate seminars I taught while at McGill University, and I would like to thank the students in those classes, as well as those in my seminars at the University of Western Ontario, for their ideas and criticism. Most recently, four individuals whom I have come to think of as colleagues in the best – that is, noninstitutional – sense have read or heard parts of this book and offered support that has been invaluable to me: Norman Bryson, Michael Ann Holly, Patricia Mathews, and particularly Linda Hutcheon. Finally, there are the numerous scholars – many of whom I have not met – on whose work I depend: I have tried to recognize as many as possible of these inspirations in my notes.

A book cannot be written on inspiration alone, however, and I would also like to thank very heartily those individuals and institutions who have donated time, funding, and an understanding of the scholarly process. Three research assistants, Anita Utas, Sonia Halpern, and Jarrod Kurek, helped

ACKNOWLEDGMENTS me with many bibliographical tasks. The Social Sciences and Humanities Research Council of Canada made funds available through a McGill University grant for my initial research on Gauguin and, even more significantly, awarded me a "Research Time Stipend" in 1987–88, which released me from teaching for a full year. I have also received research monies from the Faculty of Arts at the University of Western Ontario, for which I remain grateful. Less tangible but equally important support has come from Beatrice Rehl at Cambridge University Press, Alice Mansell, Chair of my department, and from Thomas M. Lennon who, as Dean of the Faculty of Arts at Western, has encouraged research in ways that have made a lasting difference to me. I would also like to thank the editors of the *Art Journal* and *RACAR* for permission to include in Chapter 1 parts of articles already published. Finally, I want to acknowledge two important opportunities to present my research orally that helped me to fashion a sense of my work at its inception and at its end: the Universities Art Association of Canada meeting in Montréal in 1985, where I first voiced my ideas on Gauguin, and the "Women and Reason" conference hosted at Western by the Centre for Women's Studies and Feminist Research in 1989, at which I was able to make connections between the "fathers" of abstraction and the concerns of contemporary painting.

This book is dedicated to Elizabeth Harvey. It is impossible for me to record adequately the debts of inspiration, encouragement, and support I owe her for the many years of incomparable and invaluable intellectual sharing that we have had. I can only trust that she will understand the gesture.

OUT OF PLATO'S CAVE: "ABSTRACTION" IN LATE NINETEENTH-CENTURY FRANCE

I. GAUGUIN AND THE ART OF PURE MEMORY

IN A LETTER of September 1888, Gauguin complained to van Gogh of the trouble he was having completing the portrait of Emile Bernard in the upper right of *Self-Portrait, Les Misérables* (Fig. 1). "I am observing young Bernard," Gauguin said, but "I do not yet get him. Maybe I shall do him from memory, but in any case it will be an abstraction."[1] He provided a much more elaborate description of this painting in a letter to Emile Schuffenecker the next month, a letter that – in conjunction with his comments to van Gogh – so completely captures the characteristics of the radically new style called Synthetism that it deserves to be quoted and considered in detail.

I have this year sacrificed everything – execution, color – for style, wishing to impose upon myself nothing except what I can do. It is, I think, a transformation which has not yet borne fruit but which will. I have done the self-portrait which Vincent asked for. I believe it is one of my best things: absolutely incomprehensible (for example) it is so abstract. Head of a bandit in the foreground, a Jean Valjean (*Les Misérables*) personifying also a disreputable impressionist painter, shackled always to this world. The design is absolutely special, a complete abstraction. The eyes, mouth, and nose are like the flowers of a Persian carpet, thus personifying the symbolic aspect. The color is far from nature; imagine a vague suggestion of pottery contorted by a great fire! All the reds, violets, striped by flashes of fire like a furnace radiating from the eyes, seat of the struggles of the painter's thought. The whole on a chrome background strewn with childish bouquets. Chamber of a pure young girl. The Impressionist is pure, still unsullied by the putrid kiss of the Ecole des Beaux Arts.[2]

Gauguin's seemingly off-hand discussions of this seminal work in fact amount to an essentialist theory of artistic practice that previewed the advent of "abstract" painting. Because

his essentialism is largely neoplatonic,[3] I will emphasize here the centrality this neoplatonism enjoyed in the development of abstract art. As a metaphysical doctrine, it encouraged the transcendence of natural or material appearances typical of abstract art; in addition, because so many artists from the late nineteenth century on used neoplatonic and other analogous doctrines to justify their departures from naturalism, this nexus of theories forms a potent link between the ideas and paintings of the Synthetists and those of Mondrian and Kandinsky a generation later.[4]

Gauguin's iconoclastic theory of art – his working definition of Synthetism – is encapsulated in four terms central to his descriptions of *Self-Portrait, Les Misérables:* "shackled," "memory," "pure," and "abstract." His powerfully visual metaphor of the Impressionist artist "shackled always to this world" is traditionally seen as a reference to the artist as the victim of the hell of society,[5] but the reference to being "shackled" or to "chains" can also be interpreted as an allusion to Plato's allegory of the cave in Book VII of the *Republic.*[6] There the prisoners are "chained [shackled] by the leg and also by the neck." Light comes from a fire burning behind them and projects the shadows of objects onto the cave wall in front of the captives. Because their fetters prevent them from turning around, these shadows are all that the prisoners can see. "In every way, then, such prisoners would recognize as reality nothing but the shadows of . . . artificial objects" (*Republic,* VII, 514–15). With this powerful and influential myth, Plato divides reality into the Intelligible world and that of mere Appearance, just as he did with the famous image of the Line at *Republic* VI, 509.[7] Gauguin's reference to the shackled prisoner Jean Valjean does nothing less than tie *the* central theme of Platonism, the "disaffection with terrestrial existence,"[8] to the practice of painting. Significantly, van Gogh reported that "the effect [this] picture makes on me is that above everything it represents a prisoner,"[9] a prisoner, I would argue, not only of difficult social circumstances, but more importantly, of the aesthetic chains of both the academic system *and* its would-be rival, Impressionism.

Gauguin goes on in his letter to Schuffenecker to claim, like a proud Platonist, that his colors are "far from nature." What, then, is his attitude towards Impressionism at this time, since its creed – if not always its practice – was to paint close to nature and to emphasize the vitality of color and light? No doubt he still saw himself as part of the radical break with naturalism that Impressionism represented in late nineteenth-

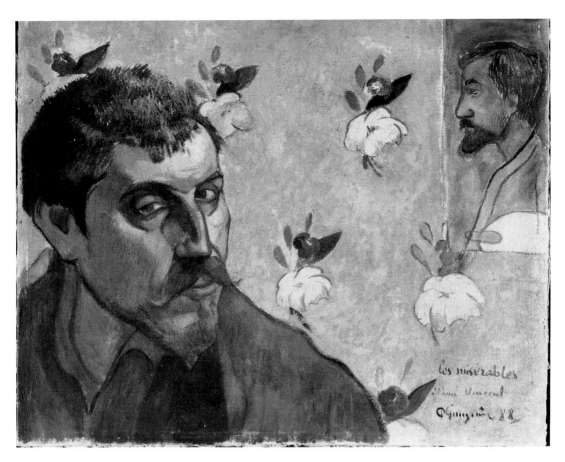

1 Paul Gauguin, *Self-Portrait, Les Misérables*, 1888. Oil on canvas, 71.4 × 90.5 cm (Vincent van Gogh Foundation/National Museum Vincent van Gogh, Amsterdam).

century France; hence his identification with the "bandit" of *Les Misérables*. Jaworska argues along these lines by maintaining that "the picture was . . . meant to symbolize Impressionism as Gauguin understood it, and the condemnation of Impressionism by the public."[10] But a reading more in keeping with Gauguin's pioneering move away from Impressionism is suggested by the neoplatonic connotations of his words. Even at this relatively early point in his formulation of the notion of Synthetism, Gauguin's phrase "shackled always to this world" is pejorative in a specifically Platonic way. He makes the reasons for this break even clearer in *Diverses Choses,* written nine years later: "the Impressionists study color exclusively insofar as the decorative effect, but without freedom, retaining the shackles of verisimilitude."[11] By specifying here that the practice of copying nature is what has shackled art, Gauguin's earlier reference to these impediments becomes more specific. In *Diverse Choses* he goes on to formulate his oft-quoted alternative to this mimeticism: the Impressionists "heed only the eye and neglect the mysterious centers of thought."[12] As early as 1888, then, Gauguin criticized the Impressionists – and thus much of his own background – for staying too close to superficial appearances. He wants to be free from both Impressionism's strictures and the "putrid" rules of the Academy in order to discover more profound truths. His *Self-Portrait, Les Misérables* and the texts surrounding it are early steps in this direction, steps taken within the new context of Synthetism in which Gauguin – in a way that anticipates the other central progenitors of abstraction I will consider – must first purify himself of all external constraints by turning to his inner self. Looking back in 1898 at the fruit that was, as he had predicted, born of this radical change, Gauguin used the metaphor of the cave again. "Painting," he said, "is now freed of all its chains."[13]

Gauguin's reference to memory in his letter to van Gogh may, like his allusion to the shackled prisoners of Plato's cave, seem innocent of philosophical or theoretical import. But here again, Gauguin was – whether consciously or not – invoking a notion central to neoplatonic thought: the theory of anamnesia, of recollection. To van Gogh he says that he cannot get the likeness of Bernard right by working from the model; the alternative was to work from memory. And as van Gogh discovered when the two artists worked together in Arles in the fall of 1888,[14] Gauguin's belief in this method was systematic and absolute. Memory was for Gauguin and those artists who followed him *the* essential faculty because,

4

they believed, it allowed access to a realm of truth inaccessible through the senses. Memory had the same epistemological and ontological priority given to it by the neoplatonic tradition wherein the soul has the ability to recognize Truth because it had prenatal acquaintance with the Forms or Ideas, with absolute Reality. Gauguin's premise that "it is better to paint from memory"[15] is not the merely subjective or idiosyncratic directive that most critics expect from him but rather a self-consciously inward turn to the soul, with a concomitant rejection of external nature or appearances, that is underwritten by neoplatonic theory. It is important to realize here and whenever Gauguin puts forward theoretical ideas that they are anything but recondite speculations. As the passages on memory I have quoted demonstrate, Gauguin is always looking for a method directly applicable to his work. The advice to paint from memory is, for example, supposedly derived from a painting manual composed by "Mani-Vehni-Zunbul-Zadi" and known to Gauguin, but it is more likely that this text is from his own hand.[16] His synthesis in memory of literary images, colors, fantasies ("chamber of a pure young girl"), and observed details about Bernard in *Self-Portrait, Les Misérables,* then, is neoplatonism in action.

The soul, not the senses, is the seat of the "mysterious centers of thought" sought by Gauguin and the Synthetists. By turning inward, away from what now seemed to him the mere surface details of Impressionism as well as the anachronisms of academic painting, Gauguin heeded the advice given by Plato, Plotinus, and all those who spoke for neoplatonism. Metaphors of vision are used by these thinkers and by Gauguin to signal the pursuit of the highest reality. For Plotinus, the soul, "withdrawing to the inmost, seeing nothing, must have its vision, not of some other light . . . but of the light within itself, unmingled, pure, suddenly gleaming before it."[17] Through memory, Gauguin can "see" Bernard's essence and without contradiction criticize the Impressionist painter for his dependence on "this world," his attention to "only the eye." Gauguin's reversion to his own self – the ultimate source of artistic freedom – finds direct expression in the "eyes closed" motif found in *Self-Portrait, Les Misérables* and other works.[18] Vision of the Ideas through recollection is an inner vision: the "bodily eye," to borrow Caspar David Friedrich's famous phrase, remains closed. Plotinus is the ultimate inspiration for this focus on inner vision: "you must close the eyes," he says, "and call instead upon another vision which is to be waked within you" (*Enneads,* I,6,8). It is thus

5

no mere idiosyncracy that Gauguin has shown Bernard's eyes closed in this picture, or that Bernard did the same with Gauguin's portrait in his *Self-Portrait* of 1888, dedicated to Vincent.

The most dramatic image of this return to the self, to that place where memory can synthetize experience and knowledge to arrive at essential truths, is Gauguin's *Self-Portrait in Stoneware* of 1889 (Fig. 2). This piece is clearly anticipated in Gauguin's letter to Schuffenecker when he describes "pottery contorted by a great fire." The 1889 image also relies on the self-portrait discussed in this letter, for, as Merete Bodelson has established, Gauguin's *Self-Portrait in Stoneware* is based on a drawing taken from the 1888 painting.[19] This drawing shows the artist with his eyes closed, as does the stoneware

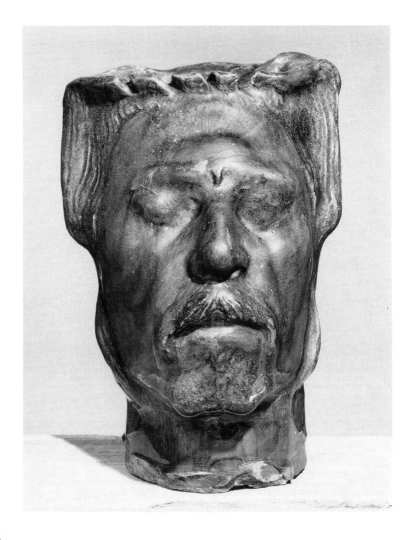

2 Paul Gauguin, *Self-Portrait in Stoneware*, 1889. Stoneware vase, 19.4 cm high (Copenhagen: Museum of Decorative Art. © Copyright Ole Woldbye).

image. The blood-like rivulets running over the eyes in the sculpture are signs of the violent intensity of an *inner* experience, to which access is gained by memory. As Bodelson has it, Gauguin "has portrayed himself *with his eyes closed, as the painter who has turned his back on Nature and now intends to paint only his inner visions.*"[20] When we recall that the fire in Plato's myth of the cave is the image of truth, this inner conflagration takes on noetic connotations. In both the self-portraits considered here, memory is a method for synthesizing diverse inspirations, very often recollections of the artist's own ideas and visions, in order to achieve a depth of experience that can only come through inner experience but whose source lies beyond the individual artist. Gauguin described this method in a letter to Fontainas in 1899: "I close my eyes *to see without understanding* the dream of infinite space flying before me."[21]

"Purity" is the shibboleth for the hierarchical metaphysic applied to the production of art by Gauguin and the other Synthetists. For Plotinus, for example, the human body, indeed anything material, is the soul's "prison or its tomb, the Cosmos its cave or cavern." (*Enneads,* IV,8,3). Plato, he exclaims, "expresses contempt for all that is of sense [and] blames the commerce of the soul with body as an enchainment" (*Enneads,* IV,8,1). But through recollection, the soul knows the true Reality that is passingly tainted by the physical: it must therefore seek to *purify* itself through introspective striving. The soul "is pure when it keeps no company; when it looks to nothing without itself; when it entertains no alien thoughts" (*Enneads,* III,6,5). Plotinus, unlike Plato, discusses purification as a necessary process in art: he uses the example of the sculptor who must look into himself and purify his statue in accordance with recollection of the Ideas (*Enneads,* I,6,9).[22] For Gauguin, the other Synthetists, and the Nabis, this process preserves the mystical/religious character of a sacred rite that it had in Plotinus. In practice, aesthetic purification meant simplification to an essential outline (Gauguin's portrait of Bernard in *Self-Portrait, Les Misérables*), and the use of "pure," unmixed color that is "far from nature." In Gauguin's description, the chrome – a yellow pigment, which, as an element, is "pure" – becomes the background in the "chamber of a pure young girl." Purity also guarantees artistic freedom, because looking only to himself, the artist indeed abstains from the "alien thoughts" of the Ecole des Beaux Arts, from its focus on the imitation of nature's appearances. This inner purity was mirrored in Gauguin's case

by his physical abstinence from French society during his flights to the "primitivism" of Martinique and the South Seas. In the final line of his letter to Schuffenecker, Gauguin, identifying himself as an Impressionist but moving towards the appellation "Synthetist" that he would use in the Volpini exhibition in 1889, sees himself as "still unsullied," "pure" in this metaphysical way.

Gauguin boasted that the design of his *Self-Portrait, Les Misérables* was "a complete abstraction." It is clear from his description of this painting that memory and the simplification attendant upon the process of purification led to what he called an abstract image. Abstraction, then, must in this context relate closely to neoplatonic theory, which was a doctrine designed to help initiates reach spiritual enlightenment. If we follow this reasoning, abstraction also turns out to be more a method than a category of painting, more a means to an end than the result. Abstraction is for the Synthetists – like the notions of memory and purity with which it is inextricably involved – an "instrument" in the Platonic sense, a way to essences that cannot be found or communicated by what were then the traditional, naturalistic means. Gauguin's abstraction from nature in this and many other paintings is analogous to Plato's use of the myth of the cave, which Gauguin also employed. This myth, (like that of the Line, reminiscence, and the ladder of beauty), is "methodological" in the sense that it is "invented for the purpose of specifying how thought is shaped."[23] Abstraction for Gauguin is also a methodogical procedure that allows painting to embody essences, in this case, the essential Gauguin, the prisoner (as van Gogh recognized) of contemporary techniques struggling to free himself. And abstraction is not only a practical matter; it also includes Gauguin's discursive explorations, his "theory," in one complex but homogeneous enterprise. Gauguin said to Schuffenecker that this new type of work was a "transformation," presumably of his earlier "style." If we can say that abstraction is the "style" of this work – in the sense of an active principle of organization that results in an identifiable appearance – then Gauguin's statement at the beginning of this letter is more comprehensible than it might at first seem. "I have this year sacrificed everything . . . for style ['abstraction']," he says, that is, for that element which allows him to reach the essential. Oscar Wilde's aphorism "it is style that makes us believe in a thing – nothing but style,"[24] though he likely meant it in quite another sense, clarifies Gauguin's meaning further. "Style"

stands for the notions of synthesis and abstraction that, when combined in a new approach to painting, gave access to a realm of truth previously denied any of the arts.

I have attempted in the preceding analysis to take Gauguin seriously as a theorist and thus to entertain the possibility that he used neoplatonic theory to elaborate a new aesthetic doctrine. This goes very much against the grain of most recent criticism, which views Gauguin as an impulsive egotist largely incapable of systematic thought.[25] It is more accurate, however, to understand Gauguin's writings as characteristically synthetic formulations of nonetheless viable theories. As he put it, "I'm not a professional. I would like to write the way I do my paintings."[26] Thus his ideas are not set forth in the manner of the Academy, of late nineteenth-century institutionalized philosophy, or even of the literary manifesto, but this difference should not exclude them from serious consideration. Modern critics have commonly followed Maurice Denis's view that "Gauguin was no professor,"[27] ignoring in the process the fact that Denis follows this statement with a rather elaborate description of how important Gauguin's theoretical arguments were to the Nabis. Denis reports, for example, that Gauguin wanted to "express the 'inner thought',"[28] a clear reference to the neoplatonic ideas discussed above. Gauguin *was,* then, a teacher in a very important sense, but he was not an academic professor. His alternate approach to writing is partly to blame for the lack of serious scrutiny given to his essays. Gauguin began his late collection of reminiscences, *Avant et Après,* for example, with the disclaimer "this is not a book,"[29] but like so many of his statements, this phrase is rhetorical. For this reason, we need to investigate the import of his writings rather than avoid the theoretical issues they raise by interpreting Gauguin's "modest" words too literally. For Gauguin and all the Synthetists and Nabis, neoplatonism was not a recondite philosophical system but a living, driving force in their art. Nowhere is this clearer than in the contrast between Gauguin's and van Gogh's work during their collaboration in Arles. This is the context in which to understand the Symbolist critic Albert Aurier's otherwise enigmatic characterization of Gauguin's art as the "plastic interpretation of Platonism done by a savage genius."[30]

The brief but profound contact between these two artists in the fall of 1888 can be seen as a dialogue about the role of the natural model in painting. Questions and answers regarding abstraction inform their correspondence prior to

Gauguin's arrival, their short-lived cooperation in the South, and most importantly, their paintings from this period. Just before Gauguin's belated arrival in Arles in October, van Gogh painted four versions of the public garden in Arles (Fig. 3) as decorations for Gauguin's room in their shared house. For his part, Gauguin disliked Arles and suffered from the tensions of his relationship with Vincent. His response to his friend's hard-won artistic accomplishments was unkind: "when I arrived in Arles," he recalled much later, "Vincent was plunged into the neo-Impressionist school, and he was floundering a good deal. . . . With all his combinations of yellow on purple, all his random work in complementary colors, all he achieved were soft, incomplete, monotonous harmonies: the clarion call was missing."[31] In his inimitably generous way, Gauguin undertook to enlighten the younger artist by encouraging him to paint abstractions, to become less dependent on empirical observation so that he could arrange colors and forms more powerfully and get at the essence of

3 Vincent van Gogh, *A Lane in the Public Garden*, 1888. Oil on canvas, 73 × 92 cm (Otterlo: Rijksmuseum Kröller-Müller. Photo: Tom Haartsen).

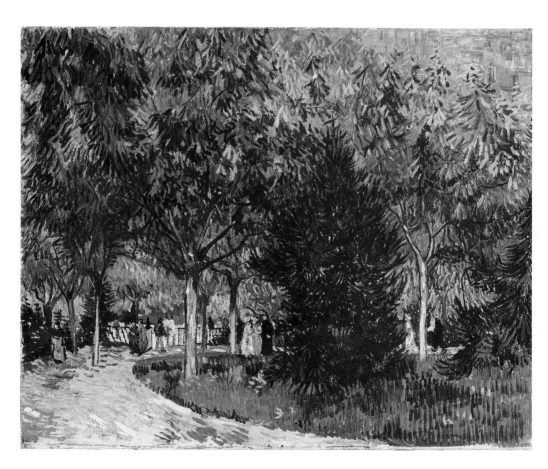

the motif. Just as he had offered his *Self-Portrait, Les Misérables* to both van Gogh and Schuffenecker as an incarnation of a new style of painting, in this case Gauguin also furnished a concrete illustration of his ideas, the *Old Women at Arles* (Fig. 4). The flattened forms and intense colors here remind us of the earlier painting and stand in marked contrast to van Gogh's *Public Garden,* with its Impressionist brushwork, shadows, and relatively conventional space. Gauguin's painting also avoids the literary, even allegorical associations with Petrarch and Boccaccio that transform Vincent's picture of the public garden at Arles into a poet's garden. Gauguin's demonstration champions the apparently opposing pole of abstraction achieved through the unfettered manipulation of the painter's vocabulary. His didactic use of this image underlines the point that abstraction is for him a technique, a way to get behind appearances to the fundamental reality. Whatever we might decide about the identity of this essence – a people's relation to their region (since the picture often carries

4 Paul Gauguin, *Old Women at Arles*, 1888. Oil on canvas, 73.0 × 92 cm (Mr. and Mrs. Lewis Larned Coburn Memorial Collection, 1934.391, The Art Institute of Chicago. Photo: Courtesy of The Art Institute of Chicago. Copyright 1989 The Art Institute of Chicago).

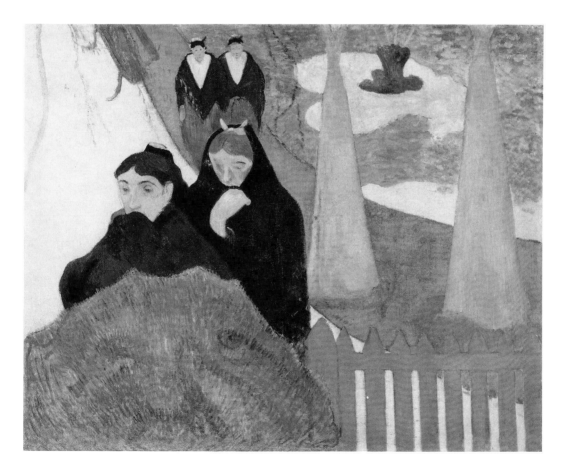

the subtitle "The Mistral"), or the legendary beauty of the Arlesiennes – we can see again that Gauguin habitually calls on memory in its neoplatonic potency to create abstract images. Where van Gogh's poet's garden pictures are direct transcriptions of a local scene, Gauguin has used the same garden at Arles as a mere starting point. The perspectively skewed path and fountain seem to be mnemonic aids that call up powerful images of Brittany, not the South. The enigmatic "cones,"[32] for example, bear a strong resemblance to the stooks of grain in a painting called *The Buckwheat Harvesters,* 1888, by Gauguin's main inspiration in Pont-Aven, Emile Bernard. Memory allows Gauguin to synthesize images of nature from both Arles and Brittany with less tangible ideas about flat composition, non-traditional perspective, and the independent effects of pure color.

The differences between Gauguin's and van Gogh's relation to nature were not the result of stubbornness on van Gogh's part: he saw himself as the elder painter's pupil, and wanted very much to work from memory in order to please. Just before Gauguin's arrival in Arles, van Gogh wrote to Bernard that "others seem to have more feeling for abstract studies than I do, indeed you may be among the number, Gauguin too... myself too perhaps when I am old.... But honestly I am so intrigued by what is possible, by what really exists, that I haven't either enough desire or courage to seek the ideal as it might result from my abstract studies."[33] Van Gogh felt an affinity for Gauguin's ideas but, as he indicated to Bernard, abstraction was simply not his way. In response to the *Old Women of Arles,* however, he drew on memories of Etten and Neunen in the Netherlands to compose his *Memory of the Garden at Etten* (Fig. 5). He described the painting to his sister Wil in terms reminiscent of Gauguin and reported to Theo in both October and December of 1888 that he was going to work more from memory. The December letter is the most assured: "Gauguin, in spite of himself and in spite of me, has more or less proved to me that it is time I was varying my work a little. I am beginning to compose from memory."[34] But ultimately, Gauguin's lessons did not take. *Memory of the Garden at Etten* is a considerable departure in approach from the poet's garden paintings, but van Gogh continued to employ a neo-Impressionist technique and in this example used the yellow-purple combination so disliked by Gauguin. Van Gogh soon returned to the close examination of natural appearances he had used so effectively before Gauguin's arrival; as he said in September of 1888 in the letter

to Bernard cited above, "I cannot work without a model." For Gauguin, however, memory continued to give privileged access to an essential world beyond this everyday experience, a world he sought to apprehend in what he called his abstract paintings. With this practical lesson in mind, we can return to Aurier's description of Gauguin as a "savage Platonist."

Aurier's invocation was not at all unusual in late nineteenth-century France; it is a reflection, not a source, of pervasive neoplatonic thinking in literary and artistic circles. What are the roots, then, of Gauguin's use of these doctrines in his development of Synthetism and his own variety of abstraction? Given the currency of neoplatonic ideas, it is possible that he knew some of the most influential texts directly. As I have argued, Gauguin's temperment was more "philosophical" than is usually allowed. His biographer, Charles Morice, explained for example that Gauguin " 'philosophizes' when he demonstrates his way of understanding

5 Vincent van Gogh, *Memory of the Garden at Etten*, 1888. Oil on canvas, 73.7 × 92.4 cm (Leningrad: The Hermitage Museum).

general ideas... [for example, Gauguin claimed that] 'philosophy... is not a logical conclusion as grave persons would like to teach us, but is a weapon that we make for ourselves as savages.' "[35] Again, the originary value of the primitive is emphasized by Gauguin. He is a "savage" Platonist, not a speculative thinker; he *uses* theoretical ideas to explain and further his work. As in his painting, the synthetic method governed the way he absorbed and deployed philosophical ideas. Denis's statement about the Nabis' synthesis of philosophical concepts aptly describes Gauguin's way of making theory his own: "we made a singular mixture of Plotinus, Edgar Allan Poe, Baudelaire, and Schopenhauer."[36] Unlike Aurier, Bernard, and the Nabis (especially Sérusier) with whom he discussed art theory, however, Gauguin rarely mentions his inspirations outright. But the one name he does cite is central: Swedenborg.

In his *Cahier pour Aline*[37] and, more significantly, in his review of the artist Armand Séguin, Gauguin quotes the following passage from the Swedish mystic: "There is somewhere in the world a mysterious book in which the eternal laws of Beauty are written. Only artists may decipher its meaning."[38] In both cases he adds approvingly, "Et Swedenborg était un savant!" A good deal of neoplatonic thought is packed into this brief quotation. The metaphor of a book in which "the law of harmony and of beauty is written" – the idea, that is, of a transcendent and immutable law that is reflected in the world by signs – suggests the division between Reality and Appearance. Swedenborg's claim that artists can read and even write (through their own creations) this divine script is strongly Plotinian in its emphasis on the role of art and artists in divining essential truth. Gauguin seconds this high valuation of his own calling by quoting Swedenborg, and in an earlier letter to Schuffenecker, he explicitly cites this model of the aesthetic freedom achieved by transcending the imitation of material reality through the process of abstraction: "Do not paint too much after nature. Art is an abstraction; derive this abstraction from nature while dreaming before it, and think more of the creation which will result than of nature. Creating like our Divine Master is the only way of rising toward God."[39] It is likely that Gauguin came to Swedenborg's writings through two novels by Balzac, *Louis Lambert* and *Séraphita,* which he mentions right after citing Swedenborg in the *Cahier.* Gauguin shows that he is well aware of the mystical nature of Swedenborg's ideas, because he uses the example of these books to disprove –

with the satisfaction of a "savage," an outsider who knows something important – the notion that Balzac is a "naturaliste." In addition, Balzac's novels provide a connection between Gauguin and Baudelaire's highly neoplatonic theory of *correspondance,* as they were also responsible for introducing Baudelaire to Swedenborg's idea of "correspondence."[40] And given his close contact with Sérusier, Gauguin would very likely have known of the equally neoplatonic speculations of the newly-formed Theosophical Society, whose beliefs again depended partially on Swedenborg.[41] Willibrord Verkade, a self-styled pupil of both Sérusier and Gauguin and an affiliate of the Nabi brotherhood, made these connections clear. "Sérusier," he wrote, "often spoke to me of a book by Balzac, *Séraphita,* in which the author develops the theosophy of . . . Swedenborg."[42] The hierarchical view of reality and the artist's semi-religious mission to work in the higher realm beyond the confiningly empirical reports of the senses, to rise "toward God" as Gauguin put it, are decidedly neoplatonic.

Neoplatonic formulations and patterns of thinking were common among the literary symbolists whose company Gauguin kept during his stays in France from 1889 on. Without going into detail about his relations and possible exchanges with Stéphane Mallarmé, Jean Moréas, Camille Mauclaire and many others,[43] it is important to record late nineteenth-century Parisian literary theory as another source from which Gauguin could easily have derived neoplatonic principles. Aurier's description of Gauguin's work as that of a savage Platonist is the most telling example because it is so specific, but Mauclaire, for example, discussed how " 'every object is absorbed back into its pure idea' " in an 1892 article in the *Mercure de France* (a journal in which Gauguin also published).[44] Gauguin could not have been unaware of Moréas's 1886 manifesto of Symbolism in which, in the words of one recent critic, the author stressed that "the new poetry would evoke immaterial 'Ideas' by means of a departure from (or distortion of) the 'objective' view of the naturalists."[45] As we have seen, Gauguin used similar metaphysical terminology as early as 1888.

One of the prime inspirations for the literary Symbolists' return to the self or soul as the source of poetic creativity was German Idealist philosophy, which, as we will see, was also crucial to the philosophical tradition that inspired Mondrian and Kandinsky. Schopenhauer's *Die Welt als Wille und Vorstellung* was by far the most influential text, but before I

discuss its importance for the Synthetist artists, it is worth considering briefly a central transmitter of the interconnected neoplatonic and German Idealist philosophies whose work was widely known in France before Schopenhauer's, Victor Cousin. Cousin's philosophy was known as "eclecticism," a "French variant of Neo-Platonic Idealism" established through the melding of recent German thinking with Plato and Plotinus.[46] There is little doubt that both the writers and painters who formed the late nineteenth-century avant-garde in France would have known Cousin's work, especially his standard translation of Plato's complete works (1820–8).[47] What would they have found so compelling in Cousin's writings? The entire essentialist edifice, including German Idealism in its French guise, offered a way to find truth without depending on the supposed "objectivity" of science: this appealed very much to the largely anti-positivistic Symbolists and Synthetists.[48] Cousin also claimed a power and freedom for art and artists, possibilities explicitly denied by positivistic philosophy. Like the neoplatonic thinkers and like Schopenhauer, he argued that art had privileged access to the Intelligible. These general considerations are found, as we saw, in Gauguin's evaluations of his own work. Thus although Cousin's formulation is not necessarily a direct source, it is certainly an example of the pattern of thinking common in Gauguin's circle and adopted by him. Cousin also discussed the specific components that Gauguin and the other Synthetists developed into a new methodology of painting: memory, abstraction, and purity. Like Plotinus and Plato, he argued that the soul knows the Ideas (and especially Beauty) through reminiscence and is reawakened by aesthetic experience *because* material objects act as signs for this ideal realm.[49] Even more remarkable is Cousin's elaboration of what he calls "abstraction immédiate"[50] as a method for apprehending the Idea of Beauty through the use of simple colors and shapes. Finally, Cousin underlines the connection between abstraction as a method of knowing the Ideas and the process of purification: "L'abstraction immédiate," in disentangling the absolute and relative, "gives itself its purity and simplicity, and the ideal is found."[51]

Schopenhauer's *Die Welt als Wille und Vorstellung* offers a compendium of neoplatonic and more broadly essentialist philosophy often applied directly to art. Though it was first published in 1819, its impact in France came only in the 1880s and 1890s and grew rapidly following the first French translation in 1886.[52] According to the philosopher J. Burdeau,

writing in 1884, "the name of Schopenhauer is on everyone's lips; he is analyzed by professors of philosophy and quoted in our drawing rooms. The literature dealing with his work . . . increases . . . almost month by month."[53] Literary figures frequently saw Schopenhauer's philosophy – often as it was mediated through a French interpreter like Cousin – as the foundation of their philosophical educations. Thus for Remy de Gourmont, "notre education . . . avait . . . été fait par le 'Shopenhauer' de M. Burdeau et celui de M. Ribot."[54] Teodor Wyzewa recommended Ribot's study of the German philosopher to "all prospective 'idealists'."[55] Idealists or not, readers could not have overlooked the neoplatonic strain in Schopenhauer's thought.[56] "The object of art," he says, "is an *Idea* in Plato's sense."[57] And it is in the perception of the Idea that art offers salvation from the ontologically wanting world of appearances. Art makes contact with the Idea by returning to the soul through memory, through "reminiscences from a prenatal perception of truly existing things." (I, 174) This type of argument was summarized in Gauguin's time in Ernest Caro's *Le Bouddhisme moderne*: "there is only pure intuition, a free vision of the ideal, a momentary participation in Plato's idea, in Kant's numen,[58] once one has attained this forgetfulness of one's transitory life . . . torment [is] . . . momentarily suspended!"[59] "Pure" intuition, or "contemplation" (as both Schopenhauer and Mondrian called it), in art is at most based on sense experience, since ultimately "the very best in art is too spiritual to be given directly to the senses" (II, 408). Here we see the rhetoric of purity in action, referring us always away from the material world.

As in Cousin's philosophy, these general neoplatonic notions are accompanied in Schopenhauer by specific discussions of the role of memory – and, in this case, of artistic genius – that are strikingly close in spirit and diction to the ideas on art expressed by Gauguin and the other Synthetists.[60] Schopenhauer's analysis of genius, madness, and memory provides a gloss on Aurier's characterization of Gauguin as a savage genius, the significance of which to our understanding of Synthetist art cannot be overestimated. For Schopenhauer, "genius is the capacity to remain in a state of pure perception, to lose oneself in perception." The genius is a "subject purified of will [i.e. individuality, social convention], the clear mirror of the inner nature of the world" (I, 185, 186). Drawing directly on Plato, Schopenhauer then claims that this sort of genius is linked and even blended with madness. His example should be recalled with regard to Gau-

17

guin's image of the "shackled" Impressionist in his letter to Schuffenecker. "Plato," Schopenhauer elaborates,

> expresses it in the . . . myth of the dark cave (*Republic,* Bk. 7) by saying that those who outside the cave have seen the true sunlight and the things that actually are (the Ideas), cannot afterwards see within the cave any more, because their eyes have grown unaccustomed to the darkness; they no longer recognize the shadow-forms correctly. They are therefore ridiculed for their mistakes by those others who have never left that cave and those shadow-forms. Also in the *Phaedrus* (245 A), he distinctly says that without a certain madness there can be no genuine poet, in fact (249 D) that everyone appears mad who recognizes the eternal ideas in fleeting things (I, 190–1).

This genial madness is a function of *memory* (I, 192), for it is the artist's memory that focuses on the Platonic Idea. He sees extremes as a result, and "leaves out of sight knowledge of the connexion of things . . . according to the principle of sufficient reason" that governs society's "normal" view of reality (I, 193–4). The artist-genius therefore appears to distort nature when in fact he sees the truth behind everyday superficialities. Schopenhauer's theory of genius perfectly describes the "disjunctions" (according to prescribed rationality) found in so many of Gauguin's paintings. Gauguin mentioned the type of art based on academic convention in a letter to Bernard in November, 1889: "as for doing commercial painting, even the Impressionist kind: no. Very deep inside myself I glimpse a higher meaning."[61] As he said about later work, his attempts to depict this higher meaning caused critics to censure him for distorting nature. "What is actually the fruit of deep meditation," Gauguin complained, "of deductive logic derived from within myself and not from any materialistic theories invented by the bourgeois of Paris, puts me seriously in the wrong, they believe, for I do not howl with the pack."[62]

It is impossible – and ultimately of secondary importance – to determine exact sources for Gauguin's neoplatonism. The question of when he might have known and applied these doctrines, however, figures in our interpretation of his work. The evidence of his letters referring to the *Self-Portrait, Les Misérables* suggests a date of mid-1888, that is, *before* Gauguin knew Aurier or Sérusier, who were steeped in this ancient philosophy. Emile Bernard is therefore the most likely inspiration. He was well versed in philosophy[63] and, as I will argue, his theories were developed in neoplatonic terms. The timing is also right, since although Bernard and Gauguin had

met in 1886, their productive interaction peaked in the sum-
mer of 1888.[64] If Bernard was indeed partly responsible for
introducing the theoretical principles with which Gauguin
would develop his dependence on memory into a practice of
synthesis and abstraction, then his much-disputed role in the
birth of Synthetism would be augmented.[65] On the other
hand, Gauguin did not necessarily require tutelage; to assume
this is to accept at face value his own self-portrait as an ig-
norant "savage." On the contrary, his sophisticated ability
to generate theoretical tracts is amply witnessed by his "Turk-
ish painter's manual." We cannot be sure when Gauguin
might have written the piece, but since one crucial passage
– "It is good for young people to have a model, but they
should forgo looking at the model when they paint"[66] – ap-
peared in the *Cahier pour Aline* of 1892, that, is before the
entire text was published in *Avant et Après* (written, c. 1900–
3), it is certain that Gauguin put these thoughts down during
or shortly after his most intense involvement with the prin-
ciples of Synthetism. Gauguin used this supposedly ancient
tract to lend authority to a new method of painting. The
manual is, in fact, very much like Plato's myths in that it is
"methodological" and seeks to prescribe how painting should
be. Two of Gauguin's directives are clearly analogous with
Neoplatonism: the advice to ignore the model when painting
and its corollary, to paint from memory. Gauguin points in
this text to two of the most important propositions that fol-
low from this theory of art: that art should be anti- or non-
mimetic, and that it should rely on anamnesis or memory.
These ideas have crucial implications for the nature and de-
velopment of abstract art from the time of Gauguin's early
experiments well into the twentieth century. Before returning
to the issue of mimeticism, however, it is worth examining
an early precursor of what became among Gauguin, Bernard,
and van Gogh a subgenre of portraits within portraits.

Gauguin's *Still-Life with Profile of Laval*, 1885 (Fig. 6) is in
many ways abstract in the same senses as *Self-Portrait, Les
Misérables* (Fig. 1). It combines a reference to the exotic South
in the prominent fertility sculpture and mango on the table[67]
with memories of Gauguin's debt to Cézanne in the other
fruit. Laval is shown with his eyes closed, suggesting that
empirical observation in the Impressionist manner is not the
purpose of the painting. Finally, Laval's image is reflected in
what appears to be a mirror.[68] This mirror can be read as a
sign for the hierarchy of existence posited in neoplatonic phi-
losophy, because memory, Plotinus said, is like a mirror

19

(*Enneads*, IV, 3, 30) in that it embodies the reflection of a higher truth, in this case, the synthesis of aesthetic influences whose essence Gauguin can express only indirectly. Pierrot asserts that mirrors were often thought to possess just this sort of occult power in the late nineteenth century. There was, he says, a "traditional belief that mirrors retain . . . the trace of every face they have ever reflected, with the result that [they] become a secret memory, continuously storing away . . . simulacra of people and things."[69] Mirrors of course are not always going to suggest the sort of ontological ordering found in this painting. But in the *Still-Life* of 1885, painted in Denmark, Gauguin had already used a mirror to reflect the profound difference between two realms of existence. Mark Roskill has noted "an implicit contrast between [the figures'] . . . shadowed existence and the bright light outside the window."[70] If we read this "window" as a mirror, the phrase "shadowed existence" takes on a neoplatonic tenor and suggests an even more profound distinction between Gauguin's despised in-laws and his own way of looking at the world. Can such a reading be admitted as early as 1885, given that Gauguin's ideas on Synthetism are usually thought to have gelled only in 1888? An answer must depend in part on Gauguin's theoretical activities at this time, and most critics now agree that his *Notes Synthétiques* was written in about 1885.[71] In this text he places painting at the top of his hierarchy of the arts because of its synthetic powers. Gauguin says that in painting, "all sensations are condensed," and that the viewer has "his soul invaded by the most profound recollections."[72] This passage gives credence to the idea that in his *Still-Life* of 1885, Gauguin could be making essential distinctions of a metaphysical sort.

With these examples in mind, we can return to the question of art's anti-mimetic possibilities through Albert Aurier's 1891 article on Gauguin. The academic artists of the period believed in a "conventional objectivity," he says, and are to be scorned as

poor stupid prisoners of the allegorical cavern. Let us leave them to fool themselves in contemplating the shadows that they take for reality, and let us go back to those men who, their chains broken and far from the cruel native dungeon, ecstatically contemplate the radiant heavens of Ideas. The normal and final end of painting, as well as of the other arts, can never be the direct representation of objects. Its aim is to express Ideas, by translating them into a special language.[73]

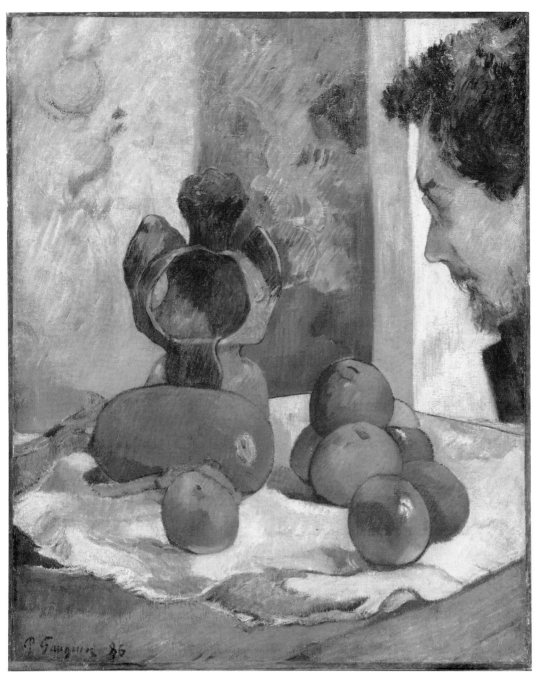

6 Paul Gauguin, *Still Life with Portrait of Laval*, ?1885. Oil on canvas, 46.2 × 38.1 cm (Josefowitz Collection. Photo: Art Gallery of Ontario).

A comparison with Plotinus establishes the lineage[74] of Au-
rier's theory. The highest reality, Plotinus says, lies "lapped
in a pure light and in 'clear radiance' . . . the original of which
this beautiful world is a shadow and an image" (*Enneads,*
III,8,11). To escape these metaphysical shadows, Plotinus and
the Synthetists follow mystical rites, "appointed purifica-
tions" (*Enneads,* I,6,7). "He that has the strength," exorts
Plotinus, "let him arise and withdraw into himself, foregoing
all that is known by the eyes, turning away forever from the
material beauty that once made his joy" (*Enneads,* I,6,8). This
is certainly the philosophical foundation for a non-mimetic
art, phrased with the now-familiar rhetoric of purity. The
all-important criterion of artistic freedom is also met by this
theory, as it is the material world that impedes liberty. Again
according to Plotinus, "the fall of the Soul, [is] this entry
into Matter: thence its weakness: not all the faculties of its
being retain free play, for Matter hinders their manifestation"
(*Enneads,* I,8,14). But matter (painting) is not completely neg-
ative since, like nature for Gauguin and those who followed
his lead into abstraction, this realm of being provides the
initial step in the process of purification.[75] Gauguin, echoing
the Plotinian proposition that art could furnish, not simply
mime, reality, posited that the "artist . . . (if he really wants
to produce a divine creative work), must not copy nature but
take the natural elements and create a new element."[76] It was
Denis who confirmed that Gauguin "freed us from the *chains*
with which the idea of copying [nature] had bound our paint-
ers,"[77] confirmed that a new, non-mimetic theory of art that
assured aesthetic autonomy had been born.

In "Les Symbolists," Aurier provided an enthusiastic inter-
pretation of what we would now call the Pont-Aven group,
but most of the text is devoted again to Gauguin. Aurier
headed the article with the following passage from Plotinus:
we are "undisciplined in discernment of the inward, [and]
knowing nothing of it, run after the outer, never understand-
ing that it is the inner which stirs us" (*Enneads,* V,8,2). As
we have seen, it is this turn back to the self and the soul that
gives access to higher reality. Inner vision relies on the theory
of anamnesia, the non-forgetting of the Ideas. Memory and
vision are inextricably linked in Plotinus: "Memory . . . must
be understood . . . to include a condition induced by the past
experience or vision. . . . At any time when we have not been
in direct vision of [Reality], memory is the source of its
activity within us" (*Enneads,* IV,4,4–5). This is the true im-
port of memory for Gauguin, Bernard, the other Synthetists,

and the Nabis, as (otherwise enigmatic) passages by Bernard
show.

Since the idea is the form of things acquired by the imagination, one should not paint in front of things but by calling them back into the imagination that had acquired them, which preserved them in the idea; thus the ideas . . . gave the simplification purporting to be the essential in things perceived.

We must simplify [reality] in order to disclose its meaning . . . I had two ways to achieve this. . . . The second way . . . consisted in relying on conception and memory and in disengaging myself from all direct contact [with nature]. . . . [This] was an act of my will signifying through analogous means my sensibility, my imagination, and my soul.[78]

Memory was *the* faculty, then, because it gave access to this world of essences while simultaneously unfettering the artist-seer. Memory guaranteed the ontological certainty that artists found wanting in contemporary positivism and what they saw as its parallel in art, academic painting. Writing explicitly about Gauguin and Synthetism, Aurier provided a poetic version of this discovery of security in the doctrine of anamnesis: "we remember unconsciously," he says, "the times when our souls relaxed in the marvelous garden of Eden of the pure ideas."[79] The metaphysical notion of origin, source of all security, is here described in a neoplatonic/Christian manner.[80] Eden is *the* origin, the progenitor that stands behind all subsequent life. The Ideas have the same function in the neoplatonic tradition, where they are the opposite of Plato's shadows, and it might be that Aurier's source for this memorable metaphor was Plotinus's description of the dialectical method that "pastures the Soul in the Meadows of Truth." Aurier's reference to "pure" Ideas is in turn the touchstone for Gauguin's abstract art, since memory brings the artist into the pure presence of ultimate Reality.

I have argued that neoplatonic philosophy was not a recondite ancient tradition in late nineteenth-century France, but that it was a living, shaping set of ideas embraced by numerous theorists and artists. How can we account for this popularity? One explanation is that it offered a philosophical justification for the return to the self, that it provided the ultimate in artistic freedom by championing the artist's role in apprehending Truth. It is likely that this increasing focus on the inner, psychological realm was at least in part due to the rise of scientific psychology at this time, a field which often "pitted against the confinement of mass man . . . the liberation of psychological man."[81] The artist, as Gauguin

complained, was chained to academic practices, to the photographic reproduction of nature. Synthetism was one way to react against this orthodoxy. Neoplatonism also offered an alternative to nineteenth-century positivism, widely held in disrepute in artistic circles, as Aurier eloquently demonstrated in his article on the Symbolist painters, using Plato as his measure. "A great many scientists and scholars today," he wrote,

have come to a halt discouraged. They realize that this experimental science, of which they were so proud, is a thousand times less certain than the most bizarre theogony, the maddest metaphysical reverie, the least acceptable poet's dream, and they have a presentiment that this haughty science which they proudly used to call "positive" may perhaps be only a science of what is relative, of appearances, of "shadows" as Plato said.[82]

Neoplatonic thinking offered metaphysical *security,* an antidote to and escape from the relativity of the everyday world.[83] This philosophy cannot be cited as a cause for the widespread dissatisfaction with positivism, but it did make an attractive alternative. "We must become mystics again,"[84] wrote Aurier in the early 1890s: neoplatonism offered a way to heed this call *and* to find certitude through art. Aurier's definition of the new art promulgated by Gauguin lays out the eidetic semiotics that holds this promise and whose basic terms were, I want to argue, adopted by the abstractionists of the early twentieth century. This art is "*Synthetist,*" he says, "for it will present . . . forms, signs, according to a method which is generally understandable." This claim to universal intelligibility is crucial to the later developments of abstract painting. The new art is simultaneously "*Subjective,*" he claims, because the object must be seen "as the sign of an idea perceived by the subject."[85] Here we have the turn to the self that is emphasized in the nascent development of abstraction. In his earlier and seminal article on van Gogh, Aurier took this notion of the work of art as sign even further by claiming that pigment itself is "a kind of marvellous language destined for the translation of the Idea."[86] Art, then, *can* gain access to ultimate reality even with material means, but these means are never to be taken as ends. According to Denis, Gauguin made this move intuitively; Aurier and Sérusier then proved him philosophically correct. It would be more accurate to say that Sérusier in particular pushed Gauguin's fledgling essentialist abstraction farther and thus inaugurated the definitive experiments in this new art in the early twentieth century.

24

During the Universal Exposition in Paris in the summer of 1889, Paul Sérusier attended the "Groupe Impressioniste et Synthetiste" exhibit organized by Gauguin and his circle at the Café Volpini. Sérusier had had previous contact with the Synthetist work Gauguin displayed at this show, but he was reluctant to follow Gauguin's directions. After seeing the Volpini exhibit, however, Sérusier pledged his allegiance to Gauguin with the passion of a convert: I have "imbibed the poison," he told Gauguin, "I am with you from now on."[1] The negative connotations of the word "poison" seem odd in these circumstances, yet it is the apparent anomaly of this locution that gives us critical access to the nexus of Platonic associations implied by Sérusier's diction, associations that, in their connections with essentialist theory, form the very conceptual foundation of abstract painting.

The "poison" Sérusier refers to was administered initially by Gauguin in Pont-Aven in October, 1888, when he gave Sérusier his now legendary painting lesson in the Bois d'Amour. Maurice Denis recorded Gauguin's oft-quoted instructions to his newly acquired pupil: "How do you see this tree. Is it really green? Use green then, the most beautiful green on your palette. And that shadow, rather blue? Don't be afraid to paint it as blue as possible."[2] The result was the famous work later named – significantly, as we shall see – the *Talisman*. Gauguin's guidance might appear to us to have been primarily empirical, for he seemed to behave as the quintessential Impressionist by forcing his pupil to attend to nature's appearances. Indeed, Sérusier had, only the day before this lesson, approached him for instruction because of Gauguin's eminence as an Impressionist painter. But as we have seen, Gauguin was at this time consciously purifying himself of his Impressionist past and actively theorizing a radical alternative. His "poison" was the new Synthetist style and its attendant philosophy that explicitly denied the empirical premises of Impressionism. Synthetism was his cure or remedy for both naturalism's arid attention to surface detail and anachronistic subject matter (the "putrid kiss of the Ecole des Beaux Arts," as he says in the letter to Schuffenecker cited at the beginning of this chapter) and Impressionism's adherence to nature's mere appearances. Gauguin's Synthetism was more than practical, more than a method: fundamentally, it was *Plato's* poison – the "pharmakon" – which in Gauguin's hands was a metaphysical antidote to

what the Platonic tradition viewed as our impoverished attention to appearance rather than essence, the outer instead of the inner, the tainted as opposed to the pure. It is to this textual tradition that we must look if we are to perceive the ideology that informs Sérusier's prototypical abstract paintings.

The term "pharmakon" figures frequently and centrally in Plato's writings. Translated variously as "recipe," "poison," or – like Sérusier's painting – "talisman," it is in every case a potent, even magical facilitator that Plato treats with suspicion. In the *Phaedrus,* writing is the pharmakon that promises nothing less than wisdom to its inventors, the Egyptians. Yet Plato condemns this "recipe" in terms that take us to the heart of his metaphysics. The philosophical lesson we are to learn is couched in terms of the myth of the invention of writing by the Egyptian god Theuth (Hermes to the Greeks) and his description of writing's powers to King Thamus:

(Theuth): my discovery provides a recipe [pharmakon] for memory and wisdom.

(Thamus): You . . . have declared the very opposite of [writing's] effect. If men learn this, it will implant forgetfulness in their souls: they will cease to exercise memory because they rely on that which is written, calling things to remembrance no longer from within themselves, but by means of external marks; what you have discovered is a recipe not for memory, but for reminder. And it is no true wisdom that you offer your disciples, but only its semblance (274E–275A).[3]

Socrates immediately broadens his mistrust of writing to include painting: "You know, Phaedrus," he says, "that's the strange thing about writing which makes it truly analogous to painting. The painter's products stand before us as though they were alive: but if you question them, they maintain a most majestic silence" (275D). Dead writing is thus opposed to living speech and inanimate painting is disparaged through a comparison with the live model on which, for Plato, it has to be based.[4] In Plato's text these ontological differences are characterized most tellingly with reference to memory.

Memory, too, can be alive or dead. If living, it is the center of Plato's doctrine of recollection, whereby the soul knows the Ideas through prenatal acquaintance. Otherwise, it is only a "reminder," as Thamus said, an imperfect trace. Memory and reminder are related, but more importantly, they are also separated by a fundamental ontological gap. This difference parallels that between the shadows seen by the prisoners in

Plato's cave and the true light of Reality, or – and this is where the reference to painting in the *Phaedrus* takes us – to the distinction between the artist who merely "represents" the bed that the carpenter and god actually "make" (*Republic* X, 597). Repetition or representation is fundamental to memory, yet here again Plato insinuates his characteristic hierarchy. In living memory, in the reports of the prisoner freed from the Cave, or in the carpenter's bed, there obtains "a repetition of truth (*alēthia*) which presents and exposes the *eidos*," but in the reminder, the shadows, and the artist's bed, there is "a repetition of death and oblivion (*lēthē*) which veils and skews because it does not present the *eidos* but re-presents a presentation, repeats a repetition."[5] True memory, then, brings the soul into the presence of the Ideas: identity, not the difference that defines even repetition, is the soul's ultimate goal. Art cannot bring the soul to this goal for Plato because, as an echo of a repetition, it is mimetic in the lowest possible way. Memory is therefore set against mimesis, and it is in this unequal relationship between memory and mimesis that the link between Plato and Synthetism can best be examined further.

In his *A B C de la Peinture*,[6] Sérusier wrote that "we carry from birth the understanding of [the] universal language" of art. This knowledge, he asserts, is obscured by faulty academic education. Thus we are forced to "recover [it] through abstraction and generalization." Memory is the prime vehicle, since our experiences of aesthetic objects "evoke notions previously acquired and preserved by the memory."[7] As these passages show, Sérusier's theory of memory is clearly filiated with the Platonic doctrine of recollection, of true memory. Maurice Denis confirmed that Sérusier had linked Plotinus's version of Platonic memory with art theory during their student days together in the Académie Julian in the late 1880s, and he tells just how "practical" this connection was: "Sérusier," he reported in a retrospective article of 1908, "taught me . . . the philosophy of Plotinus before he revealed to me the technique and aesthetic of synthetist painting."[8] Sérusier had in fact been sufficiently infected by Platonism during his studies at the Lycée Condorcet in the early 1880s to learn Greek so that he could read the original texts.[9] That Plato himself denied the artist access through his work to the Ideas presented no barrier to Sérusier, who in effect mapped Plotinus's ideas back onto Plato and thereby constructed a defense of art. Like most nineteenth-century neoplatonists, that is, Sérusier would have thought that Plotinus corrected Pla-

to's ideas on art by upgrading works of art to the second rather than the third remove from the Ideas. "The guiding thought is this," he claimed, "that the beauty perceived [in] material things is borrowed" (*Enneads,* V,9,2). "The art exhibited in the material work derives from an art yet higher" (*Enneads,* V,8,1). Like Plato, Plotinus taught that we should seek to rise to this higher sphere by purging – purifying – the material level of existence from our lives, but for Plotinus, art served as an ideal occasion for this process. "Purity" also becomes the password for Sérusier's painting.

By claiming that art can have access to Platonic universals through memory, Sérusier not only brought Plato up to date via Plotinus but also drew out implications latent in the entire Platonic tradition and developed them into a theory of non-mimetic art.[10] Again, Sérusier seemed to be correcting the notoriously negative view of art found in the *Dialogues,* a condemnation of mimesis that rests on the narrow view that art must be representational. Once the artist's idea is allowed to participate in the transcendent Idea, however, the ultimate identity of knower and known – upon which both Plato's and Plotinus's epistemology rests – opens up the possibility that art can be a perfect mimesis, that is, non-mimetic. Plotinus allowed that "beauty comes by participation" (*Enneads,* V,9,2). It follows that "Only from itself [the Idea] can we take an image . . . that is, there can be no representation of it, except in the sense that we represent gold by some portion of gold – purified, either actually or mentally" (*Enneads,* V,8,3).[11] Because every soul has images of the Ideas stored in memory, the artist must turn inward for his models, as Gauguin did, away from the "external marks" of materiality that Plato (through Thamus) condemns in the *Phaedrus.* And because these exemplars are part of the artist, there is no separation, no mimesis. Memory and mimesis are therefore no longer opponents, as they were for Plato. Sérusier has in fact inverted the dialectic of memory and reminder set out in the *Phaedrus,* because for him painting's means *must* now be endogenous. Verkade quoted Sérusier stating that the soul is "the key of the universe,"[12] and there are many Synthetist images that underline this inward turn by focusing on closed eyes and intense inner experience (Fig. 2). Again, it was memory that gave access to the Ideas in which art sought to participate. Sérusier, Verkade reported, taught "the doctrine of the reincarnation of the soul, and of its ascent through a series of successive existences to the Absolute. To '*recollect* yourself' was one of his favorite expressions."[13] His theorizing and

teaching about art would become more and more Platonic, to the point where, in the *A B C de la Peinture,* he focused on the artistic revelation of mathematical absolutes, very much as Plato did in the *Philebus* (51C).[14] But it was his earlier contact with Gauguin's Synthetist "poison" that made a non-mimetic art conceptually possible.

The close ties between Gauguin and Sérusier and the effect of the former's teachings reveal another dimension of the Platonic, essentialist subtext so crucial to the beginnings of abstract art. In initiating Sérusier into the principles and practices of Synthetism, Gauguin behaved as the "good physician." We can trace the origins of this venerable tradition to Socrates's role in Plato's *Gorgias* (521A), where the physician administers the medicine/poison, the pharmakon. Socrates demands that Callicles distinguish "what kind of care for the city you recommend to me, that of doing battle with the Athenians, like a doctor, to make them as good as possible, or to serve and minister to their pleasures?"[15] As a philosophical doctor, Socrates prefers the painful but enlightening process of dialectic over what he sees as the ultimately vapid pleasures of rhetoric. The remedy used by the physician is dialectic because it furnishes the patient with the ability to cure himself. This cure is initially dispensed by the physician as an antidote to a particular problem. What begins as a practical lesson, however, is soon extended by the patient into an encompassing method or system by which he can live.[16] This is precisely how Gauguin's relationship with Sérusier progressed. Sérusier knew Gauguin only by reputation when they first met in Pont-Aven in the fall of 1888. When approached by Sérusier, Gauguin took the younger artist in hand and showed him how to paint in the radically simplified Synthetist manner that he called "abstract." The lesson seemed simple: paint what you see and be bold about it. We know, however, that Gauguin's advice was anything but off-hand. He was consistently preaching a new aesthetic, as Vincent van Gogh discovered when Gauguin arrived in Arles, not long after instructing Sérusier, only to impart remarkably similar advice. "The mountains were blue, were they?" Gauguin asked van Gogh. "Then chuck on some blue and don't go telling me that it was a blue rather like this or that, it was blue, wasn't it? Good – make them blue and it's enough!"[17] We have seen that Gauguin was imploring Vincent to work from memory, the ideal method of whose virtues he would no doubt have tried to persuade Sérusier in Pont-Aven had there been time. Though he tried to please by following

Gauguin, van Gogh soon returned to the immediate study of nature: the contrast in reception underlines how successfully Gauguin's poison took with Sérusier in the long run.[18] What was initially a practical painting lesson became for him a creed of "abstraction" based on the hierarchical and absolute unity of Platonism. Sérusier could then cure himself and others afflicted with the disease of empirical, superficial observation that characterized academic styles and even Impressionism. *He* could then in turn be a progenitor, a "father" in abstraction's evolution.[19] The goal of the good physician – whether Plato, Socrates, or Gauguin – then, is to administer the poison so successfully that the lesson will transcend and obviate the master, who becomes merely a medium for the dissemination of higher truth. This is the same relationship of abrogation that we have seen between representational art and the new abstraction, and then in turn between abstraction and a yet higher reality. True to what seems like a Platonic script, then, Sérusier, the *Talisman,* and the idea of a new "abstract" art in general, took over from Gauguin the part of the physician. It is also true that Sérusier's role was bound to increase after Gauguin abandoned his leadership of the Synthetist artists by leaving for the South Seas. But his initiation of Sérusier was crucial because it focused on the transcendence of art's materiality in the name of a higher synthesis. Gauguin liked to picture himself as the Christ-like messiah, partly because he saw himself as a suffering, misunderstood artist–outcast, but also because he preached aesthetic salvation.

Sérusier adopted the role of the good physician when he returned to Paris after his first contact with Gauguin by giving the *Talisman* to Maurice Denis, who actually named the piece at this time.[20] As "talisman" is a synonym for "pharmakon," the *Talisman* can be understood in terms of the Platonic subtext I have been discussing. The painting, along with Sérusier's and Denis's enthusiasm for it when they displayed it to the students at the Académie Julian, then precipitated the Nabi group, for whom the painting worked as a constant reminder of the principles of Synthetism. As late as the 1920s, the *Talisman* still hung as an exemplar in the Académie Ranson.[21] It was an extreme work, but perhaps not in the way often proclaimed by recent art historians, who see its radical simplification of natural forms as an anomaly never repeated by Sérusier and thus unlikely to influence the development of abstract art.[22] For both Gauguin and his pupil, it was certainly a demonstration piece never designed for exhibition or sale.

But precisely because it was created under the spell of Gauguin, for the converted the *Talisman* had the mystical powers of a relic, powers that far outstripped its potential influence in an exhibition. Denis describes how Sérusier returned from Pont-Aven and flaunted, "not without a certain mystery," this small but potent image in front of the students at the Académie Julien, and he reports that the painting introduced all of them to the concept of the work of art as "a plane surface covered with colors assembled in a certain order."[23] The real anomaly is that the *Talisman* was not painted from memory. But since it represented Sérusier's initiation (we might say his "rite de *paysage*") and embodied the *purification* of nature's forms urged by Gauguin, the painting became a powerful mnemonic device, a memory not only of Sérusier's seminal lesson, but also of this lesson's prescription to paint the essential. Its "abstract" qualities guided artists away from superficial nature and the material world in general towards the Ideas. Sérusier's purification was Platonic: it sought to rise above the material in order to participate in the Ideas, to transcend mimesis by being a perfect imitation, that is, a non-imitation. Just as the artist as good physician is left behind, the individual work of art, however historically significant, is at best a sign of a higher reality.

Albert Aurier codified this fundamental aspect of Synthetism in his article of 1891 on Gauguin by claiming that natural objects act, for the artist of genius, "only as *signs*" of Platonic Ideas. Aurier here makes the philosophical heritage of his semiotics clear: "those who do not know about the Idea . . . merit our compassion, just as those poor stupid prisoners of the allegorical cavern of Plato did for free men,"[24] and he goes on to conclude that even paintings made through the inspiration of Ideas are themselves mere signs of this ontologically superior realm. Artists like Gauguin and Sérusier are lauded because their works "move body and soul to the sublime spectacle of Being and pure Ideas."[25] The rhetoric constantly employed by Aurier to convey the ultimate goal of art is one of *purity*. "Ideistic" art, as he calls it, leaves nature behind by relying on memory and is therefore "more pure and more elevated through the complete purity and the complete elevatedness that separates matter from idea."[26] Finally, this purity is linked by Aurier to a Platonic conception of the "abstract," which is then applied to art. The abstract is equated with the Idea: what Aurier calls the "transcendental emotivity" of a genius like Gauguin can, through painting, cause the viewer of a work to break free from the material

fetters of the medium and have his "soul tremble before the pulsing drama of the abstractions."[27]

Sérusier articulated and practised a similar set of precepts. During his second apprenticeship to Gauguin, in the fall of 1889 at Pont-Aven, for example, Sérusier inscribed a credo, borrowed from Wagner's writings, on the wall of the inn where the artists lived:

I believe in a Last Judgment at which all those who in this world have dared to traffic with sublime and chaste art, all those who have sullied and degraded it by the baseness of their sentiments, by their vile lust for material enjoyment, will be condemned to terrible punishments. I believe on the other hand that the faithful disciples of great art will be glorified and that – enveloped in a celestial tissue of rays, of perfumes, of melodious sounds – they will return to lose themselves forever in the bosom of the divine source of all Harmony.[28]

The rhetoric of purity runs through this passage, though – as would be more and more characteristic of Sérusier – it is couched in Christian language. "Art should be hieratic," Sérusier wrote to Verkade in 1895. "It is not without regret that I say goodbye to the landscapes, the cows, the Bretons who charm and amuse the eye."[29] Leaving nature behind in this way – a process inaugurated by the *Talisman* – does not mean that Sérusier's paintings are without recognizable subject matter, but rather that natural objects are in themselves signs of a higher reality.

Sérusier reveals a certain nostalgia for what has become the superficial, though still instrumental, plane of everyday existence when he mentions the pleasure that these "external" phenomena give. In Plato, however, pleasure is itself a sign of Sophistic superficiality, and this merely decorative aspect of life had to be purified. Sérusier's *Landscape at Pont-Aven* (Fig. 7) of 1890 exemplifies this process. It is based on observation but composed through the filter of memory in order to guarantee an essential image. Here the blue outlines favored by Gauguin – perhaps absent in the *Talisman* because it was painted so quickly – were put in prior to the predominant orange of the quarry or the greens of the foliage, suggesting that Sérusier must have abstracted an image of this landscape mnemonically at a very early point in the picture's evolution. This work is more finished than the *Talisman*, but it was executed in a way that encouraged the transcendence of material nature through memory, exactly as Gauguin's lesson in the Bois d'Amour implied. Many of Sérusier's paintings also demonstrate this turn to the inner life of memory via the

soul in their use of the "eyes closed" motif invoked so powerfully by Gauguin in his *Self-Portrait in Stoneware,* 1889 (Fig. 2) and *Self-Portrait, Les Misérables* (Fig. 1) from the previous year. For example, *Le Paravent* of 1891 shows six women harvesting fruit in what looks like an evocation of Eden, but is also recognizable as the coast of Brittany. Although the women are in a social situation, and although activities like picking fruit would seem to involve the eyes, Sérusier has shown the figures with their eyes hidden from us completely, averted, or closed. The result is a palpable tension between expected social interaction and self-contained inner vision. And like most of his paintings, the scene is static, otherworldly, because Sérusier thought that movement, Becoming as opposed to Being, was literally too mundane to be linked with the timeless purity that he sought through his work.

The "poison" that Sérusier accepted from Gauguin was, ultimately, the drive to transcend the material world and search for the purity of essences. The cure was painful because

7 Paul Sérusier, *Landscape at Pont-Aven,* 1890. Oil on canvas, 65.3 × 80.8 cm (Ottawa: National Gallery of Canada).

it went against the predominantly empirical practices of the day, and – as it implied that painting was only an instrument for gaining access to a higher realm – because it ultimately negated the painter's vocation. As in Plato's texts, it was unpleasant (but therefore good) to take the pharmakon,[30] because old habits (like painting landscapes, cows, and Bretons as an Impressionist) had to be discarded. In the Platonic tradition the materiality of art is *lēthē,* forgetting (in a metaphysical sense), a necessary "reminder" that must nonetheless be abandoned in favor of *alētheia,* truth, or – literally – nonforgetting, remembering.[31] Art is positive only because its inevitable materiality holds the crucial ontological difference between the Idea and its sign constantly before us and thus points to the Ideas. But just as the good physician is transcended, so too abstract painting as it was initiated by Gauguin and Sérusier had as its final goal union with the pure presence of the Ideas through the transcendence of painting itself.

I claimed at the outset that Plato's poison – the urge to transcend the materiality of art in search of a superior reality – provided the conceptual basis for abstract painting. Before examining some of this assertion's implications in the work of Mondrian and Kandinsky, however, I want first to characterize the paradoxical nature of what we might call the Platonic painting of the late nineteenth century. An aesthetic based on Plato has to see art as derivative and removed from the Ideas. Even a revised Platonism that views art as a sign of and possible means to these Ideas still requires the transcendence of the materiality upon which the arts depend, because this materiality necessarily denies the "Platonic urge to escape from the finitude of one's time and place."[32] For Sérusier, abstraction in art was not an end in itself but a way to transcend temporal, historical limitations.[33] Echoing Aurier's notion of art as sign, he claimed that "art is a *universal* language expressed by symbols."[34] Yet rather than abandon art because of its inherent shortcomings, Sérusier made the tension between the material and the Idea productive: painting remained his way to the Ideas to such an extent that his experiments with abstraction can be seen as a *response* to Plato's disparagement of the arts, an "apology" or "defense" in the Platonic sense, not just of abstraction, but of art itself. Gauguin's "abstraction" is an earlier step in this direction. Sérusier, however, sought a new mimesis more explicitly, one that so completely presented the Idea that art became non-mimetic. As we have seen, this project in fact stems from

a notion central to Platonic epistemology and metaphysics, the ideal identity of the knower and known, the doctrine of participation. If a painting like the *Le Paravent* can so perfectly capture an essence (whether of harmony or of God's presence in nature – the difficulty in specification is a problem for an essence's claim to universality) that it becomes transparent by becoming part of that essence, then art will have overcome the barriers assigned to it by Plato. As I have emphasized, this possibility was broached by Plotinus. "Only from itself [the Idea] can we take an image . . . that is, there can be no representation of it, except in the sense that we represent gold by some portion of gold – purified, either actually or mentally" (*Enneads,* V,8,3). Purification through abstraction allows painting to perform this cidetic alchemy. Plato's goal in condemning writing and painting in the *Phaedrus* is to get beyond both, in semiotic terms, to collapse the ontological difference between signifier and signified that typifies his metaphysics.[35] Ultimately, Platonic painting would like not to be painting.

In this spirit, both Gauguin and Sérusier overcame traditional symbolism by purifying objects of their expected identifiability and meaning: this process defines their "abstract" painting. If, as I am suggesting, this transcendental purification is foundational for what we normally call abstract art in the early twentieth century, then we would expect to find the Platonic precepts I have discussed at work in the next generation of artists. Two further implications would follow. First, the essentialist strain of late nineteenth-century Symbolist theory, as represented here by Sérusier, would be crucial to the birth of abstraction. Even more importantly, since the "purity" of Platonism differs crucially from the formal "purity" that, following Clement Greenberg, we commonly take to be central in the definition of Modernism, it follows (if we want to claim early abstract painting and its proponents as important parts of Modernism in the visual arts) that this definition of modern art's *self-reflexive* purity needs to be augmented in terms of the *transcendental* model I have described. Before turning to these issues in the following chapters, however, I want to establish Plato's hypothetical requirements for a defense of art and characterize more completely what I have termed his philosophy's essentialism.

In Plato's notoriously censorious attitude towards the arts, there are clues – however negatively couched – about what art should and could be. Plato's condemnation is ultimately moral rather than ontological or epistemological; if we con-

sider his *Dialogues* as a whole, painting, for example, is not portrayed as inherently bad, despite its foundation in mimesis. As Elias has claimed, "it is not imitation itself that is condemned, but the imitation of bad example."[36] Plato *does* "admit . . . the poetry which celebrates the praises of the gods and of good men" (*Rep.* X, 606), and suggests (though rather grudgingly) that if "dramatic poetry . . . can show good reason why it should exist in a well-governed society, we . . . should welcome it back" (*Rep.* X, 606). As he explains in this context, however, most art has been banished because it "has no serious claim to be valued as an apprehension of truth" (*Rep.* X, 607). That art give access to truth is Plato's prime criterion, and his investigation is, for him, "theoretical" precisely because it demands that art have this metaphysical foundation.[37] Of course judging art's necessarily material productions by the measure of non-sensuous truth is a paradoxical procedure. Panofsky for one complained that this standard is "utterly foreign to [the arts'] nature."[38] Yet by inviting art to defend itself on this eidetic plane, Plato spawned a long tradition of apologies.[39] If the potential apprehension of truth is the first necessary quality of a legitimate art, then the manifestation of this phenomenon would have to be non-mimetic. Plato's famous dismissal of the artist – who can work only "at the third remove from the essential nature" of his subject (*Rep.* X, 597) – is also a devaluation of imitation itself. Even in the *Philebus,* where Plato waxes eloquent about the timeless beauty of pure geometrical forms (51C), however, it is not clear that he envisioned the possibility of a non-mimetic art that could capture the ontological presence of these forms directly. But again, his invitation for art to defend itself clearly opened the way for others to answer his accusations. The Neoplatonic tradition "corrected" Plato by arguing that art *can* come into contact with truth. Since mimesis prevents this union, however, the idea of a non-mimetic art that focuses on the Ideas themselves rather than imitating appearances was bound to arise. Sérusier, for example, seems to have drawn on Plato's discussion in the *Timeaus* of the pyramid as the origin of all other forms for his image *The Origin* of c. 1910.[40] This and many of his other paintings try to embody a transcendental truth of this Platonic sort. Interpreted as images of the Idea itself, they are at worst only residually mimetic. And in a passage from Plotinus cited above, we are provided with the argument that this participation is not imitation at all: "only from itself can we take

an image . . . there can be no representation of it" (*Enneads,* V,8,3).

A Platonic art, then, must give access to truth and be non-mimetic. From Plato's examinations of art's inadequacies, we can derive three other requisites. His moralism leads him to denounce the artist as practitioner as well as art objects: a "painter," he complains, "will paint us a shoemaker, a carpenter, or other workman, without understanding any one of their crafts; . . . [It is] easy to produce with no knowledge of the truth" (*Rep.* X, 598–9). If the artist (or anyone) wants to approach truth, we are told, the only course is to look inward to one's own soul. Then the soul "passes into the realm of the pure and everlasting and immortal and changeless . . . this condition of the soul we call wisdom" (*Phaedo,* 79D). In order to have a hope of producing valid art, then, the Platonic artist must be a transformed agent. Gauguin and Sérusier both undergo this change. In addition, art must be "no mere source of pleasure but a benefit to society and to human life" (*Rep.* X, 607), it must be socially instrumental in this sense. This demand in turn suggests that art should never be an end in itself but always a means whereby the individual and state are improved. Finally, then, for Plato art as a discrete category and activity is ultimately transcended as it is absorbed into the perfectly harmonious State that he envisions.

The five criteria for a Platonic art that I have outlined – access to truth, non-mimetic incarnation, the ability to reform the artist's soul, social and political effectiveness, and self-transcendence – stem from the heart of Plato's metaphysics, from what Derrida calls the *"ontological,"* that is, "the presumed possibility of a discourse about what is."[41] This discourse, fundamental to the whole of Western philosophy, turns on Plato's distinction between Reality and Appearance. His dualism entails the familiar hierarchical dialectic between universal and particular, absolute and mutable, internal and external, immaterial and material. What *is,* Reality, is the realm of the Ideas, of Truth or Essence, which is defined by the first terms in this list of oppositions. Plato thus inaugurated what I call "essentialism," in Herbert Marcuse's words, "the abstraction and isolation of the one true Being from the constantly changing multiplicity of appearances."[42] The quest for this metaphysical essence guides Plato's writings on all themes from justice to art, and the " 'above and below' "[43] structure that his model entails was pervasively adopted and

modified by philosophers such as Plotinus, Swedenborg, and Aurier, and by the Synthetist artists Gauguin and Sérusier. These and other thinkers who figured in the advent of abstraction are then Platonists and neoplatonists, but because I want to discuss the aesthetic effects of philosophies that also diverge from Plato in the following chapters, I will also employ the broader term essentialism to refer to the belief in and search for the immutable and universal core of reality – a search that had manifold implications for the inception of abstract painting in the early twentieth century.

Plato's essentialism precipitated his verdict that art was unable to gain access to truth and was thus unfitted for his ideal state. The apology for art that he calls for – and in his own literary practice even partially delivers[44] – must then also be cast in terms of the attainment of essence, since to be successful, this defense would have to satisfy the five hypothetical conditions of a Platonic art form. Put another way, the mechanisms that initiated abstract painting in the early twentieth century are informed by an essentialist metaphysics with its touchstone of purity. Art was of course banished from the Republic before having a chance to defend itself; perhaps Plato was so nervous about its power that he could only offer the possibility of a fair hearing in art's absence.[45] To defend itself, however, art is required to submit its own forms for reevaluation. "Before returning from exile poetry should publish her defense in lyric verse or some other measure" (*Rep.* X, 606). We would thus expect painting, by analogy,[46] to provide concrete material "arguments" in support of its ability to embody truth non-mimetically, to turn artists inward and thereby produce a form that could lead society towards perfection. This is exactly what both Mondrian and Kandinsky do with their early abstract work, and Plato's text, as well as the tradition that reversed his view of the arts by answering his accusations, certainly lent impetus and authority to this type of answer.[47] What has not to my knowledge been emphasized is that Plato himself (and the entire apology tradition, by its example) suggests a second and corroborating way in which a defense could be formulated. "I suppose," he grants in what seems like a throwaway line that immediately follows the passage just cited, "we should allow her champions who love poetry but are not poets to plead for her *in prose,* that she is no mere source of pleasure but a benefit to society and to human life" (*Rep.* X, 607; my emphasis). In this way, the *textual* apologies by philosophers, critics, and artists – which, as I have shown with reference

to Gauguin and Sérusier, are crucial to the beginnings of abstraction – are given both a rationale and considerable weight as inspirations. This is very clear in the writings of the two central pioneers of abstract painting, Mondrian and Kandinsky. Not only is their own development of prose apologies legitimated by Plato's intimation of a textual defense, but their appeal in these texts to the defenses put forward by other essentialist thinkers, such as Hegel and Schopenhauer, is also grounded by a long and worthy lineage. Equally important to the development of abstract painting, Plato's implicit blessing of prose defenses also blurs the conventional boundaries between "theory" and "practice" that resulted, in the work of Kandinsky and Mondrian, from the partnership of textual and painted responses to the original disparagement of painting in the *Republic*. As I will argue in the following two chapters, for Mondrian and Kandinsky especially, experiments designed to prove painting's grasp of the essential were carried out *materially* on canvas or in print. Their work collapsed the theory/practice hierarchy because these categories were for them ultimately part of the same enterprise.[48]

Both Mondrian and Kandinsky emphasized the need to produce art materially in order to show its efficacy; what was in effect their apology for art had to be concrete. In examining the mechanisms by which these two artists achieved this goal, I focus on Mondrian and Kandinsky not only because of their acknowledged centrality in the advent of abstract painting, but also because they appear to develop very different forms of abstraction, "geometric" in Mondrian's case versus "expressionist" in Kandinsky's. In spite of some important divergences in approach, however, their work has in common the inspiration of late nineteenth-century abstraction, the use of landscape motifs in the articulation of its abstract idioms, and underlying all of this, an essentialist philosophy. I am not asserting (in an ahistorical, universalizing manner suitable to the metaphysical claims of essentialist thinking) that Mondrian and Kandinsky are fundamentally the same. What I do want to establish is that the extent of their shared ideology of abstraction is revealed by their mutual insistence on "purity," the hallmark of the essential and nothing less than Mondrian's and Kandinsky's end and means as they articulate the parameters of abstract painting.

THE MECHANISMS OF
PURITY I: MONDRIAN

FOR MONDRIAN, abstract painting was not primarily a goal in itself, but rather a method for making a universal, absolute truth material and thus perceivable. The characteristics that he conceived this truth to have – purity, immutability, complete intelligibility – stood behind and largely determined the processes through which he sought to manifest the absolute in art. This is not to suggest that a "theory" of art's mission artificially preceded the "practice" of abstract painting. In fact, Mondrian frequently claimed that he discovered the overarching metaphysical principles of his work through the activity of painting itself. Surprisingly – given his affinities with the neoplatonic tradition, which typically insisted that the artist's inspiration came from an Idea that was prior to experience[1] – Mondrian would never begin his paintings by focusing on the essence or universal; he always maintained instead that "experience was [his] only teacher" (338), that he deduced the timeless truths of reality through his plastic "research."[2] On the other hand, it is also the case that Mondrian insisted throughout his life on the priority of universal truth over any particular action or artifact and that a dialectical tension between these options can be found in many of his essays. "Art," he claimed in his first sustained formulation of the Neoplastic aesthetic, "The New Plastic in Painting" of 1917, for example, "although an end in itself like religion – is the means through which we can know the universal and contemplate it in plastic form" (42).[3] Rather than see this sort of formulation as contradictory, unclear, or simply unresolved, we can, I think, suggest that art as an end in itself, as an autonomous formal system, is abrogated in Mondrian's thinking (as a whole and in this example) in deference to a greater good, just as art and religion both are for Hegel.[4] If this distinction between art as an "end in itself" and a "means" can be conceived as parallel to the division

between the practical activity of aesthetic production and the
theoretical ends towards which the artist may ultimately aim,
then both dialectics are for Mondrian dissolved in his unified
textual and painterly apology for art. As he put it, "I don't
want pictures. I just want to find things out."[5]

The seamlessness of his overall aesthetic activity is dem-
onstrated by the fact that the importance he gave to knowing
the universal initiated his familiar purification of natural
forms in the material world. In his decidedly Socratic dialogue
"Natural Reality and Abstract Reality" (1919–20), which I
will examine in detail later in this chapter, for example, Mon-
drian attempts to lead his immediate interlocutors, and us,
the larger audience, to the realization that "we must . . . see
through nature. We must see deeper, see *abstractly* and above
all *universally*. . . . Then we can see the external for what it
really is: the mirror[6] of truth" (88). For Mondrian, Neo-
plasticism is a highly refined tool for manifesting the universal
plastically, and its particular forms and procedures are strictly
directed to this end. Neoplasticism's value is established only
by its instrumentality, because for Mondrian painting must
function as part of a broad philosophical and social enterprise
that seeks immutable ontological truth, as well as social justice
and stability, through "equilibrium." "If the purely universal
is to be rendered sensible and perceivable" in this way, he
argues, "everything that exists for its own sake must be an-
nihilated" (90). These foundations underlie the project of
Neoplasticism itself and should, therefore, also be our starting
point when we ask how Mondrian's definitive form of pure,
abstract painting arose historically and conceptually. My first
concern is to establish the coordinates of his articulation of
this relationship between art and truth (the universal). If my
analyses seem to be likewise ahistorical, Chapter 4 will pro-
vide a series of balancing, corrective contexts for our under-
standing of this enterprise.

Mondrian makes it very clear that the search for an un-
changeable essence is fundamental to his art: "the universal
is the essential," he wrote in 1917, "and if the universal is
the essential then it is the basis of all life and art" (71, n. 't').
Even as early as 1909, in a letter to the critic Querido that is
regarded as the painter's first extant theoretical text, Mon-
drian seems to have given primacy to essence: "there are great
intrinsic values or truths," he stated, "which remain the same
throughout the ages."[7] He makes the same point – though
now with the important addition of a psychological and so-
ciological justification – in what is perhaps his definitive essay

on neoplastic aesthetics, "Plastic Art and Pure Plastic Art" (1936): "One realizes more and more the relativity of everything, and therefore one tends to reject the idea of fixed laws, of a single truth. This is very understandable, but does not lead to profound vision. For there are 'made' laws, 'discovered' laws, but also laws – a truth for all time" (291). Mondrian's expressed goal is to manifest these unchanging laws plastically so that they can, through art, be models for society. It is here that we can see how the very structure of the system he developed entailed – in its conviction that essence takes precedence over anything individual – the process of purification that pervades his aesthetic understanding of the self as well as his own relationships to previous art and to nature.

Purity defines the universal that Mondrian seeks: "only a pure art, [can be a] . . . direct plastic expression of the universal" (42; italics omitted), and only a diligent purification of superficialities can yield this pure art. Yet Mondrian will not begin with the pure essence he claims to know, because he believes in what we might call (given his unusual introduction to the issue) man's original aesthetic sin, his embeddedness in matter, and thus in his need for ritual purification. "Adam in the Paradise story," Mondrian tells us, "live[d] in perfect equilibrium." But since this state was seen by God to be somehow unearned, Eve was created for "opposition," as a foil against which original man could honestly win his purity (256). The lesson Mondrian would have us learn from this Biblical example is that reality is made up of dualisms that must be "equilibrated" through purification. The reference to Adam and Eve invokes *Genesis*, that ultimate origin which guarantees for Mondrian the truth of his undertaking and establishes the primary coordinate in his dualism. Axiomatic assertions like "nature . . . is the mirror of truth" are built on the difference between (a superior, pure) essence and (a secondary, tainted) reflection. For the poles of this dialectic to become balanced or equilibrated – though not therefore equivalent – nature in this case must be purified, brought closer ontologically to the universal with which it is opposed. The same structure obtains in Mondrian's other well-known dichotomies: dynamic/immutable, particular/universal, material/immaterial, female/male.[8] All these relationships stem from his original metaphysical distinction between essence and its simulacra. Again, when he tries to manifest universal laws through dialectic by bringing the two parts into equilibrium, he is already committed to purity as his end and to purification as his means. In other words, the mechanism of

purity is identical with the process of achieving equilibrium, which is the constant aim of Mondrian's work, because for him only equivalent relations can embody the universal truth that art in the Platonic tradition must seek to manifest.

Achieving equilibrium in painting is then a metaphysical imperative that comes to make demands on Mondrian's material experiments, because the terms dualism, relation, and equilibrium that I have been connecting with his conception of truth are immediately and inextricably implicated in the production of Neoplastic art. The notion of dualism embraces the radically reduced means that Mondrian employs in his signature work: horizontal and vertical, color and plane. Relation describes their dialectical interaction, and equilibrium is the state of perfect balance to which they aspire. As in the Adam and Eve example above (which demonstrates that Mondrian's ideas are both inspired by and have implications beyond the formal requirements of pictorial composition),[9] the duality of, say, orthoganally intersecting lines allows for what Mondrian sees as a necessary opposition of elements. As Mondrian's Neoplastic painting as a whole attests, any combination of these elements is always individual and, ideally, never static; the type of *relation* between lines, however, is constant, and it is here that the universal, which is by definition unchanging, can be manifested through equilibrium. "The New Plastic," Mondrian says, "wishes to focus attention on the *appearance* of the work: the universal is what it *seeks* to express, but its *appearance* is the equilibrated relationship of the duality of opposites" (114). These opposites – horizontal and vertical lines, for example – must be so totally purified of any connotations extraneous to their role as means in the expression of truth and be so pure in their equivalence that they can perpetually oppose each other and thereby ultimately transcend their duality by achieving dynamic equilibrium.

Mondrian explains how his dialectic works to express essence through the opposition and purification of means:

In the New Plastic we have equivalence of *extreme opposites* and therefore a *distinct duality*. *Rhythm* is the one and the *constant relationship* is the other; the *changeable relationship of dimension* is the one, and the *immutable relationship of position* is the other. In the plastic means, *color* manifests the one and the *plane and perpendicular* the other. In position, the *horizontal* is the one and the *vertical* the other, and so on. Precisely because the duality is so *distinct,* far more effort is demanded of the Abstract-Real painter if he is to find equilibrium between the opposites. When he chooses to express *the one,* it is at

the expense of *the other,* and when he succeeds in expressing *the other* purely, it is to the detriment of *its opposite* (97).

What Mondrian is describing here is certainly the ability to manipulate painting's elements. But this ability depends upon the artist's hard-won facility for "pure plastic vision," the power to "see pure relationships" (61) amid the confusion of the everyday world. He also calls this faculty "intuition," the capacity to perceive essence. As he makes clear throughout his writings, he developed this unique vision through the experience of art by removing what he habitually calls the "veils" of appearance in order to discover and manifest truth. This is an ongoing process that will eventually lead to salvation. "Gradually," Mondrian wrote as late as 1936, "art is purifying its plastic means and thus bringing out the relationships between them" (289).

The concrete steps in this evolution towards a pure art are shaped by Mondrian's essentialism. As I argued in Chapter 1, the belief that art can lead to universal truth requires that the artist be transformed so that *he* can intuit essences (as we will see, there is no possibility for Mondrian that a female artist could do this). In his response to the Querido, Mondrian not only posits art's universality – "truths which remain the same throughout the ages" – but also this need for a new art form produced by a new, philosophical, type of artist. In claiming that "everything done in our own time must be expressed very differently,"[10] Mondrian emphasizes the process of art's materialization through the artist as agent. He joins what might still be seen as theory and practice by arguing that "clarity of thought should be accompanied by clarity of technique."[11] This is the relationship "between philosophy and art... which most painters deny,"[12] but which Mondrian seeks to exploit and unify so that art may achieve truth. From this early point, Mondrian emphasizes the newness of the art he envisions and the need for a "new man" both to produce and understand it. Of course this art's form and appearance are new, but much more important is its unprecedented ability to convey truth. Precisely because he sees this new art as evolving from the mimetic art of the past – rather than appearing ahistorically – its difference from this past art is emphasized, and the new art's role as an apologist for what former art could not do is made manifest. Neoplasticism's fundamental innovation for Mondrian is thus ontological: art's status is raised because, by becoming nonmimetic, it is able to reveal the true. In this way, his work

44

satisfies the first two conditions implicit in a Platonic art form, that it present truth *and* in a non-mimetic way. But as I have argued, the artist must change before art can approach this goal, and Mondrian is well aware from his own experience just how trying this process of purification can be: "the artist always has difficulty in making himself a *pure instrument* of intuition of the universal within him," he wrote in 1919–20 (115). Sérusier experienced a similar pain in leaving the Bretons behind. Yet for Mondrian, only with a pure soul can the artist be a means through which society itself can be transformed, and this accomplished, through which art as we know it can be transcended through its complete integration with the perfect society.

Mondrian's entire aesthetic enterprise can be seen as an apology for art in these terms. To focus a detailed analysis of Neoplasticism's coordinates that will expose some of its fundamental and undiscussed principles, however, I will concentrate now on his dialogue "Natural Reality and Abstract Reality." Its thematic and structural links with the Platonic tradition are unmistakable; it is also a prime example of Mondrian's dialogue with his broader essentialist heritage and as such offers access to his development of philosophical and mystical "sources," such as Theosophy, Hegel, and Schopenhauer. We can see that by inscribing a version of himself in this text – in the character "Z," an "Abstract-Real Painter" – Mondrian is able to dramatize the self's necessary purification, because "Z" is the incarnation of the process of artistic self-definition that the essay rehearses. As a necessary consequence, his recollective reinterpretation of his own development towards Neoplasticism in his paintings, which are, as we will see, invoked in the dialogue, is also presented as a model for aesthetic and social change. Thus "Natural Reality and Abstract Reality" makes the interdependence of text and image (theory and practice, in a conventional sense) the basis of Mondrian's concrete realization of a pure art. As a further consequence of his reconstitution of his personal artistic history, earlier art as a whole is interpreted from the vantage of abstract painting, and here again, the dialogue supplies a character – "X," a "Naturalistic Painter" – who embodies not only Mondrian's previous incarnation as a quite traditional artist but also the European heritage of mimetic painting that Neoplasticism so triumphantly overcomes. To complete this Platonic drama, "Y," a "Layman," who functions as a foil for Mondrian's apology, can, as a non-artist, be seen to embody the society at large that Neoplasticism

wants to transform and into whose perfection it hopes ulti-
mately to blend.

"Natural Reality and Abstract Reality," then, is a didactic
text in a precisely Socratic sense. Its focal point, "Z," func-
tions like the good physicians we saw in Chapter 1, who,
through a series of seemingly spontaneous conversational
sets, lead their partners to an understanding of the truth about
art. The heuristic effect that Mondrian achieves here by grad-
ually unveiling truth in this ingenuous manner must have
been even more effective for his original readers, who, since
the dialogue was serialized in no fewer than twelve install-
ments of *De Stijl* through 1919 and 1920, were manipulated
even more than we are today by the dialogue's unfolding
drama. Because Mondrian begins by re-forming his own self,
"Natural Reality and Abstract Reality" is necessarily retro-
spective as it pertains to its author's own spiritual and artistic
development. Mondrian is already an initiate. When he ex-
plains how to achieve "equivalent duality," which is the plas-
tic manifestation of universal truth, for example, he rehearses
in outline the oppositions commonly found in the theoretical
traditions that have led him to Neoplasticism. His list includes
man and nature, force and appearance, inward and outward,
material and spiritual, male and female. Equilibrium, Mon-
drian argues, resolves these pairs into an essential unity –
what he deems "purified duality" – and "is to be found no-
where but in ourselves" (96; italics omitted).[13] He thus ex-
horts his interlocutors in the dialogue to turn inward, to recast
themselves through purification as he has already done, so
that they can experience all life "abstractly in its most pro-
found essence" (96; italics omitted). The dialogue as a text,
and as the series of pictorial images that it describes, is itself
a witness to the priority Mondrian gives to the radical re-
definition of the self as Neoplastic artist, because the success
of his reconstitution *is* his very ability to stand in the text as
"Z," the leader. Had he not begun with himself, Mondrian
the author could not (in his own terms) be in a position to
administer the "poison" of abstraction to others, as he does
so zealously. The entire dialogue, then, is a fictionalized au-
tobiography of Mondrian's self-purification and displays
what is enabled by its result, pure abstract painting.

Mondrian articulates the terms and goals of the turn to the
self through his advice to "X" and "Y." He implores them
to seek the somewhat elusive quality of "repose" that he
identifies as characteristic of the landscape scene with which
the dialogue opens: "Late evening – flat landscape – broad

horizon – the moon high overhead" (83). The "profound" quality of repose that Mondrian ascribes to this scene is that "to which we inwardly aspire," (88) and which Neoplasticism seeks to manifest plastically. Though repose as a virtue in nature and art is mentioned by Mondrian here quite casually as an emotional response to a landscape scene, this notion turns out to be an important key to what he requires the self to become if it is to make the universal concrete. Repose describes the tranquility of the immutable absolute as it can appear to human perception. It is the ideal unity of warring opposites. Put yet another way, repose is the salient quality of relation. Mondrian derived this idea at least in part from the Dutch mathematician L. E. J. Brouwer, who, along with Dr. Schoenmaekers (widely recognized as an inspiration for Mondrian's formulation of Neoplastic theory), was part of a circle of intellectuals to which Mondrian belonged during World War I, when he was in the Netherlands. Brouwer's book *Leven, kunst en mystiek* (Life, Art and Mysticism) of 1905 not only provided Mondrian with three of the images he uses as scenes in "Natural Reality and Abstract Reality" – the first, third, and fifth – but even more significantly, it formulated the metaphysical principle of repose. Inwardness, Brouwer claimed,

will not loosen its ties with that other part [of reality] which provides eternal certainty, repose, and wisdom. Thus it will experience the vast blue sky as the exact counterpart of its own mood of humility and contemplation; the immutable course of the stars as the counterpart of its own freedom; the colours and branching of the plants as the counterpart of the other colours and the flow of the passions in its own blood.[14]

It is clear from this passage that Mondrian is structuring the self, the inward (and from this basis Neoplasticism and society itself), around the essential and universal because of these absolutes' "certainty," and not, therefore, around the more traditional notion of the self as an individual. Again, like Plato before him, he disparages the notion of the individual as a metaphysical and social entity. The dialectical oppositions described by Brouwer also provide the opportunity for stable, immutable *relations* that Mondrian ultimately finds in his theory of equilibrium. Repose is the point of stasis achieved through the equilibration of the various oppositions that Mondrian recites in this dialogue and that he employs throughout his plastic production. Repose also captures the perennial importance of nature for Mondrian, whose centrality is also stressed by Brouwer in the passage

just quoted. To find repose and to make it concrete, Mondrian holds in a crucial passage I have already referred to,

we must not see beyond nature: rather we must, so to speak, see *through* nature. We must see deeper, see *abstractly* and above all *universally. Then we can perceive nature as pure relationship.* Then we can see the external for what it really is: the mirror of nature. For this we must first free ourselves from *attachment* to the external; only then can we rise above the tragic and consciously contemplate repose *in all things* (88–9).

Brouwer's writings were likely one of the most immediate inspirations for the doctrine that Mondrian espouses here, but as such they would only have worked as reinforcements for ideas about the fundamental importance of the inner and the need to "rise above" the individual toward the universal sphere that Mondrian learned from an array of neoplatonic, Theosophical, and more strictly philosophical texts. His considerable debts to Theosophy have been expertly diagnosed.[15] While not in the least downplaying the importance of these doctrines to Mondrian (Theosophy's emphasis on hierarchy, the universal absolute, and purity in any case substantiates my arguments) I will focus instead on what I have already alluded to as his critically neglected reliance on Neoplatonism, Hegel, and Schopenhauer.

Neoplatonic theory celebrates art as a possible conveyance to the One, the mystical absolute. As we have seen, Plotinus's writings are part of an early tradition of apologies to Plato's disparagement of art's capabilities. Neoplatonists also placed great stock in the purification of the self, and these practices were adopted by Gauguin and Sérusier. For Mondrian, these teachings formed a philosophical background and buttress for his own ideas, and he certainly knew Neoplatonic theory through Theosophical writings by Blavatsky, Besant, and Steiner.[16] This suggests a strong conceptual link between Mondrian's move to abstraction and the late nineteenth-century experiments in this vein that I examined in Chapter 1, a connection that should not be surprising, given Mondrian's familiarity with the Symbolist tenets of Toorop's work, for example.[17] The dual emphasis on an immutable essence and the necessary reorientation of the self are common to Plotinus and to much of the art theory of both Symbolism and Neoplasticism. Both premises are emphasized in a passage from Plotinus that was in fact quoted in the first number of *De Stijl* in 1918: "Art stands above nature, because it expresses the ideas, of which the objects of nature are the defective likeness. The artist, relying only on his own resources,

rises above capricious reality."[18] Indeed, references to both the Plotinian and Platonic notion of the Idea were common in Mondrian's circle around the time he wrote "Natural Reality and Abstract Reality," which was, of course, also the period during which he made his definitive break with representations of nature. Gino Severini (who, though now remembered as a Futurist, was loosely allied with the De Stijl group in its early years) wrote in the same issue of *De Stijl* in which Plotinus was cited that "the task of our modern art is to seek to determine the direction, the aim and the extension of the phenomenon and to bring it into relation with the whole universe. . . . This brings us close to the platonic idea."[19] And taking up the slightly different but integrally related aspect of the purity of Greek metaphysical postulations – the Platonic emphasis on geometry in the *Philebus* and *Timaeus* and Aristotle's description of the absoluteness of mathematics that Mondrian himself cites in "The New Plastic in Painting" of 1917 (35, n. "b.") and to which we saw Sérusier subscribe – Van Doesburg wrote in the second issue of *De Stijl* that "pure thought, in which no image based on phenomena is involved, but where numbers, measurements, relations and abstract line have occupied its place, manifests itself by way of the idea, as reasonableness, in Chinese, Greek and German philosophy, and in the form of beauty, in the neo-plasticism . . . of our time."[20]

Severini and Van Doesburg do not need to agree about the importance of the "phenomenon" for us to see just how clearly Neoplasticism saw itself as the heir to this eclectic but consistently essentialist philosophical legacy. What this passage also makes manifest is the influence of ancient Greek and nineteenth-century German philosophy, in particular on the articulation of Neoplasticism. Without displacing the role of Theosophy here, it is useful to an overall understanding of Mondrian's work (not just his Theosophical phase) to suggest that Theosophy was important more as a point of access to and a validation of a broader philosophical heritage than as an end.[21] As Welsh points out in his pioneering article on Mondrian and Theosophy, both Dr. Schoenmaekers and Mondrian "maintain a worldview and employ a critical jargon patently derived from earlier texts fundamental to the international Theosophic movement."[22] One example, noted by Welsh and pertinent here, is Madame Blavatsky's introduction of the phrase, purported to be from Plato, that "God geometrizes."[23] Henkels argues that "a large number of Mondrian's paintings and much of his thinking is directly traceable

to important aspects of Neo-Platonic thought that he encountered in the theosophical movement, and also in the writings of Humbert de Superville."[24] I want to push this even further and posit that the conceptual continuity of Mondrian's work from his early near-illustrations of Theosophy to his abstracts of the 1920s and 1930s can best be appreciated if we focus on the essentialism that stems from Platonic theory and that Mondrian articulated in his work with the help of subsequent philosophical elaborations of this tradition found in Plotinus, Hegel, and Schopenhauer. Theosophy, then, can be seen as one of these elaborations, and for Mondrian historically, as a crucial entrance to a larger and even more complex philosophical edifice.

This point can be made even with respect to Mondrian's most overtly Theosophical painting, *Evolution* of 1911 (Fig. 8). Read in the sequence left, right, then center, this tripartite image clearly illustrates the evolutionary stages of a "Theosophic initiation," as Welsh puts it.[25] Other aspects of the work – the title itself, which refers to the central doctrine of Blavatsky's writings; the "open eyed" mystical union exemplified by the middle figure, which depends upon Rudolf Steiner's theories[26] – refer directly to Theosophy. Henkels, however, has offered an interpretation of *Evolution* that relies on the Neoplatonic idea of inner, non-ocular, vision. "The triptych as a whole," he claims, "is intended to symbolize the journey that the soul must make in its efforts to free itself from the material world (left panel), via inner contemplation (right panel), to the perception of divine light."[27] Overcoming the material world is a constant theme in Mondrian's writings, one with distinctly Platonic overtones as well. In another of Mondrian's inspirations noted by Henkels – Edouard Schuré, whose wide influence we saw in Chapter 1 – we read about "l'âme humaine *enchaînée* à la matière dans cette vie."[28] In the interest of balancing the attention given to Theosophy in the development of abstract painting, however, Henkels has in effect replaced one important inspiration with another. Yet to favor one source at the expense of another is to fragment what was for Mondrian a completely unified project, and it is also to assume that sources are somehow stable, that they are not in an important sense constructed by their dynamic reinterpretation. Thus I want to emphasize that Mondrian's use of Theosophy and Neoplatonism underline a habit of mind – essentialism – that he articulates both plastically and in theory by employing these and other philosophical ideas.

8 Piet Mondrian, *Evolu-
tion*, 1911. Oil on can-
vas, triptych, two panels
178.0 × 84.9 cm; one
panel 183.0 × 87.6 cm
(The Hague: Haags Ge-
meentemuseum. © Piet
Mondrian 1990/
VIS★ART, Copyright
Inc.).

Mondrian's advice to see *"through* nature" is an example of Neoplatonic vision, the capability to see eidetically once the self has been reoriented to the inward and thus purified. When he claims in the same passage that with this new sight we can "rise above the tragic" – the over-dependence on the material – "and consciously contemplate repose" (89), his diction subtly alludes to salient aspects of German Idealist philosophy that subtend his articulation of Neoplasticism. The references to consciousness and to repose invoke Hegel; the allusion to contemplation, as Mondrian himself explains only a few moments later in the dialogue, refers specifically to the "disinterested contemplation" of Schopenhauer (89). Like Neoplatonism, Hegel's and Schopenhauer's theories develop the interdependent notions of a universal absolute that can be reached through art and the concomitant inward turn that revises the self.

Hegelian aspects in Mondrian's thinking have been recognized by recent critics. The fundamental concept of evolution is familiar from Hegel's writings, as Welsh has noted,[29] and also, as we have seen, in Theosophy. Perhaps even more important to Mondrian was the mechanism of this dynamic movement in Hegel, dialectic, and its ultimate agent, Spirit.[30] Mondrian first refers to Hegelian influences in "The New Plastic in Painting," 1917, in order to make a point about the existence of absolute truth and its manifestation through opposition (44). We know, too, that Van Doesburg quoted Hegel and recommended that Mondrian read him. Van Doesburg – typically one to make his inspirations quite clear[31] – wrote the following in the second number of *De Stijl*:

Whatever happens in heaven or on earth . . . moves towards one aim; that the spirit be aware of itself, that it be objective to itself, that it find itself, is itself and at one with itself; it is a duplication, an estrangement, but [only] in order that it may find itself, that it be able to know itself (Hegel).[32]

Van Doesburg adds the following sentence from Hegel as an explanation: "The finite is not true, nor is it as it should be: in order to give it existence, distinctness is needed."[33] Here we find the emphasis on dialectic and opposition in the reference to self-estranged spirit as well as an allusion to spirit's affinity with the absolute ("the finite is not true").[34] Two additional ideas, central to Hegel's system but whose import for abstract painting has yet to be acknowledged, are also integral to Mondrian's formulation of Neoplasticism: the emphasis on the *self*-consciousness of spirit acting initially

through the individual agent ("Z" in "Natural Reality and
Abstract Reality"), and the related combination of the con-
crete (the material, art) with the universal (the absolute) in
what is for Hegel *and* for Mondrian the attempt to demon-
strate the concreteness of the universal in painting.

The conscious vision required to perceive repose in nature,
Mondrian makes clear, can only arise as self-consciousness.
"Plastic vision," says "Z," is "the *conscious perception of truth*"
(99). In Van Doesburg's terms, this is the Hegelian spirit's
awareness of and oneness with itself. Mondrian contrasts this
historically recent achievement of spirit with its previous lack
of self-consciousness in terms of art's history: "the New Plas-
tic, although an end in itself, leads to conscious universal
vision, just as naturalistic painting led to unconscious natural
vision" (93). Consciousness gives the artist the control needed
to express the universal through what Mondrian alternately
calls "deeper," "plastic," "equilibrated," or – not surpris-
ingly – "pure" vision. Using an organic, evolutionary met-
aphor, he contrasts this enlightened state with both his earlier
self and what from the vantage of Neoplastic abstraction
becomes the prehistory of painting: "When we are young
and unconscious, we are the toy of everything around us"
(94). For both Hegel and Mondrian, once the self becomes
conscious – unless it is to understand the achievement of this
self-awareness as merely fortuitous, which is hardly likely
for either thinker – it must see its own development as well
as that of the history of art and even society in general,
as teleological. Only when the self comes to consciousness
does it, for Hegel, even *have* a history, since only with self-
consciousness does the self conceive of a past at all. This past
is then constructed in the most fundamental sense by teleol-
ogy; it is a history construed as a preparation for the present.
Hegel describes the process of gaining self-consciousness in
the *Introduction* to his *Aesthetics,* a text that a reader interested
in the arts and in Hegel would certainly know, and which
encapsulates Mondrian's own development as well as the uni-
fication of "theory" and "practice" and the emphasis on the
discovery and manifestation of essence:

This consciousness of himself man acquires in a twofold way: *first,
theoretically,* in so far as inwardly he must bring himself into his
own consciousness . . . in general he must . . . represent himself to
himself, fix before himself what thinking finds as his essence. . . .
Secondly, man brings himself before himself by *practical* activity . . .
in what is present to him externally, to produce himself and therein
equally to recognize himself.[35]

That this notion of an envisioned end or purpose – which, once known through self-conscious apprehension, defines all of history – is crucial to Mondrian's Neoplastic enterprise is demonstrated by what I have called the recollective character of "Natural Reality and Abstract Reality."[36]

With the Hegelian subtext in mind, we can see even more clearly that the dialogue "Z" leads would not be possible had he not already attained self-consciousness and thus the ability to see "through nature" afforded by the pure vision of Neoplasticism. In guiding the very willing "Y" and the recalcitrant "X" to this ideal point, Mondrian literally recounts what have now become, thanks to his teleological definition of self, the "practical," artistic steps to abstraction, the mechanisms of purity. As recent commentators have seen, the seven settings that divide and structure this text are at the very least reminiscent of Mondrian's own progress as a painter from early naturalistic scenes to abstract images,[37] and, though this has not been emphasized, even beyond the easel to discussions of both architectural and environmental abstraction. It is the Hegelian notion of recollection through self-consciousness that molds Mondrian's personal history into this form. Thus the character "Y," who seems to be in the dialogue to ask the hard but not quite impossible questions and thus to be Mondrian's convert, says to "Z," "Now I can understand your choice of subject in your earlier period: the subjects were never capricious. Was *this drive toward the absolute* always the compelling force in your work?" "Z" answers somewhat coyly (though with reason), "If the absolute is the most profound in us as well as in all things, doesn't that speak for itself?" (92). Prior to what we might call Neoplastic self-consciousness, of course, Mondrian was a quite conventional landscape painter in the Hague School tradition, but this early beginning has been overlaid with a very Hegelian teleology that allows the new Mondrian to imply, without total disingenuousness, that he has indeed always sought the absolute. He was simply not always *conscious* of his goal. In the Platonic dialogues, the answers to Socrates' – the physician's – questions seem always already known; the questions, therefore, are rhetorical and the text circular. The same may be said of Mondrian's dialogue, and the suspicion of circularity is even more pressing because Mondrian claims (by example here and more directly in his references to plastic research discussed above) to have gained self-consciousness in the first place *through art*. But this seeming tautology is in fact more a consequence of Mondrian's Hegelianism than

54

of sloppy logic or special pleading for the merits of one's ear-
ly work. Because of the teleological ramifications of self-
consciousness, thought in this case is *properly* circular. As
Desmond explains with reference to Hegel, "the philosoph-
ical concept is *the teleological recollection of a process of origination*
within which the concrete world comes to appear as an ar-
ticulated and rich whole."[38] Following Hegel, Mondrian sees
art – and especially abstract art, the apex of aesthetic evolution
– as the perfect example of this process.

It might be objected that Mondrian does not truly lay out
a sequence of his own pictures for the education of others in
"Natural Reality and Abstract Reality," that despite the visual
echoes of his work, the dialogue's scenes are taken from
nature, not art. But this would be too literal an interpretation.
What Mondrian effects is the partial *fiction*[39] that we are look-
ing at nature: in practice, he analyzes each scene as if it were
at the very least about to become a painting, and for "Z,"
the images seem already to be art. As an initiate, that is, he
sees through nature eidetically. At the beginning of the dis-
cussion of the first "landscape," for example, "Z" evaluates
the plastic means and the essentialist goal (repose) of what is
before them: "You ["Y"] *emphasize* tone and color, whereas
I emphasize what these express – repose. But we are all trying
to do the same thing. Repose becomes plastically visible
through the harmony of relationships." (84; italics omitted).
This pattern is repeated invariably throughout the text so that
a profound, and for Mondrian, productive, ambiguity about
the object of the discussions obtains. Mondrian in effect col-
lapses the notions of landscape as external nature and land-
scape as his previous artistic specialty. We could even say
that there is a palpable difference between what "Z" sees with
pure vision (a Neoplastic painting with his own naturalistic
idiom somehow still mentally visible underneath as a pen-
timento, which is seen as a step towards abstraction), what
"X" the naturalist sees (nature in an unproblematic sense),
and "Y's" intermediary apprehension of nature becoming
abstract art. As Mondrian makes clear repeatedly here and
throughout his writings, Neoplasticism does not seek to erase
any aspect of the past, as Futurism did, for example, but
rather to maintain the past in one's self, one's art, and in the
history of art by including it in purified form within the new.
Mondrian is here very close to the Hegelian *Aufhebung,* that
dialectical process of abrogation in which the negation or
cancellation of an element within the dialectic is at the same
time a preservation of that element within a higher unity.

Just as the abstract art envisioned in "Natural Reality and
Abstract Reality" can break from the natural and yet still
acknowledge nature's importance (as Mondrian did through-
out his career), Neoplasticism fashions itself as completely
new – a break – *and* as a necessary outcome of art's evolution.

The doubleness of Mondrian's attitude towards the past
can be seen clearly in his assessment of Cubism, a movement
with which he was intimately involved (one that was part of
his personal history by the time the dialogue was published
in 1919–20), and which he credited as a precursor to Neo-
plastic abstraction. He frequently praises Cubism for break-
ing with various naturalistic habits – "Cubism broke the
closed line, the contour that delimits individual form" (64)
– but he also criticizes it for not going all the way to abstrac-
tion (338). In one sense, then, Cubism frustrates Mondrian's
teleological sense of art history by not becoming the Neo-
plasticism that he achieves. On the other hand, he charac-
terizes Cubism as a crucial step in this march towards abstract
painting. In Hegelian terms, Cubism is negative – a failure
in art's progress – but this negation is itself part of the positive
movement of dialectic. A passage from "Plastic Art and Pure
Plastic Art" (1936) shows how Mondrian also understands
the relation to his own past and to that of art history generally
in terms of the purification that self-consciousness's recollec-
tive construction entails:

If all art has demonstrated that to establish the force, tension and
movement of the forms, and the intensity of the colors of reality,
it is necessary that these should be purified and transformed; if all
art has purified and transformed and is still purifying and trans-
forming these forms of reality and their mutual relations; if all art
is thus a continually deepening process: why then stop halfway? If
all art aims at expressing universal beauty, why establish an indi-
vidualistic expression? Why then not continue the sublime work
of the Cubists? That would not be a continuation of the same
tendency, but on the contrary, *a complete break-away from it and all
that has existed before it.* That would only be going along the same
road that we have already travelled (297).

Cubism, then, has become a block to the progress of Neo-
plasticism. It may still be "sublime," but it is an earlier and
now abrogated phase as we look back from Neoplasticism.
There is change, but change, in typical Hegelian fashion,
happens historically. As Mondrian adds to the passage just
cited, "since Cubist art is still fundamentally naturalistic, the
break which pure plastic art has caused consists in becoming
abstract instead of naturalistic in essence" (297).

56

The issue of consciousness broached by Mondrian in "Natural Reality and Abstract Reality" has afforded us a perspective on his adaptation of Hegel's thinking. Self-consciousness and its relation to a revisionary teleology refers us as well to another salient aspect of the Hegelian philosophy employed by Mondrian, the requirement that conscious awareness be concrete. In the recollective logic that I have been examining, we could say that self-consciousness, the inner turn defined in the passage from Hegel's *Aesthetics* quoted above as "theoretical," is now dialectically balanced by the self's reflexive knowledge through a "practical," external medium, art. Like the theory-practice dyad of Mondrian's work, these two parts operate in tandem and are ultimately inseparable. For Hegel, "art's vocation is to unveil the *truth* in the form of sensuous artistic configuration, to set forth the reconciled opposition . . . and so to have its end and aim in itself, in this very setting forth and unveiling."[40] "Z" explicitly seeks the universal in the concrete form of Neoplasticism: "As opposed to the predominantly individual (naturalistic expression), the New Plastic can also be broadly termed *plastic expression of the universal*" (113). This seemingly impossible joining of the material and universal, he explains, can come about only through an initial opposition or dialectic set up by the extreme simplicity of Neoplastic painting. "The New Plastic, where individual and universal are *mutually opposed in a equilibrated way* and therefore *in repose,* can constantly surround us" (113). As we saw with reference to the pivotal notion of relation, the individual element in this duality is present in the always particular phenomena of plastic compositions of line and color; the immutable universal exists in each case through the unchanging relation of these particularities. For Mondrian, the necessary concreteness of this universal is made possible by the "distinct duality" of the parts that stand as "extreme opposites" (97; italics omitted). The quality of distinctness that Van Doesburg noted in his comments on Hegel is thus needed for the dialectic to be clear, concrete, and dynamic.

Within the context of the dialogue, dialectic does not apply only to the formal considerations of Neoplastic composition, but also to the "natural" as what is in a sense negated by abstract painting. Dialectic in its distinctness moves by negation, as we have seen with reference to Mondrian's formulation of self. Its aim, however, is reunification on a new level, what Mondrian titles "*pure unity*" (95). When "Y" gives in too easily to a rather simple-minded "destruction of the natural," "Z" insists that this "destruction" (negation) also

involves "*reconstruction,*" and thus that the "natural is . . . not destroyed but only stripped of the *most* external: apparent unity [nature] becomes *duality,* and apparent duality [Neoplastic abstraction] can become *pure unity*" (95). Here then is part of "Z's" answer to "Y's" potentially awkward question about the unification of material and universal: "You said earlier that plastic vision means becoming one with the universal. But what does that mean *in practice?*" (97) (once we cut through the mystical language, he seems to imply). "To see plastically," "Z" says, "is to *perceive consciously*" and this is "to *distinguish,* to *see truth*" (97). This passage ties the notions of distinctness (needed for distinguishing differences), consciousness, and truth as the goal of art together into a complex and thoroughly Hegelian knot. "Y's" important practical question and the reference to truth, which as we know, is universal, leads us to question the direction of Mondrian's dialectic, the nature of his pure unity.

He seems at first to have two goals in mind, both of which may be seen to stem from the Hegelian dialectic's final purpose, to overcome duality in some form of unity. First, unity could lead to the transcendent realm of truth that has gone beyond the materiality of art by becoming part of a new society where "painting merges into reality itself" (116). This end would be consistent with Neoplasticism's teleology and with Hegel's movement past art and religion to philosophy as the ultimate reality.[41] At the same time, Mondrian clearly envisions the peaceful unity of oppositions in the pure equilibrium of his new plastic abstraction. He emphasizes that this new art is at once "an end in itself" and a "universal vision" (93). Art's uniqueness, Mondrian seems to claim, is its ability to manifest the universal in the concrete. This is of course precisely what Plato denied that art could do. Because it turns on what Desmond calls "the metaphysics of image and original,"[42] Plato's doctrine of mimesis had to condemn art and the artist to the shadows of mere appearances. Hegel strongly criticizes Plato's view. In the *Introduction* to the *Aesthetics,* he argues that though Plato is the right starting point for a philosophy of art, "we must grasp [his] Idea more concretely, more profoundly, since the emptiness, which clings to the Platonic Idea . . . can satisfy us no longer."[43] As an apology for art still conceived metaphysically, Hegel offers what seems from the Platonic perspective the paradox of art as a concrete universal. What is even more remarkable in the context of abstract painting, Hegel calls for an end to imitation, or, more precisely, for its abrogation in a non-dualistic

imitation that collapses the disparity between original and simulacrum. In addition, he praises the "abstract *purity* [of material] . . . in shape, colour, note, etc. . . . Absolutely straight lines . . . satisfy us by their fixed determinacy. . . . A similar effect is produced by pure, inherently simple, un-mixed colours, a pure red, for example, or a pure blue."[44] This passage anticipates Mondrian's reduction to pure formal means. We have seen that Mondrian also conceives of abstraction as a material incarnation of the universal, and Neoplastic painting is by definition not mimetic. Both Hegel and Mondrian argue that art comes from the inner self, not from a transcendent reality; Platonic imitation is therefore impossible just as it was for Plotinus in a passage to which I referred in Chapter 1: "Only from itself can we take an image . . . that is, there can be no representation of it, except in the sense that we represent gold by some portion of gold – purified, either actually or mentally" (*Enneads,* V, 8, 3). Mondrian too claims that abstract art comes from the self: "inward life must create its outwardness," (109) "Z" says. There can be no Platonic ontological duality in the self's reconstruction of itself in the material form of art, since the inner, theoretical, and abstract qualities of the universal are guaranteed by Neoplasticism's equilibrated relations, and the outer, practical, and concrete aspects of nature are simultaneously subsumed without being cancelled. This complex constellation is Mondrian's concrete universal, his pure plastic unity.

As a conclusion to our discussion of Hegel's contribution to Mondrian's development of Neoplasticism, we should perhaps pose "Y's" question again: "But what does that mean *in practice?*" (97) Mondrian's *Composition in Black and Grey (Lozenge with Grey Lines)* of 1919 (Fig. 9), can be seen as Mondrian's plastic response, his conception of a concrete instance of "the starry sky as the absolute" (92). In a letter of April 18, 1919, to Van Doesburg, Mondrian wrote:

As to whether or not one should start from a given in nature . . . I agree with you in principle, there must be a destruction of the natural and its reconstruction in accordance with the spiritual; but let us interpret this rather broadly: the natural does not require a specific representation. I am now busy on a work which is the reconstruction of a starry sky, but I am doing it without a given in nature.[45]

Given its date, *Composition in Black and Grey* seems a likely candidate for the picture to which Mondrian refers. The work also realizes exactly the detailed points of composition and effect that Mondrian describes when he purports to discuss

59

a natural landscape in the third scene of the dialogue. He exclaims about the multiplicity of stars in the night sky and is enthusiastic about the relations that lines between these stars as points could make manifest. "Plastically," he says, (seeing now with the pure vision of Neoplasticism, and, it seems likely, recollecting, or at the very least planning, this painting), the stars "*fill* the space, they *determine* it and thereby accentuate *relationship*" (89). Even more specifically, we are told that the "starry sky shows us innumerable points not all equally emphasized: one star twinkles more than another. And now again these unequal light values engender *forms*" (91). In Figure 9, the double-width lines accentuate this varied pattern of relations. If we look closely at the individual "forms" that many of the intersections of these heavier lines delineate, we also see the Neoplastic equivalent of the stars' unequal emanations of light.[46] In some of these constructed boxes – the one closest to the right-hand point of the star-shaped lozenge itself, for example – eight lines radiate from a central point. In another box that forms near the center of the canvas, on the other hand, only four lines radiate and these are bounded by other diagonal lines. The difference between these examples can, given the context, be read as a difference in the strength of a star's brightness. Mondrian creates a pure duality – a duality without opposition – here by making two aspects of landscape, nature (the external scene at which we supposedly look) and art (the lozenge picture referred to in Mondrian's letter to Van Doesburg) cohabit in one painting through their mutual, dialectical interdependence. This is Mondrian's version of what I called in Chapter 1 eidetic alchemy. And as it was for Gauguin and Sérusier before him, access to the universal is gained through *memory*. "In the aesthetic realm," Mondrian reports, "we can say that the *particularity of what is given in nature* has been transformed *into unity through memory*" (108). This is the import of his claim in the letter to Van Doesburg that he is painting nature "without a given." To use memory in this way, Mondrian must overcome the particularity to which he refers here. This is accomplished through "contemplation," a term he borrows from Schopenhauer, and to whose import for Mondrian I will now turn.

Mondrian's use of Schopenhauer is explicit and crucial; as such, it substantiates Michael Podro's assertion that Schopenhauer's "influence on aesthetics and critical writing during the last hundred years has probably been greater than that of anyone else,"[47] and makes it especially remarkable that critics

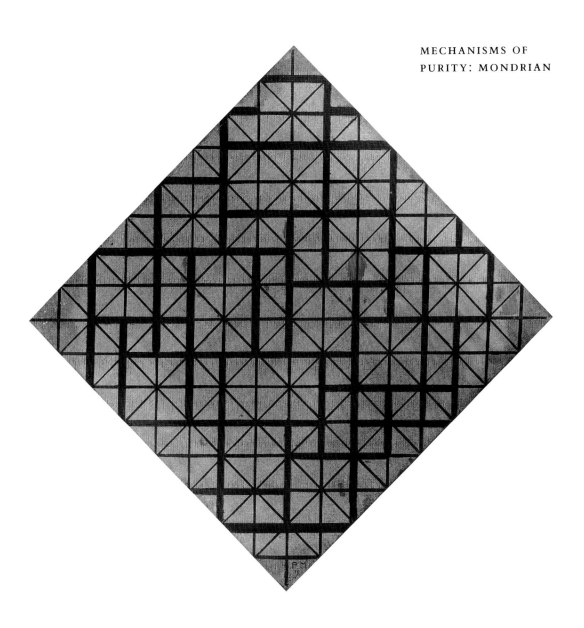

9 Piet Mondrian, *Composition in Black and Grey (Lozenge with Grey Lines)*, 1919. Oil on canvas, 84.1 × 84.5 cm (Philadelphia Museum of Art: The Louise and Walter Arensberg Collection. Photo: Philadelphia Museum of Art).

have said very little about the relation between Schopen-
hauer's thought and Neoplasticism. At the beginning of the
third scene of "Natural Reality and Abstract Reality," "Z"
explains to "Y" how to see the supposedly natural landscape
plastically, that is, how to turn the starry sky into a Neoplastic
abstract painting. The key is contemplation, which is a con-
sequence of self-consciousness and is described as a special
state of "aesthetic" attention that gives the self access to uni-
versal truth.

> This contemplation, this *plastic vision,* is most important, ["Z"
> claims]. The more consciously we are able *to see* the immutable,
> the universal, the more we see the insignificance of the mutable,
> the individual, the petty human in us and around us. . . . Through
> all vision as disinterested contemplation (as Schopenhauer calls it),
> man transcends his naturalness. . . . In the moment of aesthetic con-
> templation the individual as individual falls away (89–90).

For Schopenhauer, the "calm of contemplation" (I, 178) is a
unique, mystical[48] state in which the self finds union with the
absolute by turning inward. Only art can initiate this state
(I, 184). Schopenhauer explains that we "*lose* ourselves en-
tirely in [the object of contemplation], we forget our indi-
viduality, our will, and continue to exist only as pure subject,
as [a] clear mirror of the object" (I, 178). The prized "dis-
interestedness" of contemplation is this loss of self as a limited
individual. Mondrian clearly adopts this same essentialist
rhetoric, with its emphasis on purity and the "contrast" be-
tween what he describes as the "*changeability* of human *will*"
and the "*immutable*" (89). Nature for both thinkers is the
quintessential example of this individuality and is thus only
a clouded reflection of truth. Art, by contrast, can afford
unmediated access to the universal non-mimetically, because,
as we have seen in Mondrian's case, it is ultimately a part of
the self purified of will, part of the "clear mirror," as Scho-
penhauer puts it. In pure contemplation, Schopenhauer says,
"we are no longer able to separate the perceiver from the
perception . . . [because] the two have become one" (I, 178–
9). We are thus also reminded of Schopenhauer's image of
our *absorption* in the object of our contemplation by Mon-
drian's descriptions of the scenes in "Natural Reality and
Abstract Reality." Schopenhauer presents a compelling vision
of art as the source of profound inner experience that in turn
leads the self to universal truth. He defines art as "the work
of genius," through which it "repeats the eternal Ideas ap-
prehended through pure contemplation, the essential and
abiding element in all the phenomena of the world" (I, 184).

In a rare reference to the notion of genius, Mondrian in "The New Plastic in Painting" again demonstrates his affinity with Schopenhauer's ideas: "Art, like every expression of genius, arises when universal consciousness abruptly bursts, as it were, into individual consciousness" (42, n."q"). As I showed in Chapter 1, Schopenhauer's description of the artist-genius allies this individual with a specifically Platonic madness. Because he has escaped the shadows of terrestrial ignorance, the genius focuses on what seem to his ordinary consciousness like extremes. Though Mondrian does not elaborate this notion of genius, he does integrate the need to manifest extremes plastically into his theory of Neoplasticism: "In the New Plastic we have the equivalence of *extreme opposites* and therefore a *distinct duality*" (97). More importantly, as we saw with reference to Gauguin, what Schopenhauer describes as the sudden advent of universal consciousness (I, 178) – the repetition of the Platonic Idea – is the province of memory. Again the same can be said of Mondrian, since memory is for him also an eidetic function. "Z" makes the connection between memory and Schopenhauer apparent when he welcomes his partners to his studio in the last scene of the dialogue. Their walk may be over, he says, but what is permanent in what they have seen remains because of the mode of vision. "We haven't simply 'contemplated' visually" (106); on the contrary, "Z" at least has contemplated in Schopenhauer's sense and has thereby gained true memory images that rise above the particularities of nature. These memories are the source of a Neoplastic "landscape" like *Composition in Black and Grey* (Fig. 9). For Mondrian, the mnemonic bonds the individual in nature with the absolute and thus makes a concrete universal possible. Another aspect of memory in Mondrian's text – nostalgia – links him with both Schopenhauer and Plato. Art is made central in *The World as Will and Representation* in an attempt to defend against what Schopenhauer saw as "one of the greatest and best known errors of that great man, namely his disdain and rejection of art" (I, 212). For Schopenhauer the neoplatonist, then, art emphatically could apprehend the Ideas. The melding of art and Idea that he describes is a version of the doctrine of participation wherein like joins like. For Schopenhauer, following Plato via the Neoplatonics, the soul separated from the absolute Ideas is necessarily nostalgic for a reunion that its memory – now reawakened by art – guarantees. In Mondrian's dialogue, "Y" suggests that the individual "*matures toward the universal*" (120). He recalls a friend of "Z's,"

"who seemed to understand the New Plastic well, saying that when he contemplated its work, *he felt nostalgia for the universal, for the most profound part of himself*" (120). "Z" is understandably delighted by the prescience of his new convert: "Yes," he exclaims, "we do have a nostalgia for the universal! This nostalgia must bring forth a completely new art" (121). The reference here to contemplation ties Mondrian's discourse to Schopenhauer. But as his enthusiastic response to "Y" suggests, Mondrian's does not share the German philosopher's notorious pessimism. The teleological thinking that he develops largely from Hegel's example gives Mondrian a reformer's faith in what is to come. Neoplasticism's nostalgia is thus paradoxically directed towards the future, towards a new art that will reform man and society in precisely the essentialist terms dictated by a long philosophical tradition.

An important question remains after our analysis of Mondrian's pure abstract painting. Will art be abrogated completely because of its materiality and because it melds with a reformed society? Mondrian answers in the affirmative, but as I argued with reference to his development of Hegelian ideas, he also insists on the seemingly irreconcilable notion that because the universal is made concrete in art, abstract painting is an end in itself as well as a means. Both sides of this issue of the nature and direction of pure painting work as apologies to Plato by fulfilling the requirements of a Platonic art: Neoplastic painting's purified plastic means yield universal truth; they are both the inspiration for and result of the reforming inward turn that created the new man, the new artist, and the new version of art's history; society is in turn improved by these new forms. As I have suggested, even the Hegelian notion that art can be at once concrete and universal is an attempt to improve on Plato's vision of the arts. But the question remains, what are the implications of a pure art if it reforms society by becoming one with that supposedly perfected society? Does art still have a role, or is society finally static and without need of further critique or enlightenment? These are the sorts of ideological issues raised by the rhetoric of purity's elaboration of an essentialist doctrine that I will examine in Chapter 4. To be able to give them fuller consideration, however, we must first consider Kandinsky's involvement with purity and abstraction.

THE MECHANISMS OF
PURITY II: KANDINSKY

MONDRIAN AND KANDINSKY both spent important years of their artistic maturity in Paris. The details of two personal meetings underline graphically the contrasts between these pioneers of abstract art and give us access to a comparison of their aesthetic enterprises. Nina Kandinsky recorded a rather comic visit that Mondrian made to the apartment/studio she and her husband had in Neuilly: "It was on a glorious spring day. The chestnut trees in front of our building were in blossom and Kandinsky had placed the little tea-table in such a way that Mondrian . . . could look out on all of their flowering splendor."[1] To the Kandinskys' consternation, however, Mondrian chose instead to face away from nature, since its profusion and variety disturbed his equilibrium. A subsequent courtesy call to Mondrian's Paris studio also left Vasily Kandinsky bemused: "I really don't understand," he said to Nina, "how he can paint amid such a uniformity of color."[2] It appears, then, that the profound differences in character between these men extended to matters of art. Kandinsky made this plain in a letter to Christian Zervos, editor of *Cahiers d'art,* about Mondrian's response to Zervos's questionnaire on abstract art: "Mondrian's answer is very interesting but I find him a little narrow-minded in thinking that a given form in art could be eternal."[3] Although Mondrian's personal habits and his paintings certainly appear more strictly controlled – purer – than Kandinsky's, and although Mondrian for his part also criticized Kandinsky's work,[4] the contrasts between the two artists, if drawn too sharply, tend to hide the remarkable confluence of their aesthetic goals and methods within an overall essentialist project.[5]

Even in the essay in which he responds to the *Cahiers d'art's* challenge, and which, given his criticisms of Neoplasticism, he would presumably contrast with Mondrian's reply,[6] Kan-

dinsky exhibits his commitment to what I have described as a Platonic program for art. He begins this text with an explicit reference to its status as a defense: " 'Abstract' painters are the accused, that is to say, they have to defend themselves."[7] The immediate occasion for this response was the aggressively negative set of questions about abstract art posed by Zervos,[8] but the affinity of Kandinsky's reply with the defense tradition that we have examined makes manifest that this essay, like most of his work, is an apology for the new art in general, based upon abstraction's access to pure, absolute truth. Though Kandinsky refuses to limit abstraction to any particular set of forms as Mondrian did, he concurs with Mondrian's vision of universal truth attainable through art. "The nature of art remains forever immutable," Kandinsky claims (II, 757; italics removed). In fact, Kandinsky was given to characterizing his place within contemporary art history in terms of this search for the absolute: "Klee and myself," he wrote, are "the abstract painters of spiritual essence."[9] Interestingly too, Kandinsky extols the importance of "intuition" – a notion central in Mondrian's thinking, as we have seen – and links it with what he characterizes as man's "newly acquired faculty" (II, 760) for abstraction. "Works of abstract painting," he claims, "spring from the source common to all the arts: intuition" (II, 758). In *Reminiscences,* published in 1913 but based on memories of his early years in Russia, Kandinsky vividly describes the new type of vision, born of intuition, that allowed him literally to see phenomena in the world anew. "Everything showed me its face, its innermost being, its secret soul," he wrote, and this mystical revelation "was enough for me to 'comprehend' . . . the possibility and existence of that art which today is called 'abstract' " (I, 361). As late as 1935, he was still marveling at this special transformative power: "This experience of the 'hidden soul' in all things . . . is what I call the 'internal eye.' This eye penetrates the hard shell, the external 'form,' and goes deep into the object and lets us feel with all our senses its internal 'pulse' " (II, 779).[10] Just like Mondrian's "pure plastic vision," Kandinsky's intuitive vision, in keeping with the metaphysical distinction between appearance and reality, allows him to "touch under the *skin* of *Nature* its essence" (II, 760).

In "Reflections on Abstract Art," Kandinsky had to defend himself against the pejorative assertion that abstract art is "deliberately inexpressive and excessively cerebral" (II, 755). Abstraction's supposed emphasis on geometry (as opposed

to expression) was blamed for this fault (II, 756). This dichotomy between expressive passion and cool, intellectual geometry has remained a commonplace in discussions of abstract art in general and in considerations of Mondrian and Kandinsky in particular. Kandinsky is usually understood as the first exponent of "expressionist abstraction," a lineage that, as Harold Osborne describes it, runs from Gauguin and the Symbolists through Abstract Expressionism, and that in general seeks to "penetrate and reveal metaphysical realities behind . . . appearances"[11] by using freely invented pictorial forms that have no necessary mimetic relationship to nature. Mondrian, on the other hand, is commonly seen as a prime exponent of "geometrical abstraction," a category that seeks to overcome the idiosyncracies of merely individual expression by relying on the putatively universal language of geometry. Osborne makes this distinction central, underlining "Mondrian's insistence on excluding all contained elements with expressive character of their own and throwing the whole burden of composition on a system of relations among non-expressive orthogonals."[12] Although this discrimination of the expressive and the geometrical modes of abstraction is to a point historically accurate and conceptually useful for distinguishing the relative styles used by Kandinsky and Mondrian – especially when we remember that Mondrian's and Kandinsky's open, though not at all acrimonious, disapproval of each other's work was sometimes couched in terms of the expression/geometricization dichotomy – it also masks the considerable congruity of the two painters' overall project of abstraction and thereby prevents us from seeing the scope and implications of the essentialist purification in which both engage. Both artists meant by "expression" a special power to get *beyond* superficialities of style or appearance to an eidetic, transcendental, universal, or pure expression of timeless essence. For Mondrian, "pure art . . . [is] direct plastic expression of the universal" (42; italics removed); as I will argue, the same is true of Kandinsky's entire aesthetic undertaking, even in its most geometrical phase during his Bauhaus years. My contention, then, is that the goals and procedures of Kandinsky's abstract painting can best be understood as belonging to the same agenda that we have examined in Mondrian's work. Equally in his visual research and writing, Kandinsky provides a rhetorically and plastically powerful apology for art itself by demonstrating how it can give access to absolute and universal truth, most effectively embody this truth by becoming non-mimetic, arise from an

artist reformed through knowledge of inner necessity, improve society itself by furnishing a model for emulation, and transcend its own material fetters in a synthetic melding with a utopian world that has become the ultimate *Gesamtkunstwerk*. These of course are the coordinates of a Platonic art that I have discussed with reference to both the Synthetist generation and Mondrian, and again, purity is at once the means and goal of Kandinsky's essentialist enterprise.

Kandinsky emphasizes throughout his writings that art's goal is the manifestation of absolute truths, that painting in particular should and can be what he deems the "ineluctable will for the expression of the objective" (I, 174). In what remains his single most important discussion of art, *On the Spiritual in Art* of 1911,[13] color, form, and the other constituents of what he calls the "language" of painting are seen as important only insofar as they help to articulate "that great pictorial counterpoint, by means of which painting ... will attain the level of composition and thus place itself in the service of the divine, as a totally pure art" (I, 173). The salient notion of purity incorporated for Kandinsky the ideas of metaphysical immutability, of spiritual as opposed to material being, of essence rather than transitory appearance. He goes on to explain that it is the immutable, infallible "*principle of internal necessity*" (I, 173) that leads art to this pure state – "all means are pure that arise from internal necessity" (I, 187) – and it is through this mystical/philosophical notion of inner necessity that we may come to understand how Kandinsky defines and justifies true art.

Even though internal necessity is a trans-historical concept, Kandinsky is at pains to show how it manifests itself historically, both in the individual artist and in culture more generally. He characteristically describes its advent as a three-part, teleological evolution. In *On the Spiritual,* for example, we are told that internal necessity "is composed of three mystical necessities":

what is peculiar to [the artist] himself (element of personality) ... what is peculiar to his own time, ... [and] what is peculiar to art in general (element of the pure and eternally artistic, which pervades every individual, every people, every age, and which is to be seen in the works of every artist, of every nation, and of every period, and which, being the principal element of art, knows neither time nor space) (I, 173).

Kandinsky returns repeatedly to this triadic structure in his subsequent writings when he wants to lay out the progressive development of art as the material incarnation of inner ne-

cessity's purity. He describes the movement of the spiritual life itself with the (now famous) image of the triangle divided into three parts (I, 133–4). Painting's history has the same structure, as he explains in "Painting as Pure Art" of 1913. It begins in the primitive, individual desire "to fix [arrest] the transitory corporeal element," then progresses beyond this "practical" need towards expression of the age's "spiritual element," and finally attains "the high level of pure art, whereby the remains of practical desires are eliminated. This art speaks in artistic language from spirit to spirit, is a realm of painterly-spiritual essences" (I, 351–2). In the "Cologne Lecture" of 1914, he employs the same pattern to describe his own artistic evolution towards "pure painting, which is also called absolute painting" (I, 393). Even though Kandinsky begins each of these descriptions with discussions of the individual artist (to whose inner reformation I will return), it is the third and final term in his system – the essential or absolute element – that always makes the antecedent moments possible. "It is internal necessity that limits the artist's freedom," he argues in "Self-Characterization" (1919), "being determined by three demands: (1) those of the individual artist, (2) those of period and race, . . . and (3) those of the elements of art that exist in the abstract, awaiting materialization, the elements of the personal, of time, and of the eternal" (I, 432–3). From this passage, it is clear that the third term, because it is eternal or pure, contains and animates the other two. "The originator of the work," he maintains in the Cologne lecture, is "the spirit" (I, 394). His aesthetic, then, has the mystical perfection of the circle, because spirit (which is roughly interchangeable in his discussions with the ideas of inner necessity, the absolute, the essential, and the pure) is both the source and end of artistic activity.

The transcendental focus of Kandinsky's aesthetics is signaled, too, by his constant concern with art's effect on the *soul,* that locus (as we have seen in our discussions of Gauguin and Sérusier) of metaphysical perception and enlightenment. In one of his earliest writings, "Whither the 'New' Art" (1911), for example, Kandinsky exclaims that the "eternal" nature of Gauguin's work (as well as that of Böcklin, van Gogh, and Cézanne) is signaled by its "silence," its source and power "concealed deep down in the soul" (I, 98). In the same essay he sees the new art's goal as "the refinement and growth of the soul" (I, 101), and he maintains this emphasis in *On the Spiritual in Art* (1911). Kandinsky states explicitly that the artist's role – the defense for his art – lies in the

connection between the individual soul and the ultimate reality of spirit. "The *creative artist* comes into the world with his own soul's dream. The justification for his existence is the materialization of that dream. His whole talent exists merely for this goal alone" ("On the Artist" [1916]; I, 414). The artist's "hand is unconsciously and absolutely subordinate to the soul" (I, 415), which in turn is the seat of communication with the absolute. With a decidedly neoplatonic argument, Kandinsky explains in his Cologne lecture that because art is "cosmic" in its derivation from spirit, "the work exists *in abstracto* prior to that embodiment which makes it accessible to the human senses" (I, 394). For Kandinsky, it is precisely this material realization of essence that justifies art.

All of Kandinsky's aesthetic research – his art, his writing, his teaching – was therefore directed towards the intuitive perception and then plastic articulation of what can best be conceived of as metaphysical essences. Of course the nature of the essences in which he took interest varied: his apocalyptic imagery of c.1911 grew out of his fascination with Christian and Theosophical doctrines,[14] for example, whereas in his late Paris work he seems to have been exploring the essential generative powers of nature through biomorphic imagery.[15] Looking at his life as a whole, these individual pursuits merge into an ubiquitous and consistent search for an essential that stands ontologically above common experience. Kandinsky's "Program for the Institute of Artistic Culture," for example, a document that he presented in Moscow in 1920 in his capacity as president of this new artistic organization, lays out in detail the technical research into the elements of art that students and their instructors will undertake in the new Soviet society. To the annoyance of the younger Constructivist generation, however, Kandinsky ended his speech with an impassioned reminder of the ultimately transcendent purpose of this research.

In conclusion, I should state that the laws that have hitherto been found in art have always proved to be transient.... It would seem that an epoch has its own objectives: ergo, its own methods of resolving them. Hence, analysis of these methods might reveal their operative principle, their law. It is too easy and too dangerous to accept this law as an eternal one. But man does not stop before the unanswerable: an invisible force attracts him toward the eternal. The Institute will aspire to find the eternal in the transient (I, 471–2).

Kandinsky's reference to "laws" takes us to the heart of his research. He had studied Russian peasant law before becoming a full-time artist (I will return to his interest in social structures), and in significant ways he developed these concerns in the aesthetic realm. He was struck by the systematic nature of musical analysis and composition and actively sought the possibility in the visual arts of Goethe's "thorough-bass" (*Generalbass*) in musical harmony.[16] As in his paper for the Institute of Artistic Culture, Kandinsky is here both cautious about the possibility of finding such a foundation and also drawn to its promise of eternal validity. He recognizes that the visual arts cannot yet find this security, but he also actively projects its possibility by comforting himself with the thought that it would be "overhasty to maintain that in painting there can never be any hard and fast rules, principles resembling those of harmonization in music – or that such principles would always lead only to academicism" (I, 196–7). Kandinsky predicts that the plastic arts "will become art in the abstract sense, and will eventually achieve purely pictorial composition" in the way music already does (I, 162), indeed that "only a few 'hours' separate us from this pure composition" (I, 197). Borrowing his terminology from music theory, then, Kandinsky envisions composition as painting's highest incarnation: "In compositional painting," he claims in a passage from "Painting as Pure Art," "we notice at once the signs of having reached the higher level of pure art, where the remains of practical desires may be completely put aside, where spirit can speak to spirit in purely artistic language – a realm of painterly-spiritual essences" (I, 353).

Kandinsky first broaches the possibility of the *Generalbass,* the law of pictorial composition, in the section of *On the Spiritual* devoted to the "language" of visual art.[17] Color and form are the main components of this language, but even though he devotes a great deal of energy to their technical investigation in this and other contexts, he is quick to establish that these grammatical components are nothing but means to a higher end. He is more concerned with the "What" of art than the "How," as he puts it several times. Both form and color are subordinated to the exigencies of inner necessity: for example, "form in the narrower sense is nothing more than the delimitation of one surface from another. This is its external description. [Yet] *every form has inner content. Form is . . . the expression of inner content*" (I, 165). Giving it any lesser

meaning, Kandinsky claims, results only in "a meaningless formal game" (I, 171). The *Generalbass* that he proclaims, then, will be composed using "the laws of *internal necessity, which may quite correctly be described as spiritual*" (I, 176). If the laws of composition are then the same as laws of inner necessity, it follows from Kandinsky's own definitions they are eternal and absolute in a specific way. Why, then, does he also write that "nothing is absolute" (I, 170)?

Kandinsky – very like Mondrian – is concerned to maintain two simultaneous possibilities for art. First, that it be historically relative, contingent upon the evolution of spirit or inner necessity in the particular artist and work. Thus abstract painting, for example, can appear only when the spiritual climate is right, that is, in the early twentieth century, and when the right artists appear. At the same time, Kandinsky constantly proclaims art's heritage in the eternal, its ultimate timelessness and independence from history. By creating a hierarchy between art's particular incarnations and its facilitating metaphysical essence, he is able to preserve both possibilities, just as Mondrian did with the notion of "relation." This crucial dichotomy between the absolute and relative is reflected in Kandinsky's search for laws, in his concomitant belief in unchanging verities, and in his rejection of immediate, academic rules for artistic production. Because the balance between these poles is not always made evident, however, it is tempting to read his remarks on Russian peasant law in *Reminiscences* as a rejection of the realm of absolutes or essences that I have been claiming is fundamental to Kandinsky's aesthetic project; indeed, one prominent critic, Donald Kuspit, has made such a reading the basis of his analysis of Kandinsky in two particularly probing articles,[18] and his arguments can help us measure just what is at stake when we question Kandinsky's link to absolute values.

Kuspit claims that "Kandinsky makes a penetrating protest against the idea of absolute art."[19] His evidence is the painter's shocked response to the splitting of the atom – "everything became uncertain, precarious and insubstantial" (I, 364) – and (more importantly), Kandinsky's conclusion after studying Russian peasant law that, because "absolute crime does not exist" (I, 379, n.), absolute law like that of the Romans will not help society cope with social problems. Kuspit rightly connects Kandinsky's opinions on the legal system with the artist's search for laws in art, and he correctly concludes that Kandinsky as a result gave up "the presupposition of any absolute style for art."[20] But Kandinsky only gives up the

absolute in one limited, though important, sense. Even in *Reminiscences,* only a page after denying the absoluteness of law, he proclaims the possibility of a new aesthetic vision under whose auspices "an enjoyment of abstract (= absolute) art will come about" (I, 381); by 1936, he was even suggesting that the term "absolute" replace the notion of the abstract completely (II, 785). Law and the absolute both operate on two levels for Kandinsky. He clearly does want to free art from the immediate strictures of academic practice, strictures that claim to guarantee a timeless *style.* But style and the rules that attempt to guide it are, for Kandinsky, merely "external" in the metaphysical sense. "Dependence upon 'schools,' " he writes in *On the Spiritual,* upon "the search for 'direction,' the demand for 'principles' in a work of art and for definite means of expression appropriate to the age, can only lead us astray" (I, 175). As we have seen, Kandinsky's passionate plea is that artists look away from this external "skin" and focus on inner necessity. Instead of mere style, they will then approach "composition," whose metaphysical purity and laws are legitimated by transcendent absolutes like those of Christianity, Theosophy, or nature's "cosmic laws," only in its *subordinate* relation to which, Kandinsky argues in a late text, art can excel (II, 807). We might well agree with Kuspit that "pure line, pure color, pure composition are as rigidly formal and as inhuman and dogmatic as the conventional religious set of absolutes,"[21] but this formal purity is for Kandinsky only an instrument in a more exalted eidetic operation (and it is on this level of purity that the we should become suspicious of claims to the absolute, as we will see in Chapter 4). This is the context in which to understand properly Kandinsky's complaint in 1925: "I really wish that one finally sees what is *behind* my painting. . . . It must finally be understood that form for me is but a means to an end."[22] For Kandinsky, "it is not in the form (materialism) that the absolute is to be sought" (I, 237), but this does not mean, as Kuspit wants to have it in the earlier of his two articles, that Kandinsky abandoned the search for absolute laws in art altogether. On the contrary, Kandinsky's rejection of formal purity as a final goal[23] encouraged him to redouble his efforts to find a transcendent absolute, a *Generalbass.*

On the external, superficial level of academic training, Kandinsky sees absolute procedures as a hindrance to artistic freedom. On the plane of internal necessity, however, he declares both that "the artist may utilize every form as a means of expression" (I, 175; italics removed) – that com-

position is totally free – *and* that "internal necessity . . . limits the artist's freedom" (I, 432). What sounds like an out and out contradiction here is actually another of Kandinsky's rather delicate circumlocutions of the issue of the absolute in art. By using the type of paradox developed in German Idealism – Kant's assertion that freedom stems from adherence to law, Hegel's free individuation of historical particulars as a regulated function of Spirit, Schopenhauer's notion that free self-expression is a function of the will – individual artistic freedom is possible only as a byproduct of a transcendental absolute, in this case, of inner necessity. Thus when he speaks about a "grammatical" element like the point, Kandinsky says that he is able to "transfer it into the extraordinary condition of total freedom from outer expediency, from practical meaning" (I, 424) by placing it under the rubric of eternal, inner necessity. Although Kandinsky might well have been familiar with German Idealism through the Blaue Reiter circle[24] – Franz Marc, for example, was wont to cite Schopenhauer – and through contact with his half-nephew, Alexandre Kojève, who was a Hegelian, another likely inspiration for his equation of freedom with the absolute is Wilhelm Worringer's *Abstraktion und Einfühlung,* published in 1908. Recent critics have established Kandinsky's knowledge of this text and have debated its importance for *On the Spiritual* in terms of Worringer's sympathy for "abstract" expression.[25] What has not, to my knowledge, been remarked is the degree to which Worringer's revelation that "the abstract artist does not have to go beyond himself to discover the laws which find expression in his art"[26] parallels Kandinsky's position that the absolute of *inner* necessity is the basis of the freedom that makes abstract expression possible. For Worringer, "the soul knows here only *one* possibility of happiness, that of creating a world beyond appearance, an absolute, in which it may rest from the agony of the relative."[27] The relative is, however, as we have seen, only a source of agony for essentialists like Plato, Plotinus, Sérusier, Mondrian, or Kandinsky, who, even in one of his early art reviews (1910) allied himself with this position: "In painting, . . . it is insufficient simply to render the appearance of nature, its external reality, for it contains too much that is accidental. What is necessary . . . is that beneath a greater or lesser degree of 'reality' should lie, apparent or concealed, a firm, permanent structure" (I, 80).

For Kandinsky, art speaks the language of ontology and yields access to the realm of absolutes; this facility is, in fact,

its ultimate vocation, justification, and defense. As we have seen, however, this absolute – spirit or inner necessity – must also be concrete; it "seeks its materialization," as Kandinsky emphasizes in "On the Question of Form," his main textual contribution to the *Blaue Reiter Almanac* (I, 235). The *Almanac* is itself a prime example of this palpable manifestation. As a synthesis of the arts and ideas on the arts, it perfectly realizes Kandinsky's ideal of monumental composition, that free mode of aesthetic creation that communicates purely the internal and essential. In a particularly difficult passage later in the same essay, Kandinsky suggests that this need for purity – which, as we have seen, is the talisman of the absolute – leads to the desire in abstract painting "to embody the work of art in 'nonmaterial' forms" (I, 244). His setting off of "nonmaterial" suggests that he is aware of the paradox of creating an art that avoids materiality, but clarification of his meaning comes only in a passage from "On the Artist" (1916). "Creations of . . . art in the purest sense of the word," Kandinsky reveals, "are spiritual beings that have *no practical use and are therefore of no material value*" (I, 412; my emphasis). An immaterial incarnation of the absolute, then, is a work that is above any practical exigencies (whether personal, technical, or political), a work that is inner. Two important questions follow: how can Kandinsky's paintings accomplish this end (that is, what is the mechanism of their purity?), and why is a non-mimetic art most suited to the attainment of this goal?

Kandinsky's working process is often described as a "dematerialization"[28] of forms, colors, and motifs. An example would be the large group of quasi-religious works from the early teens where he characteristically "veils" and "strips" imagery.[29] It might be more accurate, however, to think of his approach as a *re*materialization of these elements after they have been processed by the new eidetic vision that we have seen Kandinsky describe, after they have become inner experiences. It is not Kandinsky's immediate aim to go beyond plastic art to an immaterial absolute – though his ideal of a synthetic, monumental, *Gesamtkunstwerk* might entail the same seamlessness between art and society that we saw in Mondrian's aspirations – but rather to compose a pure art that is immaterial because it is immune to merely practical concerns thanks to its filiation with the essential, which makes it free and autonomous. As Mackie has argued, Kandinsky is primarily concerned with the movement from matter to spirit, and it is this very positive metaphysical transformation

that he manifests plastically.[30] In art, he tries to embody the eidetic dynamism, the spiritual evolution that he proclaims for society at large, with the image of the triangle.

Composition IV of 1911 (Fig. 10) is a particularly strong example of this attempt to concretize essences. Washton-Long has articulated the ways in which imagery related to the apocalypse and second coming of Christ is veiled by Kandinsky in this and other pieces in an attempt to convey meaning.[31] In the center, two prominent, black vertical lines divide the picture's space into roughly equal right and left halves. These lines are not merely formal partitions, though, since by comparing the final version of *Composition IV* with its two studies,[32] they can be read as "dematerialized" versions of lances held by three figures. With the theme of battle or conflict thus intimated, we can also distinguish the guns suggested by the long black lines to the left and the central conflict between battling horses, whose limbs are entwined, in the upper left of the canvas. Kandinsky also inscribes images of boats rowing towards the salvation promised by the rainbow in the left part of the image. In the center is a schema representing a fortress, which, since it is transversed by the spears, also seems to be implicated in the struggle. The right side of the painting contrasts in many ways with the left: the

10 Vasily Kandinsky, *Composition IV*, 1911. Oil on canvas, 159.5 × 250.5 cm (Düsseldorf: Kunstsammlung Nordrhein-Westfalen. © Vasily Kandinsky 1990/VIS★ART Copyright Inc. Photo: Walter Klein).

two vertical shapes set on a mountainside can be interpreted as female saints; a reclining couple extends across the lower right. The right side is also slightly larger and considerably more open. Its colors are brighter. Kandinsky himself provided an explanation of this picture in which he emphasizes this use of binary contrasts. He describes the balancing of "masses" or "weights" and the "contrasts" between "mass and line/ between precise and blurred/ between entangled line and entangled color, and/ principal contrast: between angular, sharp movement (battle)/ and light-cold-sweet colors" (I, 383). He also emphasizes the movement from left to right and from lower to upper (accomplished by directional brushstrokes in the "sky" and the lightening of his palette) as well as the "running-over" of colors beyond the boundaries of forms. What Kandinsky has constructed in *Composition IV,* then, is an elaborate system of binary contrasts that, in combination with the movement towards the sun (which we see behind the rightmost of the two erect figures), allows him to make a "material" statement that evokes a spiritual evolution. Forms blend into one another in a particular metaphysical direction, a positive, upward direction in keeping with Kandinsky's proclamation of the coming of a new age, that of the "Great Spiritual." The saints and lovers are both cause for hope. What he depicts is clearly "inner," and thus his means and his art are by definition pure.

Kandinsky's interest in apocalyptic imagery peaked in 1911, but in subsequent paintings he continued to materialize absolute values by using the same dualistic system of contrasts, a system that relies heavily on the ontological dualities that characterize essentialist thinking. *Inner Bond,* for example, a dramatic oil from 1929 (Fig. 11), displays such contrasts even more clearly than does *Composition IV,* because Kandinsky had during his Bauhaus years developed a more geometrical mode of expression. The picture is starkly and evenly divided along a vertical axis created by the abutment of two large color masses, yellow on the left and black on the right. A strong contrast between light and dark is thus created, and this distinction is subtly underlined by the different textures of these two areas: dense and flat on the right (except where some dark blue pigment breaks through) against translucent and airy on the left (except for four saturated black spots). Another echelon of contrasts is set up by the picture's two main motifs, one of which (the left) seems to float within its yellow ground (reminding us of Constructivist experiments, but with Kandinsky's typical moodiness), whereas the other

sits firmly on top of its dark base. The geometrical form on the left is semitransparent; its counterpart is opaque. Many more comparisons of this sort can be seen, but from these observations it should be clear that Kandinsky has again elaborated a complex structure of seeming opposites. And as in *Composition IV,* his goal is to make more than a formal statement. The title alerts us to the affinity between the contrasts, the possibility of unity and harmony on the *inner* plane of existence. Many of Kandinsky's titles during his Bauhaus and later Paris years encapsulate just such a duality, so that works then resolve into what, remembering Mondrian, we might call metaphysical "repose," what Kandinsky labels "resolutions" (I, 384) with reference to *Composition IV. Inner Bond* suggests this resolution textually, as it were, and also manifests it plastically using the technique of "running-over" that we saw in *Composition IV.* Not only do forms meld into one another on either side of the later work, but the prominent half-circle at the bottom of the picture literally transverses both sides, trespassing the boundaries of any dichotomy. In both paintings, Kandinsky uses his highly evolved and sensitive formal language to speak of a domain of inner essences

11 Vasily Kandinsky, *Inner Bond,* 1929. Oil on canvas, 66 × 76 cm. © Vasily Kandinsky 1990/VIS★ART Copyright Inc.).

– whether specifically Christian in the first or more pantheistic in the second, in keeping with his search in his later work for the laws of natural creation – essences that are unchanging in all but their external manifestations.

Before considering the second of the questions posed previously – why a non-mimetic art? – I want to investigate further the theoretical impetus behind Kandinsky's desire to manifest inner necessity, spirit, or truth plastically. This metaphysical need seems to run counter to his simultaneous demand for purity, which would seem to be best fulfilled by a literally non-material expression like music (the art form that is, in fact, frequently Kandinsky's explicit model). Yet Kandinsky does insist on communicating in the concrete through the medium of painting, which he nonetheless feels obliged to define as non-material. His procedure has its conceptual roots in the same three groups of essentialist doctrine that were so important to Mondrian: Theosophy (especially the very Christian version developed by Rudolf Steiner), Hegelianism, and Schopenhauer. In addition, Kandinsky's propinquity to the latter two philosophical systems also reveals connections with the Platonic discourse that I have claimed is the father of essentialism. We know that Kandinsky was familiar with Steiner's thought.[33] He also had every opportunity to know Hegel's work either directly or in its many derivative incarnations in Munich around the turn of the twentieth century, and as I will argue, his notions of inner necessity, objectification of the spirit (or the will), and even the image of the pyramid, so closely parallel Schopenhauer's writings that a comparison seems overdue. Although historical connections clearly obtain, then, I do not want to focus on the issue of "sources." If we are to assess the implications of Kandinsky's essentialist abstraction, it is of greater import to examine the ramifications of the parallels between his doctrines and the philosophical traditions that, consciously or not, directly or not, he ratifies.[34]

Kandinsky refers approvingly to the Theosophy of Blavatsky and Steiner in *On the Spiritual*. He sees it as a spiritual, inner doctrine that leads to the essential: "Theosophy, according to Blavatsky, can be equated with *eternal truth*" (I, 145). Kandinsky must have imbibed more than Theosophy's general essentialism, too, because he notes Steiner's *Theosophie,* a text in which, as Washton-Long claims, Steiner "emphasized the need to use material means to assist the spectator in learning to understand the spiritual,"[35] and which, there-

fore, could have justified Kandinsky's use of a material form – painting, and within painting, very often another material inspiration, nature in the form of landscape – to convey his noetic messages. Kandinsky's new vision of the world (synesthetically transposed into his response to inner *sounds*) is also "connected with Steiner's speculation of the 'inner word' through which all things 'become . . . spiritually audible in their innermost essence'."[36] It is likely, then, that Kandinsky borrowed his notion of "inner necessity" from Steiner.[37] Steiner also taught that what he called pure spirit is successively incarnated in individual people in order to give them self-consciousness. For him, spirit is constant but its manifestations are relative. He also believed in "cosmic memory," the individual soul's recollection of the process of its liberation from matter, and, like Schuré (whose *Grandes initiés* Kandinsky owned[38]), Steiner also wrote about the great initiates who had made this journey, like Plato and Christ. Without denying Steiner's and Theosophy's importance for Kandinsky's early ideas, however, many critics have recently begun to place more emphasis on other analogous but discrete bases for Kandinsky's aesthetic.[39] I would in turn redirect their search for new sources somewhat by claiming that *all* the supposed origins discussed by these authors have in common an essentialist agenda, and that it is this doctrine in its various manifestations that both inspired and infused Kandinsky's work. It is in this spirit, then, that I now wish to turn to the correlations between Kandinsky's thinking and Hegelianism, a connection which, in contrast to that with Theosophy, has barely been noticed. As we saw with respect to Mondrian, Hegel also focuses on the importance of memory and on Plato. With this in mind, I want to emphasize three aspects of Kandinsky's drive to materialize the absolute that seem remarkably Hegelian: the concretization of the universal as spirit inhabiting a work of art, the link between this pure rematerialization and a metaphysics of memory, and the connection for both Hegel and Kandinsky between this manifestation of essence and the notion of freedom.

For Kandinsky, form (and color) are "always temporal," (I, 237) mere means that "concealed . . . creative spirit" (I, 235) has ready to hand as it "seeks its materialization" (I, 235) in painting. Thus "the originator of the work of art is . . . the spirit" (I, 394). This materialization in works such as *Composition IV* is by definition pure, because it is directed by the spirit. Its individual expression is relative to the artist's personality and the historical situation, but its heritage and

import are absolute. Though Kandinsky doesn't use this phrase, what he seeks to create with his "immaterial" art is directly analogous with Hegel's concrete universal. The dualisms characteristic of his work – both of structure and in the sense of a metaphysical hierarchy of lower and upper, maintained in a dynamic resolution – also constitute a strikingly Hegelian architectonic. On this same general level, Kandinsky's constant reminder throughout his writings that art and its culture are functions of spirit is reminiscent of what can be called the aesthetic re-education offered by Hegel in the *Aesthetics*. Both thinkers proclaim that art is this manifestation of spirit, a spirit that we have forgotten. Kandinsky's Hegelianism, then, can also be perceived in his characteristic need to remind his readers of the metaphysical nature of art by taking them through its teleological trajectory towards a pure, abstract incarnation, as he does in *On the Spiritual,* in particular, with his examples of the spirituality of earlier art. Like Hegel (and Mondrian), Kandinsky in effect constructs the history of art from the perspective of historically self-conscious spirit, the point at which history in fact begins (and, paradoxically, ends) and thus the goal to which all "prehistory" – now recollected – must be seen to aspire. I will return to this point below when I consider the self-revision of the artist with its concomitant implications for his perception of the history of art and art's social role.

Because Kandinsky's writing can be seen as an attempt to bring the spiritual pedigree of art to consciousness it is also, given the ultimate value he accords to the spiritual, an apology for art itself that participates in the identifiably Platonic apologetics within which Hegel also works. Mark Taylor has pointed out that Hegel's project of re-education is Socratic in flavor and derivation in that the reader of the *Aesthetics* is guided to a supposedly inner and immutable truth by a good physician.[40] We have seen the same model at work in Mondrian's writings and it also obtains quite explicitly with Kandinsky. After discussing the evolution of early modern art in *On the Spiritual,* Kandinsky asserts that in these pioneering artists "lie hidden the seeds of the struggle toward the non-naturalistic, the abstract, *toward inner nature.* Consciously or unconsciously [these artists] obey the words of Socrates: 'Know thyself'!" (I, 153). Again, this point can be elaborated when I discuss the self-purification of the artist, but in this context I want to suggest that the connection with Socrates leads us to Plato's eidetic deployment of memory. Though Kandinsky goes on after his invocation of Socrates to make

the inner turn to the self sound like a formalist plea for pu-
rification of "materials," he nonetheless makes it clear that
this focus is ultimately only a step, a means, and must be
carried out in memory of spiritual values, values that, as we
know, are for Socrates, Plato, and Kandinsky, noumenal.
The same can be said of Hegel's universal spirit as it is man-
ifested in art, with the qualification (his revision of Plato)
that this absolute manages to be material as well. All this
might seem quite removed from the conditions of Kandin-
sky's aesthetic production until we remember an example
like that of Johannes Itten, one of Kandinsky's prominent
colleagues at the early Bauhaus, who inscribed Plato's crucial
words "thinking is remembering" on a lithograph sheet he
designed for his essay "Analysis of Old Masters" of 1921,[41]
a text with which Kandinsky would have been conversant.
And Itten follows this Platonic reference with a passage that
extends the notion of essential memory into art and connects
the contemporary with the past in precisely the teleological
terms we find in Kandinsky: "Schaffen heisst wiedererschaf-
fen," creation is re-creation. The *Blaue Reiter Almanac* was
itself a materialization of just this principle. In collecting ex-
amples of earlier, spiritually progressive art, Kandinsky and
Marc worked from the premise that "the basic ideas of what
we feel and create today have existed before us, and we are
emphasizing that in *essence* they are not new."[42] Recent com-
mentary on Itten's lithograph has emphasized the inventive-
ness of his typefaces,[43] and although his innovations in this
sphere are certainly important, such a focus on formal exe-
cution seems subsidiary to the Platonic/Hegelian authority
that he manifestly invokes as the foundation for his analysis,
a theoretical analysis by which Itten unambiguously addresses
the issue of how art history's past (previous manifestations
in Spirit's evolution) affect contemporary practice. Kandin-
sky had summoned the same philosophical tradition to
ground his own reflections on art's history and significance
a full decade before Itten's essay.

Kandinsky seeks true freedom in art by avoiding the
merely external strictures of academic teaching and draws
instead on the eternal and absolute laws of art as they can be
heard echoing within the artist. To his way of thinking, free-
dom is in this way a function of the absolute, not a flight
from it, and here again, Kandinsky comes close to Hegel.
Freedom for Hegel can also be seen to function on two levels,
that of individual particularity, where it is never complete,

and that of the absolute, where it finds its total resolution. For Hegel, particular freedom necessarily involves the struggle between opposing values: "where there is finitude, opposition and contradiction always break out . . . and satisfaction does not get beyond being relative."[44] Like both Mondrian and Kandinsky, as we have seen, Hegel believes that the artist must, through this inner turn, "extinguish in himself the accidental particular characteristics of his own subjective idiosyncrasy."[45] Chained, as it were, to the level of appearances, we therefore seek "the region of a higher, more substantial truth, in which all oppositions and contradictions in the finite can find their final *resolution,* and freedom its full satisfaction. This is the region of absolute, not finite, truth. The highest truth . . . is the *resolution* of the highest opposition and contradiction."[46] Indeed Hegel defines the absolute as the identity of identity and difference, the resolution of opposition within an ongoing dialectic.[47] He of course goes beyond art to find this ultimate freedom in philosophy, but "the forms of art" lead the way, because they "proceed from the Idea itself."[48] For Kandinsky too, the very Hegelian oppositions he constructs in works like *Composition IV* and *Inner Bond* find their resolution, as he calls it with reference to the former painting, within the eidetic economy to which we are given access by his paintings. For both Hegel and Kandinsky, then, art is at once a focus in itself and a means to a higher end. It is a concrete universal.

Kandinsky's affinity with Schopenhauer's thought is signaled by the identical terminology they use to discuss the necessary materialization of Spirit or Idea in art. To explain what he calls the "objectification" of the will in *The World as Will and Representation,* Schopenhauer employs the notion of "inner necessity,"[49] as well as the image of the pyramid, within the conceptual frame of a Platonic ontology. Thus even if we didn't know that Kandinsky used another of Schopenhauer's texts – the *Farbenlehre* – for his early investigations of color theory,[50] or that Franz Marc and Arnold Schoenberg, two of his collaborators on the *Almanac,* cited this philosopher,[51] the similarity between Kandinsky's and Schopenhauer's nomenclature alone would be enough to suggest deeper ties. Schopenhauer's high valuation of music at the very least corroborated Kandinsky's thinking on this topic. Even more important for my immediate purposes, however, are two other striking parallels: the exploitation of essentialist metaphysics (with direct reference to Plato in Schopenhauer's

case[52]), and the demand that the absolute become manifest plastically. Both topics lead us again to the phenomenon of abstract art as the ideal apology for art in general.

Schopenhauer sets up the hierarchy between changing, external phenomena and an unchanging, internal principle in his discussion of the objectification of the will in the first book of *The World as Will and Representation*. Like the Platonic Ideas, he argues, the will necessarily represents itself through "gradations of objectification" (I, 153), but this dynamic process does not affect the will's transcendental purity:

> Just as a magic lantern shows many different pictures, but it is only one and the same flame that makes them all visible, so in all the many different phenomena which together fill the world . . . it is only the *one will* that appears, and everything is its visibility, its objectivity; it remains unmoved in the midst of this change (I, 153).

Schopenhauer's inventive image of the magic lantern – itself a transmutation into the realm of art and its history of Plato's allegory of the cave – allows him to connect evocatively the essentialist legacy of Neoplatonic light metaphysics with a contemporary image of the evolution of artistic forms. These styles, he argues, can evolve because their source remains constant. Using ideas that we find duplicated in Kandinsky's writings, Schopenhauer explains that "the *inner necessity* of the gradation of the will's phenomena, inseparable from the adequate objectivity of the will, is expressed by an *outer necessity*" in these phenomena (I, 154). That is, the material expression (art) can mirror the inner objectivity of absolute truth. Kandinsky makes the same point:

> This ineluctable will for expression [what Schopenhauer calls "representation"] of the objective is the force described here as internal necessity, which requires from the subjective today *one* general form, tomorrow *another*. It is the constant tireless impulse, the spring that drives [us] continually "forward". . . . It is clear that the spiritual, inner power of art merely uses contemporary forms as a stepping stone to further progress (I, 174–5).

Both thinkers also use the image of the upward, forward-moving pyramid with its broad base and narrow apex to express simultaneously the metaphysical unity and evolution of spirit from its lowest manifestations to its purest expression. For both too, art is the highest form of this purity. Marc makes this claim with specific reference to Schopenhauer and in terms that parallel Kandinsky's purification of landscape imagery in search of the essential: "The modern artist no

longer clings to the natural image, but destroys it in order to show the mighty laws which dwell behind pretty appearance. To speak with Schopenhauer, today the world as will triumphs over the world as idea."[53] Marc proposes that in art the will in its unchanging but material incarnation triumphs over the distant Idea, again providing a concrete universal.

For Schopenhauer and Kandinsky, art is the only possible salvation from the negative aspects of the will, its temporality and radical contingency. Both men see the human condition in its external, unenlightened state as one of appetite and desire manipulating the individual. The remedy is to find security without transcending material existence altogether, to find "the *essential*," as Schopenhauer implores, within "the will's objectification," since only this essence "constitutes the *Idea*" (I, 182). As we saw in Schopenhauer's relation to Mondrian, only art leads to this essence. Another way of contextualizing what both Kandinsky and Schopenhauer see as our need for essence, even in the face of what seems like a hopelessly material and impure world, is to underline its allegiance with what we might call a metaphysic of desire in Plato's philosophy. For Plato – and all essentialists – mundane existence is severely lacking in ontological capital; the result is the soul's desire for union with the Ideas, for the security of the noumenon. In the *Symposium*, this desire takes the form of Eros, so when we connect the Platonic tradition to the advent of abstract painting, we may speak of an erotics of abstraction, an erotics that is specifically transcendent in its purity. Though Schopenhauer often departs from the Platonic view of human reality,[54] he heartily concurs with this depiction of metaphysical desire. As Harries writes, for Schopenhauer, man is dissatisfied and "dissatisfaction is implicit in the nature of desire. . . . To make desire constitutive of man is to say that man is by his very nature a being in need."[55] Kandinsky uses these same arguments to demonstrate art's essence and its restorative role for the individual and society. Throughout *On the Spiritual*, he complains of the lack of spiritual awareness in society and he shows how the artist and his art can lead everyone below them in the spiritual pyramid out of this disastrous situation. He continually lambasts those artists and citizens who stay on the surface, untouched by spirit. An unregenerate artist is the most dangerous, since he can use "his powers to pander to baser needs [and] peddles impure content in an ostensibly artistic form" (I, 135). Perhaps because of what they perceived as society's

negative blows against the progress of spirit, both Kandinsky and Schopenhauer map a potent "nostalgia for the absolute" onto art.

A final aspect of Kandinsky's participation in Schopenhauer's discourse should be examined briefly before we open the question of abstract art's particular qualifications to lead art itself into the future. Extending the metaphor of desire, Kandinsky acknowledges the isolation that "those lonely souls who hunger and possess the power of vision" (I, 135) feel in contemporary society. Theirs is the plight of Plato's freed prisoner after he returns to the cavern of shadows: he sees the shadows for what they are and wants to lead the others shackled there towards the light, but they do not believe him. He is "mocked or regarded as mentally abnormal" (I, 135). Kandinsky's metaphors here connect with many salient aspects of the essentialist tradition: he clearly sees himself – as Gauguin did – as Christ-like in both his vision and suffering. Both artists also specifically continue the Platonic tradition, which itself of course flowed into early Christian doctrine, both in its emphasis on eidetic vision as opposed to "spiritual night" (I, 135) *and* in its reliance on memory as a way of gaining access to the realm of essences. Schopenhauer's connection of memory with madness, which, as I argued in Chapter 1, he makes within the Platonic context of the cave (I,190), perfectly describes the artist-seer's passionate conviction and his resulting marginal status in society. Gauguin exiled himself and was thought to be mad because of his "extreme" – according to what Kandinsky might label the external judgment of academic circles – painting; Sérusier banished himself to Brittany; Mondrian was always viewed as a monk and marginal socially; Kandinsky, too, it seems, suffered exclusion and adopted the martyr's mantle. "Madness," then, though seemingly nothing more than a derogatory epithet thrown at the artist, reveals much of the essentialist lineage that instills in the artist a disgust with anything but the "inner" and a strong thirst for metaphysical purity.

Both Kandinsky and Mondrian were devoted to the cause of a non-mimetic, "abstract" art based on the access to and materialization of universal values. Kandinsky, however, was much less dogmatic about the nature of this new art than was Mondrian. Indeed, as we saw at the beginning of this chapter, he felt that Mondrian's aesthetic was too narrowly based. For Kandinsky, spirit or the absolute was the most important consideration (as it was for Mondrian), but he saw many

ways to express it, all of which were ultimately nothing more than relative, historical means to a timeless end. In the *Almanac* and in *On the Spiritual,* for example, his own brand of historicism – Hegelian in its belief that Spirit uses the appropriate particular forms to communicate itself materially at any given time – blends, rather oddly, with a totally synchronic presentation of art objects from different periods and cultures that are joined only by the similarity that they share, the "connecting thread" (II, 479) of inner necessity. Differences between his examples are, Kandinsky holds, merely external: he proclaims the solidarity of "artists who seek the internal in the world of the external," no matter what their temporal or cultural differences may be (I, 151). Kandinsky thus extols the spiritual purity and unity of Russian and Bavarian folk art, children's art, Baroque churches, and the paintings of Henri Rousseau (which he collected), in short, the primacy of any form that could express and communicate the inner. As Washton-Long has definitively shown, it is this overriding desire for spiritual communion that led Kandinsky to keep using veiled references to natural and religious phenomena even after he had envisioned a non-objective art, since he rightly acknowledged that his audience would, in the early years of this century, miss any message conveyed through pure abstraction.[56] When he did move to abstraction, then, Kandinsky exercised that very freedom from external absolutes for which he had long fought. " 'Absolute' means do not exist in painting," he wrote in a late essay; "its means are relative only" (II, 823). He had developed this idea much earlier, for, as he states in the *Almanac,* "form is always temporal, i.e., relative, since it is nothing more than the means necessary today . . . [and we must not exalt] the relative to the level of the absolute" (I, 237; 239). As a means, however, abstraction, like the aesthetic freedom that it exploited, *was* explicitly subordinate to an absolute, that of the pure, noumenal essences Kandinsky sought to materialize in his paintings. Kandinsky thus moved towards abstract expression because of what he saw as spirit's inner necessity, its need to materialize the absolute appropriately. He felt that society largely rejected the new art because of its external differences from the past; on the inner plane, he proclaimed its continuity with a great range of earlier artistic expressions. His career can be understood as an attempt to explain how the new, abstract art is, through spirit, linked to the past and why it is the harbinger of his ideal future society.

We have seen how Kandinsky thought that abstract expres-

sion gave access to the essential in a direct way that had been unusual for art in the past and that was even less feasible for traditional art during his time because of the base materialism of representational styles. His argument, like Mondrian's, is historical in a teleological sense, because both men thought that abstraction was simply the best means for the present, but not necessarily forever. Yet they also believed that any historical manifestation was relative to the universal, facilitating essence that they were seeking to communicate in the purest possible manner. Kandinsky demonstrates abstraction's parentage in one of his earliest essays with the revealing image of this new art as a *crystallization* of the absolute. In "Content and Form" of 1910–11, he gropes towards a definition of eidetic "composition." Already, however, the metaphysical implications of his nascent theory are legible:

This [new] kind of composition will be constructed upon the same basis which is already known to us in embryonic form, only which now will develop into the clarity and complexity of musical "counterpoint." This counterpoint (for which, in our terms, we have as yet no word) will be found further on, on the path of the Great Tomorrow, by the same eternally unchanging guide – Feeling. Once found and *crystallized,* it will provide the expression of the Epoch of the Great Spiritual. And [its] . . . *characteristics will rest upon the greatest of all foundations* – upon the Principle of Internal Necessity. (I, 90; first emphasis added)

Kandinsky's metaphor of crystallization takes us again to the ontological discourse of his critical forbears, in this case, Worringer and Schopenhauer. As Tower suggests, Worringer sees the "urge to abstraction" at work in "the life-denying inorganic, in the crystalline, or, in general terms, in all abstract law and necessity."[57] For Worringer, the "crystallinic" is the purest form of abstraction, found only in Northern European peoples. Klee picks this up (by characterizing himself as a crystal, as we shall see in the Postscript) and so, I believe, does Kandinsky in the passage just cited. To crystallize is to capture purely an essence, to arrest and manifest it historically and materially. This is exactly what abstraction claims to accomplish in art, as we saw with respect to *Composition IV* and *Inner Bond.* Crystallization and abstraction are techniques – not goals or objects – within an eidetic alchemy; they distill essence, whether in the seer's stone (one mystical incarnation of the crystal) or an abstract painting. Schopenhauer uses the image of crystal formation in this way: "The ice on the window-pane is formed into crystals according to the laws of crystallization, which reveal the essence of the natural force

here appearing, which [in turn] exhibit the Idea" (I, 182). For
Kandinsky, abstraction also has laws that derive from this
Platonic metaphysic, and, inspired by Klee in his later career,
he explicitly compares these laws with nature's operating
principles. Abstract painting is the way to the future of civ-
ilization because it is an essential crystal of the individual
artist's personality, the immediate culture (with its necessary
relation to its own past) and – most crucially – of immutable
Spirit. In another telling reference to the power of the crystal,
Kandinsky extols the importance of "theory" in his overall
aesthetic project: "theory is the lantern[58] that illuminates the
crystallized forms of yesterday and before" (I, 141). Theory,
then, within which we should include all aspects of Kandin-
sky's research – all means of gaining access to the essential,
not just his writing – can operate on an inner plane in a way
analogous to self-consciousness in Hegel's thought. In this
"contemplative" mode, theory actually constructs the ma-
terial history of spirit, the history of art, by recognizing crys-
tallized forms. Mere external theory – the rules and
procedures of art making – always lags behind praxis, as
Kandinsky notes several times in his texts, but theory proper
has the same essentialist ancestry as inner necessity or spirit
itself.

Kandinsky strives to achieve a non-mimetic art for two
main reasons: first, mimetic or representational art has come
to represent the academic superficialities that deafen us to
inner necessity. This is partly an historical – that is, contingent
– situation, because he does see some figurative art (like Henri
Rousseau's) as yielding access to essences. More importantly,
however, non-mimetic art is pure and thus accords with the
purity of the absolute that Kandinsky feels he must make
manifest. He wants an art that is *part* of the absolute, not
merely a reflection of it, which is the best that representational
painting can hope for in the early twentieth century. In a
plain reference to the poverty of mimesis, Kandinsky com-
plains that even "virtuoso" representational artists "are like
starlings who do not know a song of their own, but imitate
more or less well that of the nightingale" (I, 413). He desires
instead to dissolve the discrepancy between original and copy
(nightingale and starling), to have what he calls in *Point and
Line to Plane* (1926; the text in which he focuses most intently
on "formal" questions, but which nonetheless finds its in-
spiration in his essentialist project) "direct, inner contact" (II,
532). Only an essential expression can be ontologically direct
in this way, because only this type actually joins with its

89

source in the Platonic sense, which is what Kandinsky implicitly calls for in *Point and Line to Plane*. "The street," he explains, "may be observed through the window pane, causing its noises [sounds] to become diminished, its movements ghostly, and the street itself... to appear as a separate organism, pulsating 'out there' " (II, 532). On the other hand, "one can open the door: one can emerge from one's isolation, immerse oneself in this organism" (II, 532), and create without any mediation or interference. Only a non-mimetic, abstract art form can embody this union with the absolute, because only it is sufficiently pure. Paradoxically, but totally in keeping with the Platonic script within which Kandinsky works, the "isolation" he refers to is the external world of constricting rules, rules that keep the artist in the shadows of representational imaging. The immersion to which he refers begins with the turn to the self, the soul, and the concomitant revision of the artist.

It is in *Reminiscences* that we find Kandinsky's most compelling description of his own transformation from a legal scholar in Russia, through the period of his reasonably conventional though not academic in the strictest sense artistic training in Munich, and into one of the most radical painters in the Western tradition. As its title suggests, this text was written in retrospect and from the vantage point of Kandinsky the convert to abstract painting. Like Mondrian's autobiographical "Natural Reality and Abstract Reality," then, *Reminiscences* is strongly teleological and even didactic. In Hegelian terms, both of these fundamental texts could only have been written once what we might deem eidetic self-consciousness had been achieved. The personal, artistic, and social histories that both authors present literally could not exist as aesthetic "compositions" without the search for and discovery of the essential that is itself, again in Hegelian terms, justified by its manifestation in the work of a particular, historically situated individual. Kandinsky vividly recollects (in the Platonic and personal senses) several epiphanies that initiated the type of inner vision – what Mondrian, following Schopenhauer, called "contemplation" – that in turn precipitated his abstract expression. Perhaps the most striking of these early experiences involved his re-vision of one of his own paintings as an abstract. Significantly, Kandinsky explains this phenomenon in terms of the epistemological and ontological interpenetration of subject and object that, as I argued above, is one of the touchstones of the essentialist metaphysic. And what is more, Kandinsky also describes this

milestone in terms of *absorption,* the very metaphor Mondrian uses in "Natural Reality and Abstract Reality" to create the instrumental fiction that nature and art are one. "For many years," Kandinsky remembers, "I have sought the possibility of letting the viewer 'stroll' *within the picture,* forcing him to become absorbed in the picture, forgetful of himself" (I, 369). And, he claims, turning to his epiphany,

> Sometimes . . . I succeeded. . . . After my arrival in Munich, I was enchanted on one occasion by an unexpected spectacle that confronted me in my studio. . . . I returned home with my painting box having finished a study, still dreamy and absorbed in the work I had completed, and suddenly saw an indescribably beautiful picture, pervaded by an inner glow. . . . It was a picture I had painted, standing on its side against the wall (I, 369).

Kandinsky takes two main lessons from this happy experience, first, that "objects harmed my pictures," (I, 370) and second, that there is a certain sort of absorptive reverie, a special species of inner vision, that allowed him to see objects anew. This new vision, as we have already seen, requires that the artist indeed forget his external, conventional self, lose his encumbering individuality, or as Schopenhauer would have it, his will, and recall a more essential, pure stratum of existence that is found in the soul. This is the ultimate import of Kandinsky's citation of Socrates's famous dictum "Know thyself!" (I, 153). Absorption, then, like crystallization, is both a metaphor and method for the process of gaining access to the absolute and making it manifest in all its purity. Schopenhauer's description of contemplation, this new vision of an object or landscape, likewise focuses on the connection between absorption and the unification of subject and object in direct perception:

> We *lose* ourselves entirely in this object . . . we forget our individuality, our will, and continue to exist as pure subject. . . . We are no longer able to separate the perceiver from the perception, but the two have become one, since the entire consciousness is filled and occupied by a single image of perception (I, 178–9).

This is also Kandinsky's ideal aesthetic state, one in which original and simulacrum – the structural coordinates of mimesis – have been collapsed. Indeed, it was very likely a landscape that Kandinsky mentally transformed into what was for him the first abstract painting, given that this genre was the focus of his activity during his early Munich period, as the anecdote just cited itself suggests with its not incidental

reference to the picture he was carrying with him, implying that he had been working *en plein air.*

Kandinsky describes in *Reminiscences* a number of other similar incidents that turned him inward and made him realize a new sort of vision. His initial inability to recognize the motif in one of Monet's *Haystacks,* although a "painful" (I, 363) experience because it went against the grain of his artistic training, helped him to realize the abstract power of the palette. His reaction to the splitting of the atom – discussed previously – was similarly one of feeling "precarious" but at the same time, it was very positive, for through it he "removed one of the most important obstacles from [his] path," (I, 364) the formerly irrefragable materiality of nature. He was now able to see the universe more freely as both fluid in its evolutionary dynamism and *spiritual* in its essence. His concentration on inner values, the values of a soul pure because of its heritage, also led to a revised opinion about the color white, that habitual symbol of "immaculate purity" (I, 186). In the Cologne lecture, written shortly after *Reminiscences* and equally autobiographical, he relates another formative experience that occurred during a particularly hot summer in Germany in 1911. "One's skin cracked," Kandinsky exclaims,

One's breath failed. Suddenly, all nature seemed to me white; white (great silence – full of possibilities). . . . Later, I remembered this feeling when I observed that white played a special role . . . in my pictures. . . . I know what undreamed-of possibilities this primordial color conceals within itself. . . . I.e., the inner, thousandfold, unlimited values of one and the same quality . . . [this revelation] tore open before me the gates of the realm of absolute art (I, 397–8).

Kandinsky's immediate pictorial references here are to such works as *Painting with White Form,* 1913, and *Painting with White Border (Moscow),* 1913.[59] He also rightly predicted the ongoing importance of white as an image of the metaphysical purity of absolute art in his work, especially in the early 1920s, as is witnessed by pictures such as *On White I* (1920), *White Line* (1920), *White Oval* (1921), *White Cross* (1922), and *White Zigzags* (1922).[60] Even in his decidedly geometrical Bauhaus paintings, Kandinsky focused on white in works like *Whitebound* (1929),[61] suggesting that he maintained his essentialist interest in this (and no doubt other) colors even when his work appears to be at its most formal.

Kandinsky's ability to see differently, to hear the inner sound of spirit (as he might put it), is fundamental to his

breakthrough into abstract painting. To accomplish these changes, an artist must "immerse himself in his own soul" (I, 213), reorient this inner organ to the purity of the absolute with which it now communes. "In one's entire life," he says, "(hence in art too) one's aims must be pure" (I, 211). Kandinsky's "aims" were retroactively transformed by his turn to inner necessity. As we saw with reference to Mondrian's very Hegelian self-consciousness, once enlightened, the artist rewrites his own history in terms of his newly acquired pure motives. Thus in *Reminiscences*[62] Kandinsky characterizes his entire artistic development as follows:

Only after many years of intense work, innumerable cautious experiments, ever-new, unconscious, or semiconscious impressions which I began to experience and to desire more and more clearly, and by means of which I acquired the capacity inwardly to experience artistic forms in increasingly pure, abstracted form, did I arrive at the pictorial forms . . . on which I am working today, and which will I hope be given much more fully perfected shape (I, 370, n.53).

In another autobiographical essay, "Self-Characterization" (1919), Kandinsky again proclaims that he had "progressed with logical, precise steps along the path that led to pure painting, and [had] gradually removed objects from his pictures" (I, 431). Significantly, these "steps" are laid out by Kandinsky in the triadic progression that he sees in the manifestation of inner necessity in general, in the three "mystical necessities" discussed above. "My process of development," he says in the Cologne lecture, "consists of three periods," each of which corresponds to the evolution of spirit away from individual and contextual concerns towards "pure painting . . . and the attainment of the abstract form necessary for me" (I, 393). All of Kandinsky's life becomes a "means" – like abstraction – towards the end of his teleological system, the manifestation of the absolute.

We can see his teleology in action not only in his writings but also in the self-conscious and self-revising recollections of his pictorial compositions. Artists habitually look back on their own work for inspiration, of course, but Kandinsky's mode of incorporating his earlier means of expression within what for him was the "higher" form of abstraction operates on a recognizably Hegelian plane that is unusual. Many of his paintings from the mid–1920s, for example, refer to his earlier work, but in a new, abstract idiom. *Rückblicke* of 1924[63] is a special case, as Kandinsky executed it to demonstrate to Nina the feeling of *Small Pleasures* (1913).[64] Yet because this

canvas was an explicit recollection, we are able to see the extent of Kandinsky's pictorial *Aufhebung*. As he had done in characterizing his entire artistic development, Kandinsky here works from the vantage point of inner necessity's *current* spiritual achievement. The result is a very purified version of the 1913 picture. The forms are more regular and, most significantly, they are now set in a very open, white space rather than in the tumultuous compositional cacophony of *Small Pleasures*. In *Beginning* of 1925,[65] Kandinsky suggestively recalls his own beginnings in landscape painting with an image whose mountain form, low horizon, clouds, and sun are reminiscent of his 1910 Murnau oils.[66] Both *Beginning* and *Development* (1926),[67] however, update these inspirations from nature in terms of Kandinsky's current geometrical proclivities. My point is that these changes are not simply stylistic, which Kandinsky would see as "external," but rather responses to what the artist perceived as an inner need, to the evolution of spirit.

As the inner man is changed by his perception of this absolute, so too is his account not only of his own history but also of art's history in general. Kandinsky comments frequently on both the overall, evolutionary sweep of art history and on the import of its individual periods, styles, and artists. "The progress of art in general," he writes in "Abstract Art" of 1925, "is a slow-moving advance, having as its point of departure purely external practical-purposive [i.e. individual] aims," which then moves through an "intermediary period" in which the external demands of nature are in equilibrium with the inner needs of spirit, and finally arrives at the present, pure level of abstract expression (II, 515–16). He is adamant that abstraction be seen as continuous with earlier expressions of spirit: the new painting, he insists, "was in no way the rejection of all previous kinds of harmony and beauty, but was their organic, immutable, and natural continuation" (I, 102). We can see this theory at work in Kandinsky's paintings. Not only does he make manifest his ability to transcend, without completely forgetting, his own early work, but he also makes pictorial references to other examples of abstract art that he thinks are limited. He upsets Neoplasticism's authoritarian purity by alluding to its signature forms within what would, for Mondrian especially, be an inappropriate context. In *Self-Illuminating* (1924),[68] for example, the upper left corner is commanded by what appears to be the corner of a Mondrian work from this period. The

rest of Kandinsky's canvas, however, displays a vibrancy and range of both color and form which he used to counter Mondrian's narrowness. *Small Signs* (1925)[69] is an unusual piece in Kandinsky's oeuvre. It is dominated by a smooth, saturated red background upon which he has superimposed several forms that are immediately recognizable as references to Constructivism. As if to pictorialize his opinion that Constructivism, too, was narrow in its focus on technological concerns, however, Kandinsky also inscribes an odd block of what appear to be hermetic signs in the lower right of the picture. He thus acknowledges Constructivist practice but overlays it with his own ongoing interest in spiritual values. A final example demonstrates the Hegelian continuity that Kandinsky achieves in his work by incorporating memories of both his own evolution towards pure painting and the attempts of other artists to follow this path. *Picture Within a Picture* (1929; Fig. 12) thematizes this entire mnemonics. In the upper right, we see a very geometrical "picture," which in its inclusion of geometricized mountains and heavenly orbs, itself recalls both Kandinsky's earlier Bauhaus period (with its rigorous geometry) and the earlier-still landscape work. These references are inscribed within a larger frame that, with its freely applied orange ground, announces Kandinsky's return in the late twenties to a more expressive handling of paint. An additional picture appears within this canvas when we look for references to other modes of abstraction. Near the center is a "picture" that has the form of a Neoplastic painting, but which is painted in ochres and yellows that threaten the purity of this internal painting's white rectangle. Kandinsky thus mirrors Neoplasticism's quest for the absolute, but in transforming this type of painting's means to accord with his own more eclectic and expressive eidetic path, Kandinsky obviates the mirror in favor of a direct apprehension of the noumenon.

Kandinsky makes it clear in both his writings and paintings that other artists and their works should be measured against (his perception of) spirit's advance. If they seem to him to fit into the proper historical manifestation of the inner, the right level of the pyramid, then they are praised; if not, they are discounted. French nineteenth- and early twentieth-century painting, "Impressionism, Neo-Impressionism, and Cubism," for example, "was a logical, mighty, and increasingly rapid advance toward" abstraction (II, 513), because it focused at the right moment on the "*external evaluation*" of

form (II, 513). Because for Kandinsky art history has entered a third phase, these French accomplishments can only be seen as propaedeutics to the present.

> Once these aims had been attained, and it was found to be impossible to draw any kind of internal conclusions . . . French art . . . [returned] to the corporeal. . . . If French art remains loyal to [this] purely external Romantic principle, it will be forced back into the shadows of art theory (II, 513).

Art is only successful, then, if it manifests inner necessity in an historical form congenial to spirit. Otherwise it returns to being a prisoner of Plato's shadows, a fate Kandinsky assigns to Purism – which, he holds, despite its name, didn't understand that only abstract expression could be pure – and, even more significantly, to Cubism.

Perhaps because some Cubism was in many circles thought to be abstract and because artists like Mondrian assigned to it a formative role in the development of an even more advanced form of expression, Kandinsky quite outspokenly distanced himself from this movement in all its incarnations. In a 1937 interview, for example, he stated bluntly that "I never had anything to do with Cubism" (II, 807). This is largely true in terms of stylistic influence, but in *On the Spiritual*, Kandinsky discussed Cubism in order to lay a theoretical groundwork for rejecting its analysis of form. He praises Picasso's energy in terms that thinly veil a fundamental criticism. "Picasso," Kandinsky writes, "throws himself from one external means to another. . . . He arrives at the destruction of the material object . . . not by dissolving it, but by breaking it up into its individual parts. . . . In this process he seems, strangely enough, to wish to retain a semblance of the material object" (I, 152). Kandinsky, too, at this time thought it expedient to refer to nature, so this is not the problem. What he objects to in Cubism is its *external* procedures and the attendant dematerialization of objects. He contrasts this process with his own work's reliance on "*the laws of internal necessity,*" (I, 176) which, as we have seen, are concerned to re-materialize nature in harmony with the absolute, just as Kandinsky himself was reoriented towards the spiritual. Kandinsky comes to see Cubism as part of an outmoded approach he calls "naturalism" (I, 352). Given the upward movement of the spiritual triangle in the early twentieth century, Cubism appeared to him atavistic in its "inertia" (I, 195), its inability to keep up with inner necessity's demand for new (abstract) expression. This condemnation is

12 Vasily Kandinsky, *Picture Within a Picture*, 1929. Oil on cardboard, 70 × 49 cm (USA: Private collection. © Vasily Kandinsky 1990/VIS★ART Copyright Inc.).

underlined by Kandinsky's relegation of Cubism to the annals
of art history: "it is remarkable," he exclaims in 1936, "how
Cubism, which is just as old (or young) as abstract painting,
has nonetheless already become 'historical,' and hence sac-
rosanct" (II,785). Kandinsky no doubt grew weary of con-
stantly defending the principles of abstract art, but he did not
want the art he had done so much to vitalize to become
ineffectual, as he thought Cubism had. Hence his somewhat
smug tone in comparing Cubism's fame with abstraction's
continuing need for apology: "Abstract painting is continuing
to evolve further," (II, 742) he said.

This evolution involves a social role for the artist and his
pure abstraction, as Kandinsky argues by contrasting his art
with what he sees as the false purity of "*l'art pour l'art*."

In those periods in which the soul is neglected and deadened by
materialistic views, by disbelief, and their resultant, purely practical
strivings, the opinion arises that "pure" art is not given to man for
a special reason, but is purposeless; that art exists only for art's sake
(*l'art pour l'art*). Here, the bond between art and soul becomes half
anaesthetized (I, 212).

As we would expect, art for Kandinsky must instead serve
inner, absolute values by avoiding not only the emptiness of
what he calls "airy-fairy" *l'art pour l'art* (II, 512) but also the
"practical, utilitarian" concerns of Constructivism (II, 512).
If both art and artist can become prophets for the Great Spir-
itual as Kandinsky desires, then he will have satisfied the third
requisite of a Platonic art and consolidated his defense.

Kandinsky's self-characterization as a visionary and saviour
is well known. The St. George imagery so prevalent in his
early work is perhaps the best example,[70] since as Weiss states,
"Kandinsky enlisted St. George in his 'battle' to redefine the
limits of painting."[71] He also pictures himself as St. Vladimir
and St. Martin, two champions of the healing powers of the
spiritual. Art aims to be "the seer of the future and [its] leader"
(I, 100). Inner necessity is the source of this messianic talent,
and inner necessity, as we have seen, becomes concrete in art
through the chosen artist "who conceals within himself the
secret, inborn power of 'vision' " (I, 131). Kandinsky states
plainly that his "theory," his written work, as well as his art
aspired to transform individuals and their society:

My book *On the Spiritual in Art* and the *Blaue Reiter*, too, had as
their principal aim to awaken this capacity for experiencing the
spiritual in material and in abstract phenomena. . . . My desire to
conjure up in people who still did not possess it this rewarding
talent was the main purpose of both publications (I, 381).

Weiss points out that this missionary ideology "was not un-
known to the Symbolist generation,"[72] an important point
corroborated by Fineberg.[73] In Chapter 1, I examined in some
detail Sérusier's use of the *Talisman* as the medicinal "poison"
of the new abstraction, a purgative for the old ways and a
preparation for a pure art and society. Although Kandinsky
does not use the term "poison" in this way, his revolutionary
vision for the effects of abstract painting is directly analogous
to Sérusier's proclamation of abstraction's curative power as
well as to Gauguin's "savage" aesthetic and social insurrec-
tion, and Kandinsky's anarchism[74] finds incentives in the same
Symbolist milieu.

As a self-proclaimed initiate into the mysteries of inner
necessity, Kandinsky felt that he had not only the gift but
also the duty to communicate his knowledge to the masses.
This was the prime goal of all his aesthetic research. By
proclaiming this social responsibility, he invokes the meta-
phor of his speech versus the silence of both the unenlightened
and inner necessity itself. "The artist essentially works for
people who are called laymen or the public and who as such
have hardly any opportunity to speak," he and Marc wrote
in a 1911 version of the *Preface* to the *Almanac*.[75] Both the
texts and images in this publication speak for the public.
Kandinsky has a voice because he understands the inner di-
mensions of the world, its "secret soul, [which is] inclined
more often to silence than to speech" (I, 361). In fact, he
holds both the power of interpretation and communication,
because the source and goal of his knowledge remain silent.
In his role as mediator, Kandinsky himself is very like the
Hegelian concrete universal. His universal or essential di-
mension is guaranteed by his soul's contact with the absolute,
which would otherwise remain mute, as it needs to be man-
ifested historically in the artist and an art form (abstraction)
in order to communicate its trans-historical message. Kan-
dinsky and Mondrian claimed that they "spoke" for spirit
merely as "pure instruments." Their goal was to make them-
selves and their art forms pure enough to accept and then to
communicate these pure, inner values. This end is what dis-
tinguishes all external considerations from the essential im-
port of the inner, what has aptly been called "spiritual
abstraction" versus "mere abstraction,"[76] which for both art-
ists is the despised realm of decoration.

"Artists of true art work in silence," (I, 98) Kandinsky
says, citing Gauguin's flight to the South Seas as one example.
This silence is a metaphysical quality of the soul, analogous

to Mondrian's ideal of "repose," the state in which no more apologies are needed, because perfection has been achieved. If Kandinsky is at all self-conscious about his own painting and writing, which he usually seems to be, then this call for silence can only suggest that his own pictorial and discursive work is finally only means by which we may return to the silence of the absolute. Unlike Plato, then, Kandinsky does not feel that "the painter's products... maintain a most majestic silence" (*Phaedrus*, 275D). On the contrary, he defends art against Plato's accusations in precisely the terms intimated in the *Republic:* art is not always silent (especially since it must defend itself), but it leads to the absolute, which is. Working "in silence" refers to the essentialist goal, not the material means; it is a corollary to Kandinsky's other metaphors for this, the ultimate justification of art: spirit, inner necessity, crystallization.

Kandinsky pictures his own artistic development as a search for a purer and purer language in which to speak for his silent partner, inner necessity, and to his mute audience, society. He holds that art is timeless but that individual forms must be mutable in order to respond to the demands of spirit. The question arises, then, of whether or not abstract painting needs to be subsumed in a yet higher form, and if so, what that form would be. Despite the potency of abstract painting, Kandinsky seems to conclude that spiritual development does require even stronger medicine; his prescription is the modern *Gesamtkunstwerk,* the synthetic product he deems "monumental" art (II, 509). The theater and what he calls the "old Russian" church are Kandinsky's prime examples of this ideal (II, 712). These expressions in effect circumvent the limitations of the individual arts like painting, whose "means of expression... are predetermined... and in essence, incapable of change" (I, 88). Here we see again Kandinsky's habit of dividing reality into the essential and the mutable, since painting, like every art, "is eternal and unchangeable... [but nonetheless] employs changing forms" (I, 89). Abstract painting has purified this form as much as is materially possible, so Kandinsky seeks to merge abstraction with other similarly purified arts to create a monumental synthesis that in its sheer inclusiveness empowers the soul to come even nearer to the absolute. As he argues in "On Stage Composition," an essay published in the *Almanac,* a synthetic art can "support and ... strengthen a particular sound of one art by the identical sound belonging to another art, thereby attaining a particularly powerful effect" (I, 259). This synesthetic collaboration

should not be thought to be less pure than one art working alone, however, because purity is determined by the goal, which is essence.

Kandinsky does not give a sense of what might follow his monumental abstract art or of whether or not this synthetic form is in fact to be thought of as the liminal, transitional art that *ends* art's history and begins a stage of spirit's progress that is less material. I believe that this Hegelian reading can be sustained with reference to Kandinsky and Mondrian alike. In a passage from *Point and Line to Plane,* for example, Kandinsky declares that there are "three basic kinds of connections between art history and the history of 'culture' " (II, 657). Art can be "subordinate" to the epoch, "opposed" to it, or, most significantly for our purposes, art even "oversteps the boundaries within which the epoch would like to confine it, [it then] predicts the content of the future" (II, 657). Abstract art has this transcendent power because it "frees itself from the oppressive atmosphere of the present" (II, 658) through its allegiance with the timeless noumenon. In its augmented, monumental form, abstract art still plays out a Hegelian and Platonic drama that seeks ever-purer manifestations of essence, and at least potentially, searches for a complete transcendence of mirroring through unification with this absolute. For Mondrian, art eventually melds with society and there is no more need (or possibility) for "questions." Kandinsky also seeks that state where silence prevails. Both artists characterized themselves as mere conduits for the articulations of spirit. But the rhetoric of purity through which they sought to become such instruments of eidetic communication has a strong absolutist bias. It is a metaphysical position with profound social and political implications that are anything but neutral.

PURITY AS
AESTHETIC IDEOLOGY

W E HAVE examined in some detail two crucial moments in the development of abstract painting, the late nineteenth-century Synthetist experiments in France and the definitive founding of abstraction by Mondrian and Kandinsky in the early twentieth century. The machinations of the rhetoric of purity and its attendant essentialist metaphysics link these innovations historically and, as I have argued, causally. My aim in this chapter is to evaluate more completely some of the central implications of this aesthetic. I will again use Mondrian and Kandinsky as my prime examples, but before turning to these figures, more needs to be said about the ideological nature of the notion of purity.

Purity as a rallying point is anything but monolithic, even within the abstract tradition I have focused on. Yet as a metaphorical shibboleth to a complex philosophy, the idea does establish a common though historically inflected core of meaning. The constant appeal to purity as means and end – its "rhetoric" – works, as we have seen, within an essentialist frame already constructed by the metaphor itself: "each time that a rhetoric defines metaphor, not only is *a* philosophy implied, but also a conceptual network in which philosophy *itself* has been constituted."[1] The conceptual network integral to purity as a functioning concept is what I call its "ideology." As such, it is not something added on to the articulation of abstract painting, like an explanation or demonstration, but rather a facilitating mechanism in itself. It is not the "theory" that can be separated from the "practice," since these categories were collapsed by the artists at issue here. Neither is this ideology simply a transhistorical (and thus ultimately ahistorical) framework for the elaboration of culture, the sort of "reality" – to cite one prominent exponent of this view, Louis Althusser – whose "structure and functioning are immutable,"[2] even though this supposedly secure stasis is

exactly what Mondrian and Kandinsky were seeking. Althusser's related claim that "there is no practice except by and in an ideology"[3] is substantiated by the example of the relationship between abstract painting and the metaphor of purity, providing that we stress the historical specificity Althusser points to by delimiting *an* ideology within a specific set of circumstances. As he also argues, ideology always has a "material existence,"[4] and this necessary incarnation comes with a context that cannot be abrogated. These points were crucial to our understanding of the specifically material appearance of the ideology of purity in painting, the focus of my first three chapters. Materiality, of course, creates tensions (at the very least) for the self-proclaimed Platonic, essentialist goals of pure abstract art, because purity was initially defined in this tradition as immaterial. As W. J. T. Mitchell has suggested, however, this particular vision of ideology is also rooted both conceptually and etymologically in a theory of *imagery,* as "ideas" are held to provide mental images upon which we draw.[5] For Plato, these images are ideally immaterial mnemonic imprints of the original Ideas; immateriality guarantees their purity as exemplars of absolute and universal truth. "Logos," the other root of ideology, reinforces the call for an unmediated access to the essential, because as we have seen in Plato's *Phaedrus,* the (spoken and heard, not written) word is argued to present the Ideas in their pure ontological presence. Because it is both mimetic and material, painting – like the written word – cannot, Plato seems to claim, yield such purity. Yet in spite of the apparent finality of this philosophical position, Plato and the series of apologists he inspired (including Hegel) do not proclaim the end of art simply because art involves materiality and the senses. On the contrary, art as the yoking of idea-logos *is* the concrete imaging of purity. Abstract art seeks to answer Plato by inventing a type of image that is mental because it has immateriality as its telos, but which nonetheless works through the material instrument of painting. Mediated mirror reflections of the pure Ideas in an appropriately if only metaphorically pure abstract art will thus (it is argued) lead to direct contemplation of and union with pure truth.

The subtext we have seen working in the plastic apologies for abstraction from Gauguin through Kandinsky ties their work directly to all these aspects of ideology. In addition, these experiments in abstraction adopt the revisionary mission belonging to ideology in Plato, the need to transform not only art, not only the individual, but also society in

general and especially in its political aspect. Socrates is the
model ideologue, as Mondrian discovered. Purity as an aes-
thetic ideology fundamental to the advent of abstract painting
therefore had ramifications for all aspects of the overall project
of essentialist art that Plato's philosophy inaugurated, for the
art "itself," its creation and embodiment, for art as a model
for society, and – closely related – for art as a more specifically
political force. In discussing each of these interrelated areas,
I will argue that purity unavoidably and, in the case of most
artists, unconsciously, entails aporias and indeed antinomies
that greatly affected the look, development, and meaning of
that abstract painting bent on becoming pure. In the first
section of this chapter – "Absolute Autonomy" – I will con-
sider two dilemmas that apply to abstract painting as it de-
velops its own material and theoretical practice, its claim to
absolute status (which runs afoul of its concomitant need for
evolution), and its claim to autonomy (which clashes both
with the definitive connection with a transcendent essence
and also with the need to lead society). This uncomfortable
intermingling of ideologies within the unresolvable dialectic
of the absolute and autonomy raises three important concerns
that I will discuss briefly: Mondrian's notorious refusal to
allow diagonals in his pure Neoplastic work, the psycholog-
ical and sociological motivations for the passionate adoption
of the rhetoric of purity by Kandinsky and Mondrian, and
the implications that this mode of pure abstraction has for
our understanding of Modernism itself. In the second section
– "Universal Exclusivity" – I will turn to another insur-
mountable paradox that stems from the attempt to have a
pure art perform a social function (as Plato demanded it do),
and ultimately to construct the ideal state. First, abstract
painting's role as a social instrument is jeopardized by the
fact that "art" for both Kandinsky and Mondrian is itself
transcended. The claim to social reform is also based in part
on another potentially damning paradox, that of pure paint-
ing's putative universality. This universality, however, is it-
self the product of a process of purification that is radically
exclusionary in ways that are historically determined. The
"feminine," for example, is held by Mondrian to be unsuited
for his (now dubiously) "universal" Neoplasticism. Finally,
we must question the characteristics of pure abstract painting
after it has achieved its goal. Both Mondrian and Kandinsky
claim that the state modeled on their pure art will be har-
monious, equilibrated, and free in its material, social, polit-
ical, and spiritual dimensions. But there is a price to be paid

for this aesthetic guarantee of metaphysical stability, for in establishing the "perfect" state, art must relinquish its previous role as an innovator, its difference from society at large that has enabled the leadership demanded by the essentialist tradition itself, not to mention by other visions of art's roles. "The new spirit" and new art, we read in the sixth issue of *De Stijl,* "is characterized by certainty, it does not question, it offers a solution. Human consciousness . . . expresses itself in art in such a way that – by creating equilibrium – it excludes every question."[6] Pure abstract art – notwithstanding its rejection by the ultimate twentieth-century doctrine of purity and of control in the arts, National Socialism in Germany – has the potential for authoritarian rigidity. These important themes are considered in the third, and last section, of this chapter, "Authoritarian Freedom." Their discussion will, I hope, keep us thinking about the potentially extreme and specifically historical consequences of the rhetoric of purity, both in its immediate mid twentieth-century context and (to cite Kandinsky), as its art "predicts the content of the future" (II, 657).

I. ABSOLUTE AUTONOMY

I have examined how experiments with abstract painting by Gauguin, Sérusier, Mondrian and Kandinsky were governed by their common adoption of an essentialist philosophy and practice. The purity of their work, each artist claims, is guaranteed by this essence for which they strive. Roughly synonymous with essence, then, the absolute is for them an immutable, perfect, and, of course, pure quality to which abstract painting can provide access. Mondrian and Kandinsky were especially self-conscious about the tension produced by what they saw – following Hegel and Schopenhauer particularly – as a need for this transcendental absolute to appear materially. Like the thinkers by whom they were inspired, these artists struggled with what Marcuse aptly describes as the "age-old philosophical question of realizing the essence in existence."[7] Their "solution," I have argued, closely parallels Hegel's image of the concrete universal. It is not my aim to decide whether or not the abstract artists succeeded in solving this philosophical conundrum with their new art. What I do want to claim – more modestly – is that they *tried* to resolve just this sort of problem, and that their attempt very decidedly controlled the choices they made in devel-

oping their non-mimetic expressions. It is in this sense, then, that their (supposedly transhistorical) plastic production is contextually determined.

The absolute had two main connotations for these artists, meanings that in their necessary combination created difficulties for the conception and execution of abstract painting. Because the absolute was on the one hand transcendent, beyond time and materiality, and therefore something to be sought after, it was also profoundly *not* found in the corporeal world. To get to this essence, change was necessary, and change had to be temporal. But in order to gain union with the transcendental absolute, material change had somehow to be *like* this absolute. Purity, as we have seen in examples from Plato, Plotinus, Swedenborg, Aurier, Gauguin, Sérusier, Steiner, Hegel, Schopenhauer, Mondrian, and Kandinsky, was posited as this crucial link, the definitive characteristic of the absolute in history. Hence the word "purity" is anything but an empty idea, since art, after purification, could mirror this ultimate reality; with further purification, art could lead the artist (and his public) to presence, to a meeting "face to face." Material change is therefore held to be part of this unchanging absolute because, as we have seen, the end defines the means of getting back, through memory, to pure presence. To recall just one example of this logic, Mondrian sees art's forms and its individual painted examples as evolving towards the static absolute of *relation*. As the De Stijl architect Oud put it, "Impurity in art... arises as soon as means are considered as aims."[8] The two hierarchically conjoined absolutes – transcendent and material – are defined and justified by this priority of ends and means in a way that implicates another concept central to the self-definition of abstract painting: autonomy.

Kandinsky and Mondrian claim that their plastic means are at once self-sufficient and merely keys to unlock higher understanding. Culturally, autonomy as defined by this self-sufficiency and the focus on "internal," formal concerns is a necessary part of the ideology of art as it is sustained during this period by the "institution" of Art in the broadest sense.[9] The importance of this definition of autonomy helps to explain why Mondrian and Kandinsky are at pains to elaborate the formal breakthroughs accomplished in their work. But Bürger's analysis of the ideology of autonomy remains partial, because purity as an equally powerful ideology within the articulation of abstract painting claims as its source and justification a noumenal referent that is explicitly meta-artistic

and beyond the individual. The metaphysics of purity leaves the abstractionists with the paradox of an absolute that must appear in what is by definition a tainted, material form; simultaneously, this doctrine also constrains them to look for ultimate purity beyond art as an autonomous category. In both cases, the paradox is somewhat diffused by the emphasis on the ranking of means and ends, but in both cases, too, this forces abstract art to deny frequently its existence as material. Thus Van Doesburg writes that "we abstract painters work more within our spirit than on canvas. When we start on the canvas, the worst of the work has already been done."[10] Mondrian endorses this view: "although born of the material, art remains basically hostile to the material. . . . The most profound art cloaks itself in the least capricious appearance" (153). The two artists thus agree that Neoplasticism should become pure by minimizing its attention to material means, but Van Doesburg also criticizes Mondrian for focusing on the abstract as a *static* and rigid absolute, for opting, as Van Doesburg saw it – and again, in tandem with thinkers on whom he based his theories[11] – for the ruling part of the hierarchy, for the fixed and immutable as opposed to the dynamic. As we saw at the beginning of Chapter 3, Kandinsky also characterized Mondrian as inflexible and narrow. The issues that stand behind these accusations were crucial to the development of De Stijl and they lead us to the importance of the absolute for Mondrian particularly. Mondrian's much-discussed use of the diagonal line in his compositions provides a focus for these concerns.[12]

Discussions about the role of diagonal and oblique lines in Neoplastic composition animated the members of De Stijl from 1918 until well after the loosely affiliated group dissolved in the early 1930s.[13] The intensity of the polemics involved suggests the importance of this debate. More than composition in its simple sense is at stake, for example, in Van Doesburg's outspoken remarks in a letter to Oud of June 24, 1919. Mondrian had proclaimed that Neoplasticism marked the highest achievement possible in the material realm, to which Van Doesburg answered by defending "the concept that we were a transition. . . . Everything is in perpetual motion! Mondrian is in fact a dogmatic."[14] The fundamental issue is the conception of the absolute, whether it is static (as Van Doesburg claimed Mondrian made it) or dynamic, as Van Doesburg held in his theory of "countercomposition" or "Elementarism." As we have seen, Mondrian claimed that orthogonal intersections could alone

express the truth of relation. He viewed change and dynamism as desirable within a system of right-angle intersections, but only as a means of expressing the immutability of relation itself. All of Mondrian's manifest interests in plastic movement – in painting, jazz, and dance,[15] for example – can be understood to operate on the level of instrumental plastic *means* with which he approached the absolute that in itself he conceived as unmoving, despite his claims to the contrary (which seem in retrospect to be rationalizations aimed at diffusing Van Doesburg's criticisms). As Mondrian's close friend Harry Holtzman writes, Mondrian was "an eternal optimist with undiminished interest in the dynamics of change."[16] The notion of "plastic," that which gives form, in Neoplasticism is itself a recognition of the need for change through art. This utopian optimism, however, is the key to understanding how it was that Mondrian could concurrently embrace change in his own work and long for a timeless absolute. Late in his career he could – to recall the Platonic subtext of which Mondrian was manifestly aware in this specific context – answer the question of "whether he felt the Greek idea of the perfect object, the *archetype,* was part of his search," by saying "that is what we are against, because that is the key to the classic and tragic finality from which we must free ourselves."[17] Though he seems to do the opposite, Mondrian here *affirms* that the "finality" of Platonism is his goal; what he denies is that art has as yet achieved this end. He wants dynamism in Neoplastic painting in order to free art and society from the "tragic" finality (that is, defeat – an appropriate sentiment during the early years of World War II, when Hitler's armies were occupying more and more of Europe) of complacency and individualism (the context, we should remember, for his notion of the "tragic"). As his essays concerning Soviet and Nazi oppression (to which I will return) demonstrate, even after being forced out of Paris and London by the German advance, he was still sufficiently optimistic to see as possible this transformation towards a perfect future in which no further questions need be asked.

Van Doesburg's early frustration with Mondrian's views stems from the latter's growing inflexibility regarding the use of the diagonal. As early as 1918, Mondrian himself participated in the plastic research into the potential of the oblique line: *Composition in Black and Grey (Lozenge with Grey Lines)* of 1919 (Fig. 9), for example, was one of four early experiments in which Mondrian is thought to have inscribed diagonal lines in a rectangular field and only spontaneously at

a late moment turned the composition onto a point to make a diamond within which the major lines intersect at right angles.[18] In "Natural Reality and Abstract Reality," of 1919–20 however, Mondrian focused on the orthogonal relation within a rectangular frame that he was also, and more consistently, investigating at this time. His initial openness to the possibilities of the diagonal evaporated at about this time, in part, it seems, because of his falling-out with Van der Leck – with whose work he associated the diagonal – over an exhibition.[19] Van Doesburg's letter to Oud corroborates this chronology. Mondrian's increasingly negative attitude was at least also partly responsible for Van Doesburg's articulation in the mid-1920s of his theory of Elementarism, a theory that explicitly condemned Mondrian's version of Neoplasticism in terms of the resistance to change and dynamism for which the diagonal had become the sign.

"Elementarism," Van Doesburg wrote with typical zeal, "advocates the complete destruction of traditional absolutism ... (the nonsense of rigid oppositions like ... man and woman, man and god, good and bad and so forth)."[20] As I have argued, Van Doesburg was not against the notion of an absolute in general but opposed its conception as static with Elementarism's "absolute notion of universal movement," (166) exemplified by the diagonal. Like Mondrian, Van Doesburg looks for the essential through art, but what he finds is a principle of perpetual vitalism instead of static perfection. Van Doesburg – who as we know was an avid reader of Hegel – envisioned an ongoing evolution, "a perpetual transformation" (160), of plastic forms; as a result, he had what Mondrian no doubt saw as the temerity[21] to claim that Elementarism defined and then developed Neoplasticism (157), whose "established equilibrium [was found to be] a dead end" (154). Where Van Doesburg argued that "there are no objective and absolute laws, independent from the ever deepening and changing vision (laws which, if they existed, would cause a stultifying dogma),"[22] Mondrian replied in the essay "Home – Street – City" of 1926 by reiterating that there "is only one road" to the "pure equilibrium" of the future: the *"pure plastic means"* that he spells out through six Neoplastic "laws" (209). Thus the nature of the absolute as embodied in painting is the specific, material battleground for the interpretation of purity. Not surprisingly, the "oblique" is castigated as "naturalistic and capricious," in contrast to the "perpendicular position" that uniquely expresses "the immutable in contrast to the mutable" (210). Because he defined

the absolute as fixed and the diagonal line as dynamic, Mondrian was led by the purity of his own working philosophy to exclude the oblique in favor of orthogonals. Concomitantly, since he saw the need for continued plastic and extraplastic evolution towards this absolute, he could not tolerate the notion of art as an autonomous entity concerned with its own ever-changing definition. His dedication to the abstract as a particular sort of absolute thus very much controlled the choices available in his Neoplastic expression, and, as we will see in the later sections of this chapter, produced more aporias. Before examining further his self-imposed predicament, though, it is time to ask *why* Mondrian (and Kandinsky, as we saw in Chapter 3) so consciously – even in the face of internal paradoxes and articulate challenges – continued to employ an essentialist rhetoric of purity committed to the union with a fixed absolute beyond the realm of art. We can answer that both men pursued their research under the auspices of theories that entailed precisely this search, but what personal and societal phenomena occasioned their sympathy for such ideas?

The theoretical coordinates of essentialism – whether in the work of a thinker like Plato or as adopted by an artist such as Kandinsky – can be seen to stem from personal and social pressures more fundamental than the demands of philosophical rationality that guide the development of a position once it is set in motion. George Steiner has coined the felicitous phrase "nostalgia for the absolute" to encapsulate this pathological striving for "total explanation."[23] What he describes is the need for metaphysical and religious certitude that characterizes the Western philosophical tradition. Steiner claims that "mythology" satisfied this desire in ancient times by meeting the following criteria (each of which is also met by the purity of early abstract painting): having "a claim to totality," demonstrating a recognizable beginning and development that is "preserved" by canonical texts and authentic disciples, and finally, adopting its own language. Ancient mythology was, through a process of purification, in part transformed by Plato and Aristotle into philosophy,[24] and enlisted as doctrine in systematic religions, thus perpetuating this "hunger for the transcendent."[25] According to Steiner, however, these traditional guarantees of security have lost their authority in recent times: thus "the political and philosophic history of the West during the past 150 years can be understood as a series of attempts to fill the . . . emptiness left by the erosion of theology" and similar explanatory

systems.[26] On an admittedly general level of analysis, the artists who pioneered abstract art exemplify precisely this attempt to sate a metaphysical thirst for certitude – a thirst initiated to a considerable extent by specific personal, social, and political instability – by promoting the essentialist rhetoric of purity.

Before examining some of the psychological and social background to these artists' often unconscious choice of essentialist doctrine, I want to investigate further the theoretical implications of their metaphysical nostalgia, implications that are inextricable from the production and meaning of abstract painting in this tradition and which help to focus our attention today on the lasting importance of memory as we in turn consider the history of abstract painting. The rhetoric of purity is a profoundly metaphysical discourse that seeks through abstract art to return the artist (and the work's audience) to an absolute that is by definition original and unassailable. Platonic memory is frequently the vehicle for this return: as Mondrian writes in "Natural Reality and Abstract Reality," for example, looking at Neoplastic paintings, one feels "nostalgia for the universal, for the most profound part of himself" (120; italics removed). Remarkably, he supplies what we might call an eidetic psychology as an explanation for his nostalgia: "the relativity, the mutability of things creates in us a desire for the absolute, the immutable" (178). This desire is always for an original and thus certain quality of purity that is sometimes explicitly religious, as in the case of Mondrian's invocation of the Garden of Eden as a perfection to which Neoplasticism can return us (211), or Kandinsky's use of apocalyptic imagery from the Bible as a metaphor for abstraction's curative power, and sometimes seemingly more mundane – as in Kandinsky's appeal to the purity of children's and "primitive" art.[27] More frequently, however, the desire is best described as a philosophical[28] discourse that "glorifie[s] the invariant at the expense of change," and whose ontological "security is measured by certainty of knowledge [which in turn] . . . is measured by adhesion to fixed and immutable" laws.[29] This return to the supposed safety of timeless origins is, of course, characteristically Platonic, as is the nostalgia attendant upon the difficulty of this return in the face of metaphysical desire.[30] It is just this sort of security to which Kandinsky and Mondrian aspire by calling for an "absolute"[31] painting based on what they claim is the originary purity of abstraction.

Why, then, did the early abstractionists choose this pallia-

tive metaphysical doctrine? To adumbrate an answer first on a general level, I think we can understand their sympathy for the invocation of purity in art as an example of what Susan Bordo calls a "response to anxiety," a "flight" from turmoil to an absolutist answer.[32] Systems offering metaphysical certitude have frequently been the response to inner and outer instability, as in the case of both Plato and Descartes.[33] Such systems – and here Schopenhauer, Hegel, and Husserl are typical – also consistently create a hierarchy between absolute knowledge and certitude, deemed "pure," and everything else, which is by definition corrupt, a status often attributed to the body and other material "fetters." As we have seen throughout the development of abstract painting, "for these 'privileged representations' to reveal themselves, the knower [too] must be purified."[34] Purity and purification are, in short, powerful tools for organizing and controlling otherwise inchoate experience. This need for security and intelligibility is seen by the anthropologist Mary Douglas as basic to human behavior. Purity's emphasis on "separating, . . . demarcating and punishing transgressions," she writes, "function[s] to impose system on an otherwise inherently untidy experience. It is only by exaggerating the difference between within and without, above and below, male and female, with and against, that a semblance of order is created."[35] These hierarchical distinctions characterize the essentialism that structured the advent of abstract painting. If, following Bordo and Douglas, we can assert that the need to order experience through an appeal to purity is especially urgent in moments of crisis, then it is not difficult to see why Kandinsky and Mondrian, despite their differences as individuals and artists, looked to this essentialist tradition. In addition, Kandinsky in particular had an immediate source in Worringer for just this sort of thinking. "The urge to abstraction," he wrote, "is the outcome of a great inner unrest inspired in man by the phenomena of the outside world; in a religious respect it corresponds to a strongly transcendental tinge,"[36] to what George Steiner calls nostalgia for the absolute. This flight to purity is of course not a necessary response, but it was remarkably widespread during the lifetimes of these artists, both as a reaction within art and also – with chilling results – in the not unrelated political arena, with the Nazi "solution" of genocidal racial "purification," to which I will return.

Mondrian's Neoplasticism is a prime example of aesthetic control in response to a deteriorating social and political sit-

uation.[37] It is not, however, an "escape" into formal aestheticism, because Mondrian saw his art as a "pure instrument" (115), a social agent able to transform the world for the better. The same is true of Kandinsky; witness his condemnation of art for art's sake. Abstract art's absolute status guaranteed its ability to lead society, but only after it had purified its own means. Hence the double and contradictory emphasis on a transcendent absolute end and art's autonomous means. The reformative mission of De Stijl can easily be seen as an anxiety response, since the movement was conceived during World War I very much as an answer from the politically neutral Netherlands to the major European powers' seemingly inevitable hostilities. Mondrian held a privileged position in the eye of the storm. As an initiate into "pure vision," however, he felt estranged both aesthetically and politically even in his own country. For the rest of his life, he existed – intentionally, from accounts of his aloof personality – on the margins of society, an existence very like the enlightened prisoner in Plato's allegory of the cave. In terms of the evolution that Mondrian proclaimed for civilization, he was himself located liminally between the old traditions and the "new man." The precariousness of this status is mirrored – or perhaps to some unmeasurable extent caused – by his movement from the Netherlands (where he was required by surrounding conflict to stay during W.W.I) to France (from which he eventually fled because of the German occupation in World War II) to England (where the house next to his was bombed in the blitz) and finally to the United States, his shuttling among Dutch, French, and English as languages and cultural norms. The only constant was Neoplasticism, and he literally surrounded himself with its principles, making art into life itself, as he frequently said.[38] Echoing Plato and thus underlining the parallel between the philosophical and social in the rhetoric of purity, Mondrian wrote – with a mixture of pride and regret – that "the new art finds itself a *stranger* to that from which it was born. This is the phenomenon of all life" (246; emphasis added). In his essay "Realist and Surrealist Art: (Morphoplastic and Neoplastic)," 1930, Mondrian reveals the exalted but thus marginal place of the enlightened Neoplastic messiah in terms of Platonic and Neoplatonic light metaphysics whose prime classical antecedent is again the allegory of the cave. As in "Natural Reality and Abstract Reality," he makes this myth of pure vision autobiographical by writing about a "landscape painter" whose uncertainty gives way to absolute knowledge:

At dawn, night still prevails. The feeble light seeks to overcome it. One feels the oppressiveness of disequilibrium, night-day, light-dark. It is the aspiration to equilibrium. Hope-despair. Absence of certainty. Waiting for day-light (228).[39]

What seems like a practical, if poetically compressed, description of the landscape painter's work *en plein air* turns out to be the articulation of a theoretical position with a long heritage, just as it did when Mondrian constructed the elaborate fiction of painting an actual landscape in "Natural Reality and Abstract Reality." Like Gauguin, Mondrian may not have had any students in the academic sense,[40] but he was a pedagogue in the Socratic line, a good physician who exemplified truth through the "purity" of his life, even if this meant going against contemporary aesthetic and social mores and thus living in a state of tension, like a Socratic gadfly. In an immediate sense, this marginal existence and the art it allowed Mondrian to produce was necessary to keep the "mirror" clear, to develop that purity of vision that allowed him to see through nature's veils: "the purer the artist's 'mirror' is, the more true reality reflects in it," he wrote in a late fragment (367). Mondrian's ideal is an art of essence, a non-mimetic art that obviates mirroring – representation – altogether.[41] The security that this revealed truth in turn offered was even more fundamentally necessary to control and ultimately ameliorate a societal situation whose precariousness necessitated Mondrian's peripatetic existence.

Kandinsky's self-definition as the spiritual leader struggling amid external (social and political) and internal (spiritual) chaos is even more explicit, and he had equal reason to adopt an essentialist philosophy of purity as a controlling mechanism. Like Mondrian, he was by choice and then circumstance alienated from his own country; similarly, too, he made this into a virtue, into the entitlement of the initiate and exile. As early as 1910 – as I noted above – he extolled those producers "of true art [who] work in silence and are unseen" (I, 98), because they are misunderstood innovators who were either forced to abandon their homelands – like Gauguin – or who "hid" like Cézanne. Having thrown off the shackles of materiality, abstract artists may enjoy enlightenment, but they are mocked when they return to the shadows of their former societies. Thus the uneasiness stemming from witnessing, as he did, the 1885 student riots in Moscow, for example, can be sublimated into the virtue of privileged marginality within an essentialist philosophy. One can assume the mantle of a spiritual savior who works through

society's forms towards a utopian future, even when (as I argued in Chapter 3) the immediate cause of one's concern is the study of Russian peasant law's absolutism. In *On the Spiritual,* for example, Kandinsky constructs the entire third section ("Spiritual Turning-Point") through the metaphor of insecurity and fear characteristic of the lower reaches of the evolving spiritual triangle yet magnificently absent at its apex, where there is *"no more fear"* (I, 142). For Kandinsky personally, solace from prerevolutionary rebellion in Russia was found in the unique inner absolutism of peasant law, as he recalls in *Reminiscences.* When he returned home after the 1917 revolution, his aim as president of Inkhuk was "to find the eternal in the transient" (I, 472), to seek essence through art. Back in Germany in the 1920s, Kandinsky reflected the optimism of the Weimar Republic[42] even during the rise of National Socialism. Washton-Long suggests that the main cultural direction during the Republic was both antimaterialist and socialist. The contemporary art critic Herbert Kühn, for example, linked Expressionism and Socialism in terms that must have seemed like a fulfillment of Kandinsky's projects for art education. Kühn argued that both Expressionism and Socialism desired "humaneness, unity of the spirit, freedom, brotherhood of the *pure human.*"[43] The certainty of abstract expression continued to be Kandinsky's way to this utopian goal throughout his Bauhaus years, even though National Socialism closed the Bauhaus and forced him to flee to France. Here, again an émigré, he lived quite comfortably on the outskirts of Paris even while France was besieged and then occupied by the German forces. As what he defined as the political situation worsened, Kandinsky honed the purity of his abstraction. Political quietism overtook what has been described as his "generally liberal social outlook."[44] It is too easy to condemn this lack of "engagement" from the safety of the present, but I do want to argue in this context a point to which I will return later in this chapter, namely, that Kandinsky's retreat from contemporary politics is a direct result of the supposedly apolitical options offered by his essentialist philosophy. In a 1926 Bauhaus essay called "The Value of Theoretical Instruction in Painting," he criticized Neue Sachlichkeit's social and political agenda as "the ultimate in confusion" (II, 703). For him, all of present history was conveniently "external." If one wanted to make a difference in society through art – as Kandinsky passionately did – "inner" values had to be the focus. Abstract art distilled such values; since its metaphysics justified day-to-day political abstinence

in the name of the future improvement of the polity, this
new art may have been a rationalization for what amounts
to complicity with authoritarian politics, but it was not a
simple escape into the supposed autonomy of art's inherent
concerns. Essentialism and its attendant purity is a highly
politicized position. But a paradox remains, for as an external
absolutism bore down on Kandinsky, like Mondrian, he "re-
sisted" by comforting himself with an aesthetic of purity
whose absolutism was merely latent.

The tension between the demands of a transcendent ab-
solute and art's autonomy raises important questions about
the place of the purity of abstract painting within a definition
of Modernism in the visual arts. To discuss the issues of
Modernism in detail would, of course, take volumes, and it
would take us away from the central arguments of this book.
Without pretending to offer a new definition of this vexed
term, then, what I do want to suggest is that the essential-
ist purity that defined the advent of abstract painting pre-
sents us with a dimension of the Modernist enterprise that is
not adequately explained by either of the predominant para-
digms of this movement. At the risk of reducing complex phe-
nomena to a crude opposition (a strategy that is, however,
quintessentially Modern),[45] we can distinguish Clement
Greenberg's influential arguments about the "purity" of art's
unique means and materials on the one hand from the fre-
quent claim that Modernism is best characterized by the
avant-garde's interventions into social and political praxis on
the other.[46] If we can call these two tendencies the formal
and political respectively, it can be seen that the essentialist
purity of abstract painting attempts initially to partake of
both: its research into art's means is decidedly formal and it
applies discoveries in this realm to the project of leading and
changing society at large. What sets the purity of essentialist
abstraction apart from either of these practices, however, is
its ideal of an obsessive self-mortification, its sublation not
only of its own materiality (now seen as merely instrumental),
not only of its medicinal role within society as the desired
changes come to pass, but its complete forgetfulness and
transcendence of its own institutional status as art. Let us
look at this process one step at a time.

Greenberg addresses the issue of purity in art compellingly
in two early essays, "Avant-Garde and Kitsch" of 1939 and
"Towards a Newer Laocoon," 1940.[47] He argues in the earlier
essay that art's move into the search for a pure, self-reflexive
absolute was an historical and social strategy, an attempt to

"find a path along which it would be possible to keep culture *moving* in the midst of ideological confusion and violence" (I, 8). The emphasis on purity, however, causes the arts to be "hunted back to their mediums, [where] . . . they have been isolated, concentrated, and defined," as he puts it in the "Laocoon" article (I, 32). "Purity in art," then, "consists in the acceptance, willing acceptance, of the limitations of the medium of the specific art" (I, 32). The social context of this powerful idea, however, is almost erased in Greenberg's later writings in favor of what has come to be seen as his preoccupation with the formal "essence"[48] that defines purity. Thus in "Modernist Painting" of 1965, Greenberg writes that

the unique and proper area of competence of each art coincided with all that was unique to the nature of its medium. The task of self-criticism became to eliminate from the effects of each art any and every effect that might conceivably be borrowed from or by the medium of any other art. Thereby each art would be rendered "pure," and in its "purity" find the guarantee of its standards of quality as well as of its independence.[49]

Kandinsky and Mondrian seem at first to fit Greenberg's definition of purity exactly. "Gradually," claimed Kandinsky in *On the Spiritual,* "the different arts have set forth on the path of saying what they are best able to say, through means that are peculiar to each" (I, 153). And in "Natural Reality and Abstract Reality," Mondrian wrote that the "New Plastic . . . [is] an end in itself" (93). But if we follow either of these quotations just a little further, we see that both artists immediately make the autonomy of their art relative to a transcendent absolute. Kandinsky writes: "Consciously or unconsciously, artists turn gradually toward an emphasis on their materials, examining them spiritually, weighing in the balance the inner worth of those elements" (I, 153). As we know, the inner and spiritual are his ultimate goals, and he emphasizes this in the same passage with a reference to Socrates's inner knowledge. Thus what for Greenberg is a "pure" component like form is to Kandinsky "always temporal, i.e., relative, since it is nothing more than the means necessary today" (I, 237). The same is true of Mondrian, as we realize when we see the passage cited above in context: "The New Plastic, although an end in itself, leads to conscious universal vision" (93). Greenberg reduces the absolute sought by purity to a quality particular to the art in question. "Picasso, Braque, Miró, Kandinsky, Brancusi, even Klee, Matisse and Cézanne derive their chief inspiration from the medium they work in," (I, 9) he claims. But his list is too inclusive. Kandinsky

and Mondrian were careful to separate themselves from Cubism and both wrote against the principles of Surrealism. Their interest in the medium – despite the remarkable physicality of paintings by both these abstract artists – was ultimately subordinate to a transcendental rather than imminent guarantee. And perhaps most tellingly, both artists clearly and without any sense of contradiction sought to expand the parameters of painting into the modern *Gesamtkunstwerk* that Mondrian foresaw in Neoplastic architecture and which Kandinsky called "monumental" art. Their enterprises were synthetic, not reductive in Greenberg's sense. His paradigm of aesthetic purity is a powerful interpretive tool when applied to a movement like Cubism, but it cannot adequately account for the essentialist purity of early abstract painting.

Bürger contends that the "avant-gardistes proposed the sublation of art – sublation in the Hegelian sense of the term: art was not to be simply destroyed, but transferred to the praxis of life where it would be preserved, albeit in a changed form."[50] Early abstract painting proposed just this, but in its search for purity beyond the material world, it cancelled the Hegelian *Aufhebung* on which it depended for its temporal evolution. As in Hegel, art transcended itself as material and overcame its role as a reforming opposition within society, but unlike Hegel's system (where the extent to which art as a form of Spirit's self-consciousness is recalled as Spirit progresses is certainly in question), higher forms of consciousness do not remember their otherness as art. Kandinsky makes it clear in his experiments with theater and music – his monumental art – that he seeks "direct, inner contact" (II, 532) with what he calls the "divine." This return to the fundamental, spiritual nature of art results in a melding with the absolute that negates art's very separateness from other aspects of reality. Art does not manage to remember its status as the material incarnation of spirit's search for perfection once that perfection has been reached. This is even more clear in Mondrian. He characterizes Neoplastic abstraction as a "direct plastic expression of the universal" (42; italics removed) and actively looks forward to the time when "painting merges into reality itself" (116). At this point, there would be no more need for art, no more need for it to purify its plastic means or for it to transform society. Perfection, it is argued, is the point at which no more questions need be asked. It is a state of "silence" for Kandinsky, of "repose" for Mondrian. The essentialism of early abstract painting thus augments the definition of Modernism to include an art that

is not finally about itself nor that tries to change society. Modernism's purity is in part the ultimate Hegelian negation[51] – the dialectical overcoming of art as a category – which in turn for the artists involved is the most exalted achievement open to the aesthetic. Theirs is at once the ultimate apology to Plato's condemnation of art's weakness and the supreme fulfillment of his dream to obliterate art's disturbing ability to upset his perfect, static worldview.

II. UNIVERSAL EXCLUSIVITY

Both Kandinsky and Mondrian envision an art that in its purity is able to reform society. We have seen that this social role depends on two factors that do not always work harmoniously together: to be a social force, art must declare its autonomy as a separate phenomenon. At the same time, its very denotation as *pure* depends on a transcendental absolute that denies art's materiality. And a third problematic requirement emerges when we investigate how it is that these artists plan to improve their society. To overcome the vagaries of what Mondrian calls the "individual" (the "external" for Kandinsky), art must be universal; through purification it must achieve essential truth. Mondrian asserts that

Pure plastic vision must construct a new society, just as it has constructed a new plastic in art – a society where equivalent duality prevails between the material and the spiritual, a society of equilibrated relationship (99; emphasis omitted).

He explains that the metaphysical and practical pedigree of Neoplasticism gives it this privileged responsibility to lead: "only *pure plastic* has the power to 'show' things 'as they are.' Neo-Plasticism . . . clarifies and purifies; it can influence the whole of life because it is born of life's totality" (151). Kandinsky makes similar claims for abstract art's heritage and its mission in society. Both artists see their work as a plastic "language" with which essences can be communicated, but again, the "voicing" of this language – abstract composition – is but a means with which to overcome language, to achieve the silence of purity. This material language was to be universal in the sense of being the absolute truth and in the sense of being completely intelligible. As it did for Plato in the *Philebus* (51 C), Euclidean geometry frequently provided the model.[52] This is certainly true for Sérusier, as we have seen, as well as for Mondrian's devotion to the right angle inter-

section and Kandinsky's use of the triangle as metaphor and image. Yet for Mondrian and Kandinsky, even such pure imagery remains merely instrumental within the hierarchy of essentialist values. As art's social effectiveness is realized, "as the new culture evolves," Mondrian argues, "all philosophy and all art will gradually become superfluous" (221). The "path ahead" along which the spiritual triangle moves, according to Kandinsky, "lies in the realm of the nonmaterial" (I,141). "Nonmaterial consequences" alone have value (I,444). The process of radical purification of art and self initiated by the rhetoric of purity precisely so that art could have beneficial social consequences thus yields the paradoxical result of erasing art's difference from that which it hopes to improve. Art loses its defining alterity as it blends with society. As art becomes universal, it effectively disappears. Purified of its defining relationship to the goal of social change, its potential for critique is occluded. We have seen the import of this sublimation of art's social role in *Reminiscences,* where Kandinsky veils a reference to art's self-image as critique with a discussion of "individual initiative" during the student uprisings of 1885 in Russia. "Every individual (personal or collective) action is productive because it undermines the stability of our form of existence. . . . It generates a critical attitude toward accustomed phenomena," and thus makes change possible (I, 361–2, n.). The project of abstract art depended on this potential for criticism, and this potential in turn relied on art's difference from that which it sought to change. By losing itself in purification, art becomes an indistinguishable part of a perfection where no more leadership is needed and no more aesthetic undermining is necessary. But what would this universality be like?

Its extreme form is found in Mondrian's aesthetic, which, although closely analogous in structure and design to Kandinsky's, is more radical and less flexible both conceptually and in its plastic realizations. Mondrian posits a rough equivalence among the notions of the universal, the absolute, and essence (31; 42). All are exemplified by purity, and as discussed above, all search for metaphysical security. Because this security must (according to what is a very widespread argument in Western metaphysics) come from an absolutely fundamental quality, the mechanism of attaining universality is inherently one of purification. "Philosophy most typically aims at *a priori* knowledge in possession of which . . . all contingent exposition should simply drop away."[53] In the cases of the prime exemplars of this emphasis on certainty – Plato,

Descartes, Kant, Husserl – Norris goes on to claim, "philosophy wills itself into being by an act of *exclusion*."[54] As some degree of exclusion is necessary to any form of thought or art, we need to ask all the more *what* is excluded. The extreme process that I call purification is at the root of the essentialist achievement of the universal, which claims the right to erase any particulars. The universal in pure abstract painting claims to derive from plastic research into such pure methods and to be both metaphysically fundamental and globally intelligible. Far from being a deductive and inclusive principle, however, its purity stems from the exclusion of traditional subject matter, nonprimary colors, and diagonals (in Mondrian's case). Innumerable artists are also excised from the history of art in the name of purity. In short, for Mondrian especially, "totality is no longer the conclusion but the axiom," as Herbert Marcuse says with reference to the universalizing urge in general.[55] This is not to suggest that there were no changes in Mondrian's thinking or art, but that this change, "dynamic equilibrium" as Mondrian often called it, was for him always a way to a perfection that, if realized, would transcend art. Both Mondrian and Kandinsky seek to rise above individuality; licensed by their initiation into superior knowledge, throughout their careers they claim for abstract painting the role of physician to society. They claim that their mission has as its only interest society's improvement. But the ideological commitments of the rhetoric of purity manifest themselves as soon as we realize that Mondrian's "society of equilibrated relationship" (99; italics omitted), for example, is built on exclusions rather than reciprocity. If equilibrium rules in his ideal art and in the society that this art models, we must remember – to adapt Orwell's warning – that some are more equilibrated than others.

The most excluded principle and individual of all is the female. Her purification in Mondrian's work is a microcosm of his entire aesthetic and offers us an excellent vantage from which to assess the implications of his essentialist enterprise. Mondrian theorized about the inferiority of the feminine in some of his earliest writings and devoted the lengthy and concluding sections of his first major statement of the axioms of Neoplasticism, "The New Plastic in Painting" (1917), to a detailed defense of what we might call the intrinsic "maleness" of abstract art. He seems obsessed with the relation between male and female in the aphoristic comments of the 1912–14 *Sketchbooks,* notes that constitute the seeds of his later

art theory. "Woman is against art, against abstraction... in her innermost being," he announces.[56] Try as she might, a woman is "never completely an artist" (34) because her defining feminine principle, Mondrian holds, is passive, form-receiving "matter" or material, whereas the male is imbued with "force" that shapes this material according to higher principles (24). In "The New Plastic in Painting," Mondrian reveals his authority for these lamentably conventional views. "Ancient wisdom," he tells us, equates the female with the physical and natural and the male with spirit, intellect, and – crucial in this context – with the universal (56, n. "g"; 57, n. "l"). This ancient tradition is Greek and specifically Platonic and Aristotelian, and in Mondrian's case it was very likely transmitted by Theosophy. But Mondrian does not only follow this tradition; he involves himself with it with an energy sufficient to add the novel claim that woman also embodies "tradition," both in its general cultural sense and in the visual arts specifically (57, n. "l"). Thus the female principle, which he sometimes distinguishes from the biologically female by claiming that women and men have both female and male principles in their makeup but at other times literally (and damningly) equates with mundane women, works for Mondrian as the initially negative pole within an unbalanced economy searching for equilibrium. The feminine is the outer that opposes the male's inner values, it is material where the male is spiritual, plastically, it is horizontal (like the earth) where the male is vertical (aspiring to the Divine). With a quintessentially Hegelian flare, however, Mondrian argues that this "negative" opposition provided by the female is actually *the* positive precept in the dialectic of spirit's evolution, as it stimulates the male to transcend the material altogether:

In our time, oppression by the female, a legacy of the old mentality, still weighs so heavily on life and on art that there is little room for male-female equilibrium. As *tradition,* the female element clings to the old art and opposes anything new – precisely because each new art expression moves further away from the natural appearance of things. Consistently viewed, the female element is hostile to all art on the one hand, while on the other it not only realizes the art-idea but reaches toward art (for outwardness reaches toward inwardness). It is precisely the female element, therefore, that constructs art, and precisely its influence that creates abstract art, for it most purely brings the male to expression (68–9, n. "l").

Eve is necessary to Adam, as Mondrian notes, lending Biblical authority to his views, and like Adam, Mondrian is gen-

uinely nostalgic for what he envisages as the equilibrium of prelapsarian unity. But with this essentialist nostalgia comes the indelicate, exclusionary mechanism of purity. "For in the beginning everything was good and became debased only during the culture of particular form in which everything became particular. Universality was lost: it must be re-created," Mondrian wrote in a fragment of c. 1938 (363). Even near the end of his career, then, his familiar method held: "we must reject nothing of the past but must purify everything" (363). His prime target of course is the material, individual, *female* principle for which – despite the seeming generosity of his dialectical cancellation of the negativity of the female – he harbors venomous scorn: "the feminine and material rule life and society and shackle spiritual expression as a function of the masculine. A Futurist manifesto proclaiming hatred of *woman* (the feminine) is entirely justified" (137).

Mondrian's longing for the security[57] of a unified male-female echoes Plato's description of the creation of man and woman in the *Symposium,* the myth of the androgyne or hermaphrodite.[58] Hoek has suggested that Mondrian's frequent use of the oval format during his experiments with Cubism relies more on his interest in this myth and its reverberations in Plato, the Hindu Tantra, Theosophy's "world egg," and Rudolf Steiner's notion of evolution, than on its use by the French Cubists.[59] I would go even further to claim that Mondrian's indisputable interest in the androgyne as an ideal forms a decidedly Platonic basis for the hierarchy of male over female that underlies his misogyny, and that his exclusion of the female principle in his plastic research is an integral part of his ruthless purification of self, art's tradition, and (ideally) society, a purification that can be seen as nothing short of an aesthetic eugenics based on the discrimination of gender.

Mondrian arrives at this dubious position in the extensive notes to "The New Plastic in Painting." "*Fully human* life . . . needs both outwardness and inwardness, female and male. Life's most perfect state is *the most complete equilibrium of the two. . . .* It is important to realize," he goes on to assert in a passage that is very probably a direct reference to the *Symposium,*

that perfect equilibrium of female and male presupposes that the two have attained equal degrees of *profundity*. *Profundity,* because the relatively outward female and relatively outward male constitute an *outward* duality and thus cannot constitute true unity. This is seen in the unhappy situation of the relatively physical herma-

phrodite, [who is] . . . the unity of an *apparent* duality, while the spiritual hermaphrodite (the ideal of the ancient philosophers) is the unity of a *real* duality (67, n. "f").

In the *Symposium,* Aristophanes entertains his audience with a description of the "real" nature and origin of "man" (189 E).[60] "Besides the two sexes, male and female," he explains, "there was a third which partook of the nature of both, and for which we still have a name . . . 'hermaphrodite' " (189 E). This "half male and half female" being was "round" in shape originally, and had a double complement of all bodily parts (189 E – 190 A). Zeus, however, split these ideal units into two, creating the two sexes we now know. What he also created was a nostalgia for sexual reunification that is analogous to the desire the soul has for the Ideas: "the work of bisection . . . left each half with a desperate yearning for the other" (191 A), a desire that Mondrian seems to have inherited, given the evidence of his praise of the "spiritual hermaphrodite." Mondrian borrows from Plato the ideal of the supposed equality of the sexes in the hermaphrodite. In attempting to return to this pure, equilibrated state, however, he is compelled by his notion of purity as the immaterial and by his conception of the feminine as material to purify the female principle of its sexuality in order to realize his ideal duality. The male principle – the universal, essential, form-giving, abstract – is defined as spiritual, that is, above the materiality of physical passion and procreation, and is thus always predominant in the dialectic of equilibration. "Harmony" is achieved precisely because purification proceeds hierarchically by excluding what is held to be the female element.

Inflammatory though the term eugenics might sound, when we remember the experiments designed to produce a pure Aryan race carried out during World War II and Hitler's concomitant program of purifying German art (to which I will return in the final section of this chapter), Mondrian's retrospective, pure version of his own heritage as an artist and of the genealogy of Neoplasticism, exercises a control over these histories that is explicitly sexual. His condemnation of the feminine does not apply only to individuals or even just to the material ingredient in society and art: because the female is equated with tradition itself, this censure covers the entire history of art up to the advent of his abstract painting. In fact, he claims, "representation of *any* kind, the *portrayal of any aspect of nature, whether landscape, interior, still life, etc.,* can be defined as *predominantly female*" (69). Thus when

Mondrian looks back at his forbears as he constructs the prehistory of abstraction – as we saw him do in "Natural Reality and Abstract Reality" – they are all "female" in the sense that they must be purified: "we must . . . purify everything" (363). By constructing a genealogy of purified females like Cézanne and the Cubists, he in effect controls the "breeding" that the evolution towards pure art must promote, the mix of influences and models embraced. The "new man" will thus be born by purifying the feminine. He dedicates this work "aux hommes futurs" in his 1920 essay "Le Néo-Plasticism," and, I would argue, thus attempts to guarantee that they inherit a properly pure and static equilibrium. This dedication might seem to some as harmless, utopian enthusiasm for a different but fleeting *style* or trend in art, abstract painting. A critic as informed as W. J. T. Mitchell, for example, assures us of "the obsolescence of abstraction" today, of its secure reification as "a monument to an era that is passing from living memory into history."[61] His view fits comfortably with the widespread opinion that art is largely decorative, that it is less important and even less "real" than society writ large. But can Mondrian's ideology and material practice be neutralized so effortlessly? I will argue that they cannot, specifically because the discourse – and by using this linguistic term I agree with Mitchell's larger argument that "the meanings of [abstract] paintings is precisely a function of their use in the elaborate language game that is abstract art"[62] – that he fathered has established a masculinist frame for abstract painting *and* because what I see as his control over the inheritance of abstraction continues not only in painting, but as he hoped, pervades culture generally.[63]

Mondrian's discourse returns us yet again to Plato, to the Plato who recommends eugenics in order to secure the stability of society,[64] and who also proclaims in the passages from the *Phaedrus* that we examined in Chapter 1 the need to maintain a pure, explicitly male line of inheritance through the spiritual intercourse of master and pupil.[65] In denigrating writing in the *Phaedrus,* Plato complains that this mnemonic device would allow anyone to gain knowledge, to become an initiate. This would undermine the controlled transmission of wisdom between a good physician and an ideal student, between Socrates and Plato, for example.[66] This patriarchal and hierarchical exchange also typifies the development of abstract painting in a practical way, as in Gauguin's instruction of Sérusier. Mondrian also ensures the male purity of abstraction's inheritance, not by censoring writing or paint-

ing as a generic activity – he could hardly proscribe the ve-hicles of his own critique – but by making sure that the female, material part of this art is conveniently transcended. Mondrian keeps the line pure for the men of the future. What he also does – duplicating the pattern discussed above with reference to the absolute in art – is condemn this future art to a static, undifferentiated "perfection." Mondrian needs the opposition of the female, just as abstraction as an abso-lute needs materiality for its own evolution. Mondrian's essentialism also entails this "progress" from change to im-mutability. In the *Metaphysics,* Aristotle codifies a list of op-positions that had characterized Greek philosophical reflection for centuries: "limit and unlimited, odd and even, one and plurality, right and left, male and female, resting and moving, straight and curved, light and darkness, good and bad, square and oblong" (986 A). Selecting from those principles that line up on the male side, we have (moving from the less to the more significant): straight, good, one, light, resting, and limit. With the female, we see curved, bad, plurality, dark, moving, and unlimited. The first list is remarkably similar to Mondrian's characterization of Neoplasticism as orthog-onal, as unified, as enlightened, as repose, and – though he denies this – as limited. In the Greek tradition, matter (the female) is mutable, always changing. This is what Mondrian needs, but only as a way of getting to the immutable male, the universal. He achieves stability, but at the expense of the possibility of further change. His "flight from the feminine"[67] into metaphysical security is no doubt at root another anxiety response to contemporary society and to the idiosyncrasies of his own psyche. His ideal of equilibrium, in spite of his claims for equality, is an escape from difference – sexual, art historical, and ontological – into androgyny, where there can be no mimesis because all difference is conflated into one unit.

To see how this retreat from sexual difference effects Mon-drian "in practice," we need only look again at *Evolution* (Fig. 7). This early manifesto of spiritual enlightenment through art can be read as Mondrian's imaging of the spiritual her-maphrodite, of his drive to purify the feminine in order to clear the way for abstraction.[68] The triptych moves from left, to right, to center in its attempt to reproduce (not merely represent) the dawning of Theosophical knowledge. The common figure shown in all three canvases is clearly female, but both she and her environment change in crucial ways. On the left, she is flanked by two red flowers, which, in

Rudolf Steiner's color symbolism, suggest deep affection. On the right, these flowers have been transmuted into Theosophical triangles that glow yellow, the color of spirit. The background on the left is purple; on the right, it is much bluer, responding to Steiner's notion that blue is the color of devotion. In the center, yellow and pure white frame the figure's head and dominate the upper part of the picture. These changes as well as the opening of the woman's eyes in the final stage have been discussed by other commentators.[69] What has not, to my knowledge, been remarked is the *increasing* "maleness" of the figure, her evolution towards the equilibrium of the hermaphrodite. On the left, the figure's gender is emphasized not only by her exposed breasts but also by her prominent hair (a central focus of male desire around the turn of this century) *and* – given the notion that woman was defined as passive, receptive matter – by her apparent sexual openness to this erotic/spiritual experience. Her eyes are closed; she leans her head back, arms behind her, in a pose of ecstatic submission. This posture is unchanged on the right, but significantly, her hair seems to have been shortened. It now appears just below her jawline because the head has tilted forward slightly as she "awakens." The center panel completes this transformation. The hair has been replaced completely by a white mantle that extends from the top of the image, around the head, and into the two forms that frame the shoulders and contain the large triangles. The figure faces us squarely, eyes open unnaturally wide, as if to announce that she has been purified of her materiality. Her male, spiritual component has been strengthened so that "she" is now an equilibrated, androgynous "force." Even her jawline seems to have widened and sharpened. We focus on the upper, intellectual part of her body because of its yellow and white frame; her sexuality has become strictly subordinate to this purity.

We know that Mondrian's disparaging ideas about the feminine found expression in his sketchbooks in the period 1912–14. Could not *Evolution,* painted just two years before, be an example of his plastic research leading the way for subsequent, more explicitly discursive formulations of his hierarchical worldview? This would explain in part Mondrian's choice of a female candidate for enlightenment,[70] an anomaly if we recall his low opinion of woman's spiritual and artistic potential. But as he makes clear in "The New Plastic in Painting," it is the impure female who must be improved if the male is to triumph, just as it is naturalistic art that must be

purified in the name of abstraction. Mondrian's reasoning here brings us to a second purpose for which the female is to be purified. The feminine embodies outwardness, he argues, but

> the male element, on the other hand, remains *inwardness* despite its exteriorization. The most purified male comes closest to *the* inward, while the most purified female shows the least outwardness. Thus, through the most purified female and the most purified male, the *inward* is brought to expression most purely.... True socialism signifies *equilibrium* between inward and outward culture (66).

By invoking Neoplasticism's social calling in the context of his purification of gender, Mondrian has in effect set his ideal of hermaphroditic equilibrium up as the model for society. Woman, as a dialectically functional means that must nonetheless be expunged, helps him to define art and art's transformation of society as the resolution of all opposition into inward, universal purity. Because only the male principle can achieve this state, however, Mondrian thus defines both the aesthetic and social realms as male. His work is thus very appropriately dedicated to the men of the future, since in his ideal world, there will be only men. But these men will have had their form-giving potency purified, for in effect they are hermaphrodites. Their "perfect," self-contained sexuality is impotent because the female has been excluded as a source of opposition and desire. In attaining aesthetic and sexual repose, society happily relinquishes its potential for change. I have hinted already at the fascist bearing of this envisioned society. As Georg Bussmann has contended, since 1945 Nazi fascism itself and certainly its repressive art policies "came to be judged as a 'foreign body'."[71] Because our culture rightly sees the atrocities of this period as the ultimate barbarity, there is also a tendency to view them as aberrant in order to distance ourselves from their horrors, and, even more importantly in this context perhaps, from the possibility of their future reoccurrence. Bussmann contends that "it is Fascist to believe that the contradictions inherent in art can be eliminated once and for all, so that a foundation can be laid for a true culture, which would have what Hitler called 'eternal value' " (124). As if this description were not already close to the aesthetic rhetoric of purity I have been examining, Klaus Theweleit has argued very persuasively (and chillingly) in his discussion of the proto-Nazi "soldier-male" that "a specific male-female (patriarchal) relation might belong at the center of [an] examination of fascism, as a producer of [its]

life-destroying reality."[72] Dijkstra is even less subtle: "I intend to show," he asserts near the beginning of his book, "that the intellectual assumptions which underlay the turn of the century's cultural war on woman also permitted the implementation of the genocidal race theories of Nazi Germany."[73] These "intellectual assumptions" are largely codified by the rhetoric of purity. To begin to question the implications of pure abstraction's dedication to the men of the future (the men of *our* present?), we should, I believe, look at an extreme parallel, that between plastic and Nazi purity. Both are based on an analogous "aesthetic." Without for a moment equating the results (a utopian vision versus the "final solution"), the comparison should not be disqualified because Mondrian's prescriptions have not come to pass. In other words, we should not fall into the all-too-common unwillingness to perceive the constant potential for personal or state fascism by thinking this comparison too extreme or historically hypothetical. Thus I want to link the exclusion of the feminine with a consideration of the explicitly political implications of the purity sought by early abstract painting.

III. AUTHORITARIAN FREEDOM

Both Mondrian and Kandinsky had a complex and problematic relationship with the demand for political engagement that was integral to their apology for art. Mondrian's equation of equilibrium and socialism (69) demonstrates the confluence of the aesthetic and the political in his work, and his late essays on "oppression" in life and art were, as he told Holtzman in a letter of February, 1940, spurred by an "impulse [from] the actual world situation; I am trying to make clear that art shows the evil of nazi – and communist – conceptions."[74] Kandinsky was intensely, though briefly, committed to the new Soviet government's attempts in the early 1920s to reform art education and museums. In both cases, personal motives for such activities were at the very least supported by these artists' involvement with a Platonic aesthetic that made art's moral and political dimensions central to its definition. For Plato, this definition was of course negative – in the *Republic,* art is banished because it would engender bad results in the polity, but its efficacy is thus emphasized; the same is true of writing and painting in the *Phaedrus:* these pharmakons are presented to the ruler as political aids and are rejected because they would have the

wrong effect, not because they are ineffectual. The call for a praxis that goes beyond the social to reform the state, however, conflicts with art's claim to autonomy – what Mondrian calls, subscribing to a long tradition that still thrives today, its disinterestedness – a claim that must in some way be satisfied, as we have seen, if art is to be a discrete agent capable of effecting change. This is the first problematic that I wish to scrutinize. The imperative for an art that is at once disinterested and politically effectual is taken by Mondrian in particular into even more difficult territory in the essays occasioned by authoritarian regimes. Art's proclaimed ability to expose and even to resist such oppression rests on its "freedom," a quality that in turn is defined by its status as disinterested, its place above the "individual" concerns of day-to-day politics. This focus on art's freedom is in fact a retreat into the aesthetic made, paradoxically, in the name of political activism, of change in the future. The result for both Mondrian and Kandinsky is an aestheticization of contemporary politics in terms of the rhetoric of purity. By presuming to have a higher, evolutionary understanding of their historical circumstances, both artists (however unwillingly) revert to an ahistorical search for absolutes, which, under the banner of freedom, radically devalues the specific tragedies of current European society.

Works like Kandinsky's *Composition IV* (Fig. 10) are filled with images of struggle and conflict that he tells us in part stem from his immersion in Europe's social and political upheaval. As this painting demonstrates, however, his zeal for transforming this troubled society is figured in terms of a future perfection to be realized through spiritual – not material and political – revolution. Kandinsky habitually sees the disasters of contemporary politics in terms of his own creed of a purity achieved through art. Early in 1914, he wrote to his dealer Herwarth Walden that the war is regrettable because "inner culture [will be] set back for an indefinite time."[75] War, then, is "external" according to Kandinsky's nomenclature. "What will come afterwards?", he queried Klee in a letter from Switzerland in 1914. Kandinsky's answer to his own "question" is telling: "a great explosion, I believe, of the purest forces which will also carry us on to brotherhood."[76] Another (would-be) artist – more directly involved in politics but nonetheless extending his aesthetic passions into society – spoke in 1937 of the need for "the cultural cleansing of the people's life: there [must] be a cultural renascence as well as a political and economic reform."[77] Hitler

was all too willing to subsume particular effects to the goals of purity; in art specifically, the individual always took second place to the "expression of the essential character of the abiding people [in] . . . and eternal monument" (586) dedicated to "the German future" (591), and in society, to the "absolute value" (595) of both art and the Thousand Year Reich. In addition, Kandinsky invokes the image of the Biblical apocalypse so central to his painting at this time in order to see the war as positive within a spiritual and aesthetic context. Present suffering is a helpful purgative if our eyes are on a future realization of spirit. Thus in spite of overtones that remind us of current events, Kandinsky employs his essentialist art as a way of *not* acknowledging the "merely" temporal and particular present. Within the coordinates of his art theory, even immediate human concerns are "external" relative to the true issue, spiritual development. As we have seen, this position directly informed his behavior as president of Inkhuk, where his goal was to work through "transient" phenomena towards the "eternal" (I, 472). His no doubt genuine commitment to change actually resulted in a doctrine of political optimism and abstinence. In a discussion of art's return to "naturalism" in the early 1920s, for example, Kandinsky cites "among the other, likewise external reasons that also affect [this] issue . . . [is] the whole political situation of all countries – and the resulting, mainly financial phenomena: hesitation, uncertainty, and fear. Far more important," he immediately adds, however, "are the *inner* reasons, which carry within themselves much that is cheering and even fortunate" (II, 481). "Trying to give art 'political' aims," he complains with reference to Neue Sachlichkeit in 1926, is "the ultimate in confusion" (II, 703). Concentration on inner values will alone lead to truly "political" solutions. While arguing that art can and should lead society, then, Kandinsky in effect advertises painting's aversion to current and indeed any form of history, since the turn to self and to art's means is, in its own terms, ahistorical. It is also a flight to an aestheticized worldview, one that is psychologically understandable, and historically specific, given the fears that Kandinsky himself ascribes to others, but also one that conflicts with an art form whose main justification is its social and political mission. In Kandinsky, abstraction is an art whose rhetoric of purity takes it beyond the aesthetic but whose performance succeeds only in transcending its own demand for social and political efficacy.

Mondrian's double obligation to an art of political action

and autonomous purity brings him to a similar point, but as usual, his ideas are more elaborately worked out than Kandinsky's and thus bear more detailed analysis. While he endured the blitz in London in 1939, Mondrian began an essay entitled "Art Shows the Evil of Nazi and Soviet Oppressive Tendencies." These are the notes that most decidedly stemmed from "the actual world situation," and which Mondrian expanded into the longer essay "Liberation from Oppression in Art and Life" when he reached the safety of New York. Though he told Holtzman that his reason for not identifying the agents of tyranny in the title and text of the second piece was the Soviet decision to fight with the European allies against Hitler, and that he thus wanted to "wait and see what will happen after the war,"[78] this omission also focuses our attention on Mondrian's tendency to draw back from the political into a secure, aesthetic vision. He claims in the draft essay that "plastic art is . . . *not . . . bound* by physical or material conditions, it does not tolerate any oppression and can resist it. It is disinterested, its only function is to 'show.' It is for us to see what it reveals" (320). Art does not only "show," however, for as Mondrian makes clear in both essays, its vision is the basis for a real resistance to totalitarianism in both art and life and thus for his constant optimism. His point is that art's disinterestedness *allows* it to show how oppression operates; autonomy, then, is the propaedeutic to action.

Mondrian begins "Art Shows the Evil of Nazi and Soviet Oppressive Tendencies" with a short denunciation of these regimes in general but moves very quickly to his main topic, Neoplasticism. The later essay says even less about oppression in "life," and is in fact an excellent summary of the art theory he had developed over several decades. His argument, like Kandinsky's, is that oppression is actually a positive force because it "creates by its negative action; it strengthens opposition to itself" (322). Political oppression is thus rapidly subsumed by his dialectic of aesthetic opposition, and as I have suggested, anti-feminism is closely connected both historically and theoretically with fascism. Without claiming that Mondrian was one of Theweleit's soldier-males, it is instructive to see just how close the "logic" of female exclusion is in both cases. After analyzing a great deal of data from the beginning of this century, Theweleit posits that, typically in this patriarchal world, "relationships with women are dissolved and transformed into new male attitudes, into political stances, revelations of the true path, etc. As the woman fades

out of sight, the contours of the male sharpen; this is the way in which the fascist mode of writing often proceeds. It could almost be said that the raw material for the man's 'transformation' is the sexually untouched, dissolving body of the woman."[79] When we recall the importance of the artist's inner "transformation" and the role of woman in Mondrian's writings, then this description even applies remarkably well to the peculiar dynamism of *Evolution* (Fig. 8). Theweleit goes on to conclude that this exclusion of the feminine is a "safety mechanism" (218), a flight from the "aliveness of the real" (217) or from "hybrid" – impure – substances (409–10). What Philippe Lacoue-Labarthe has called the "confusion of an aesthetic and a political project"[80] with reference to the Nazi promotion of Wagner's music is another example of the inevitable imbrication of what was never kept separate by either Mondrian or Kandinsky, "life" and "art." Because the disinterestedness or aesthetic autonomy sought and yet denied by pure abstraction is, I would argue, a delusion, we should be especially wary of its rhetoric. As Theweleit warns, "under certain conditions, this particular [male-female] relation of production yields *fascist* reality" (221).

For Mondrian, all values are simply relative to what he – like Kandinsky – sees as a larger and more significant system, the evolution of man towards purity. Destruction in the human arena is understood by Mondrian aesthetically and seen as useful:

We can conclude that plastic art shows a *double action* manifested in life and in art: an action of decay and an action of growth[,] a progress of intensification and determination of the fundamental aspect of forms, and a decay through the reduction of their external aspect. Art and human life show that this reciprocal action does not destroy but manifests the intrinsic value of form. By establishing greater equivalence of the opposing factors, a possibility of approaching equilibrium is created (324).

In using his own art as an example in his discussion of fascism, Mondrian means to liberate society, and I do not intend to cast doubt on his motives. As a recent critic has put the point in a different context, however, "the political significance of an idea rarely coincides with what its advocates think or claim for it."[81] Mondrian's reliance on the paradigm of purity in his prescriptions takes his ideas in a direction that he would abhor. Yet by claiming that "art is freeing itself from oppressive factors that veil the pure expression of life[;] What is true in art must also be true in human life" (324), he invokes the mechanisms of purification that exclude elements – like

the feminine, representation, or entire episodes in art's history
– in what can be construed as an oppressive way. "Objective
oppression" – the difficulties imposed by external forces, both
economic and political – and the "subjective oppression" that
results from "limited vision," can only be overcome through
purification, a process that Mondrian describes in this context
using military and patriarchal metaphors: "plastic art reveals
to us that in order to *vanquish* objective oppression, existing
elements and forms must be selected carefully, or if possible,
transformed. To *master* subjective oppression, the transfor-
mation of our mentality is needed" (323; emphasis mine). By
focusing on art's supposedly disinterested self-purification,
then, we can see (and change) political reality. Hitler uses a
similarly militaristic diction when describing the vocation of
the new German art in his speech at the opening of the Grosse
Deutsche Kunstaustellung cited previously, but he does not
conceal the political agenda of his (mere?) words: he promised
to "wage an unrelenting war of purification against the last
elements of putrefaction" in German culture.[82] What Mon-
drian sees, however, is indeed an image produced by a "trans-
formation of [his] mentality," since he views the evil of events
c. 1940 just as he did right after World War I in "Natural
Reality and Abstract Reality": "evil, *in terms of evolution,*
sometimes is not evil" (107). Evil has been purified through
its absorption into Mondrian's aesthetics.

"Art is disinterested and for this reason it is free," Mon-
drian argues (327). Its freedom, however – what we could
as rightly call its purity, autonomy, or self-definition as art
– is the basis in these "political" essays for art's opposition
to oppression. Mondrian attempts to draw a sharp contrast
between Neoplasticism and Nazi art, which also "claimed to
purify art . . . [but by] dictat[ing] the way art had to go,"
(321–2), that is, by forcing it to regress to representation and
by censoring *Entartete Kunst,* of which Neoplastic abstraction
was thought to be the prime example. He in effect opposes
his work's "free" purity to the oppressive purity of Nazi
ideals. We know that Neoplasticism did not have the disas-
trous effects of the aesthetic, eugenic, and genocidal purifi-
cation practised by Hitler, and I do not mean to lessen the
raw horror of this history by comparing it with Mondrian's
aestheticism. To put this another way, it is impossible within
the confines of a book on art to avoid doing just what Mon-
drian does with totalitarianism, that is, to see it in terms of
art. Although my critique of Mondrian's ideology is certainly
not apolitical, an important difference is that I do not claim

to be able to affect politics with my analysis. Again at the risk of sounding extreme, however, I would ask if this crucial difference was not more a result of unequal power than of the import of ideas, especially given the express goal of Neo-plasticism to reform the state according to its principles. Mondrian himself speaks of the distribution of power in the context of the search for equilibrium: "art shows that differ-ence in power and capacity exist and are necessary, but [that] abuse of these factors is fatal" (329). Hierarchy, that is, is proper, but it must be equilibrated. Yet this equilibrium is seen to be just only from the perspective of an essentialist and patriarchal doctrine of purity that is anything but dis-interested. Individual exclusions are not given the chance to defend themselves. This may not seem very important in the case of diagonal lines, for example, but again, Mondrian's Platonism encourages him to apply his aesthetic to all of life. "If kings were just," he writes in a passage from "The New Art – The New Life: The Culture of Pure Relationships" (1931) that deserves comparison with Plato's conclusions in the *Republic,* "a republic would be no better than a monarchy" (265). In this polity belonging to the men of the future, how-ever, we might suspect, as Marcuse did, that "the intuition of essence helps to set up 'essential' hierarchies [in which the] values of human life occupy the lowest rank."[83] Is it right to say, as Mondrian does, that Neoplasticism's purifications in-volve no "oppression" in the sense of dictating a direction in which "art had to go," or that abstraction was "not bound" by material or historical circumstances? Oppression in this context is equivalent to having an interest, a criterion that Mondrian's obsessive attention to purity with all its ideolog-ical connotations certainly meets. Given the chance, would Mondrian be a benevolent philosopher-king?

When we think about the notion of purity from the vantage point of the late twentieth century, then, it is impossible to ignore its most heinous realizations during the Nazi reign. The doctrine of racial purity was fundamentally an aesthetic ideology of exclusion and oppression supported by the fear-some technology of the "final solution" and the death camps. Without suggesting for a moment that Mondrian or Kan-dinsky had any sympathy with National Socialism, the shock value of a comparison between these quests for absolute an-swers through mechanisms of purification can alert us to the ideological implications of purity in abstract painting. If we recognize the potential for oppression that typifies both Mon-drian's and Kandinsky's (even though he was more liberal

135

on the level of plastic experimentation) work, then the banning of abstraction by the Nazis appears as little more than a fortunate irony of history. Mondrian's abstraction was of course pilloried in the *Entartete Kunst* exhibitions. But Hitler and his advisors missed other excellent aesthetic vehicles for their "male" (in Theweleit's sense) doctrine of purity. Emil Nolde – a member of the Nazi party since 1920[84] – was also mocked. *Style* excluded him, as it did Mondrian and Kandinsky,[85] despite the ideological purity of his racism, and his typically Expressionist misogyny.[86] We must remember too – before sheltering behind the common-sense view that Mondrian's work must be anti-Nazi because they rejected it – that the project of the *Entartete Kunst* exhibition was explicitly one of cultural purification, of clearing away the perceived sickness in society as a basis for a new, German art/society (Hitler insisted on the indissolubility of the two), which would be represented initially in the concomitant and dialectically related exhibition at the House of German Art in Munich, opened nearby just the day before the parade of "degenerate" art. Defining his aims at the opening of the Reichstag as early as 1933, Hitler proved his belief that "art must be part of the community... and thus answerable to external demands" (Grosshans, 28) with the claim that "simultaneously with this political purification of our public life, the Government... will undertake a thorough moral purging of the body corporate of the nation" (*Speeches,* 568).

The rhetoric of purity manifests a similar goal within early abstract painting and in the Nazi ideal of a new German classicism: both are nostalgic for an absolute in art that reflects other unquestioned values and provides final answers. The Nazi emphasis on classical statuary and architecture recalls Greek achievements, and, more immediately pertinent to this study, Hitler's definition of classical art as "functionalism fulfilled with crystal clarity" (Grosshans, 83) takes us back to Kandinsky's equation of the crystal with absolute values, discussed in Chapter 3. In a similar vein, Hitler codified what he called the "law of clarity" in racial terms: "to be German is to be clear" (*Speeches,* 587). Like Mondrian, with his emphasis on "distinctness," Hitler here draws on the ancient – but menacingly present – rhetoric of purity. Like Kandinsky particularly, Hitler *also* saw himself as a striving artist who could lead society into the future by redeploying selected traditions from the past. Because abstraction is at least in appearance completely new, and because this form wants to lead society, Mondrian's and Kandinsky's is a "nostalgia for

the future,"[87] a longing that, like Plato's, focuses on a future perfection that is nonetheless informed by putatively timeless values that might have established themselves in past times (earlier Athens) or in past art (the primitive). In all cases, however, this nostalgia and its concomitant need for purity in art and society can be understood to be conditioned by a range of what I have called the anxiety responses to an unstable society.[88] A more specific parallel between these calls for purity is found in their common dependence on three crucial inspirations: Plato, Schopenhauer, and Theosophy. Hitler's longing for stability through the guaranteed genealogy of the *Volk* is sometimes expressed within a Platonic opposition of change versus true stasis: For modern art, "National Socialism desires to substitute a 'German' art and an eternal art. . . . The people in the flux of phenomena is the one constant point. . . . There can therefore be no standard of yesterday and today, of modern and unmodern; there can only be the standard of 'valueless' or 'valuable,' of 'eternal' or 'transitory,' " Hitler claimed (*Speeches,* 586–7). Internationalists like Kandinsky and Mondrian were not interested in the racism of the *Volk,* but as we know, they did seek an immutable absolute through art. We know, too, that according to contemporary accounts, Hitler "read and re-read" Schopenhauer's *World as Will and Representation* during World War I (Grosshans, 19). From here he could easily have derived his pessimistic vision of a world in decline and his hatred of individualism (which we see paralleled in Mondrian's theories). Dietrich Eckart, a close friend and advisor to Hitler, also read Schopenhauer and speculated on cultural decline in ways that influenced Hitler. And as in Schopenhauer's writings, art was for him the vehicle for salvation. Eckart "assigned to artists many of the functions of the priest . . . only those attuned to the historical necessities of the German people . . . could claim the position of artist" (Grosshans, 67). Both Mondrian and Kandinsky saw themselves as messiahs in this sense, able to read the teleological development of Spirit and to promote its evolution through art. Plato's shadow also falls across the Theosophical doctrines with which these artists and the progenitors of National Socialism's ideology were fascinated. The publisher Eugen Diedrichs (1867–1930), whose promotion of a "mystic world-view" that countered society's materialism and positivism was adopted by the Nazis,[89] referred to Plato as one of his sources for a belief in an encompassing life-force that shaped history.[90] Theosophy shared these ideas,[91] so it should

come as no surprise that we find them echoed in Mondrian's writings, even years after he had suspended his active participation in the Theosophical Society. In "Art Shows the Evil of Nazi and Soviet Oppressive Tendencies," he extols Neoplasticism's freedom "from all oppression" by linking this art with the notion of an unerring life-force: "we feel the complete life that art establishes as the pure expression of life (*élan vital*). We see this life in art as dynamic movement-in-equilibrium" (321). For Mondrian and Kandinsky alike, this life-force is the motor of evolution, and both men emphasize its teleological infallibility. For Mondrian, life's "unchangeable plastic laws" as embodied in abstract art provide "continuous progress" that is "always right" (326), no matter what happens to plastic or human individuals along the way.

Through the necessary evolution of plastic forms, both Mondrian and Kandinsky hope to achieve the perfect silence of "repose," that crystalline, white state where no more questions can be asked and no more discordant, impure discourses can be heard. This state of universal being is apolitical and ahistorical, but if it is to be achieved (and let us remember that both artists saw its realization far in the future, so its possibility is not cancelled by the fact that history has not to date gone this way), it will need to use a political process. The state of purity envisioned by abstract painting in this tradition is profoundly conservative in the sense that it remembers an ultimate, past authority very like the complete unity of Plato's Forms, and because it strictly curtails any further change. Certainly Mondrian and Kandinsky allow for dynamism in their *painting* – and in their late work especially – but this is only change within a larger evolutionary structure that they hope will reach the static perfection of the absolute.

KLEE AND THE INTERROGATION OF PURITY

IF MONDRIAN'S AND KANDINSKY'S essentialist abstraction can, in its quest for purity, be seen ultimately to transcend the need for art in favor of a silent, static perfection, then Klee's protean painting can be understood as a dissenting voice that questions the rhetoric of purity from within its own terms of reference. Although numerous commentators have emphasized Klee's status as an outsider in the Modernist tradition,[1] it is important to recall that he was also very much part of that generation to which Kandinsky and Mondrian belonged and that he shared many views with the former in particular, especially during their time together at the Bauhaus.[2] Without homogenizing the differences among these three artists, I would emphasize their mutual interest in the relation between nature and abstract art, their common grounding in the neoplatonic tradition,[3] and the centrality of the notion of purity in their thinking about the visual arts. Because Klee was so intensely involved with many of the same aesthetic concerns that shaped Mondrian and Kandinsky, and because, as I will argue, he consciously rejected the essentialist purity that they embrace, his work offers an historically situated critique of a pure abstract art that would transcend the possibility of critique itself. By offering this new interpretation of Klee as a postscript to the investigation of the rhetoric of purity in abstract art, however, I do not mean to heroize him at the expense of the other artists considered here or to remove his work from its historical context by making it an exemplar of my own critical concerns. Peter Bürger has written that "if aesthetic theories are historical, [then] a critical theory of art . . . must grasp that it itself is historical."[4] I take this to mean that morally, we must assume responsibility for what we write about history and art history by confessing, inasmuch as this is possible, our own critical interests, our ideology. Through Klee, then, I want to extend

my critique of the absolutism of the rhetoric of purity along
what I will define as postmodern lines. I am *not* claiming Klee
as a postmodern – he remains in most ways typically Modern
– but I am suggesting that his disruption of abstraction's quest
for metaphysical purity does intervene in what was becoming
for Kandinsky and Mondrian a naturalized, unquestioned
transcendental project, and that this intervention is only ap-
parent in light of recent critical directions that I will call
postmodern. Put another way, my interest in and critique of
purity in abstract painting has arisen within what I would
describe as the postmodern preoccupation with impurity.[5]
My analysis is thus historical, just as was Klee's interrogation
and rejection of the essentialist foundations of abstraction. In
suggesting how Klee destabilizes this vision of art as self-
transcendent, I am, of course, simultaneously arguing for a
particular understanding of the postmodern, one that is de-
cidedly positive and that thereby goes against some com-
monly held opinions. I see the postmodern at its best as
critically historical in its relation to tradition (especially that
of Modernism), I understand its ludic dimension to be central
to its powers of critique, and finally, I claim that postmod-
ernism's relentless discursiveness saves it from transcendence
and grants it the ongoing potential for important social and
political critique.[6] All of these characteristics are focused his-
torically in Klee's edifying rejection of the rhetoric of purity.

To understand how Klee challenges the premises and im-
plications of noetic purity, we must first appreciate the extent
to which he works within this discourse both visually and
textually.[7] His main essays on art appeared c. 1918 – 1928 and
their ideas closely parallel those set down by Mondrian and
Kandinsky during these same years. In fact, Klee's "Creative
Credo," written in 1918 and published in 1920, was com-
posed as an affirmative response to Kandinsky's essay "Paint-
ing as Pure Art," which was written in 1913, but which Klee
most likely read or reread in 1918 when the essay was pub-
lished in Herwarth Walden's *Expresionismus – die Kunstwende*
in 1918.[8] In this essay and throughout Klee's writings, we
see the now-familiar opposition of appearance and reality that
derives from neoplatonism. The famous opening sentence of
the "Creative Credo" is itself an expression of this hierarchy:
"Art does not reproduce the visible but makes visible."[9] In
"Ways of Nature Study," 1923, Klee makes this philosophical
point concrete by referring to art's history in a way that is
congruent with Gauguin's complaints about Impressionism

and with both Mondrian's and Kandinsky's opinion of almost all earlier art. "Yesterday's artistic creed and the related study of nature consisted," Klee holds, of "a painfully precise investigation of appearances.... The art of contemplating unoptical impressions...and of making them visible was neglected."[10] In this context he emphasizes in a decidedly neoplatonic manner the source of this true vision, because "non-optical... contact" stems from "the cosmic bond that descends from above."[11] And Klee adopts what he calls these "upper ways" because of a "yearning to free [himself] from earthly bonds."[12] He refers throughout his extensive writings to the search for "essence" – "algebraic, geometrical, and mechanical problems are steps in our education towards the essential"[13] – and this metaphysical desire is pictured in a work from 1923 entitled *Eros* (Fig. 13). Klee's characteristic signs of motion and direction, the arrows, here point to the empyrean apex of a triangle that itself recalls Kandinsky's famous image of spirit's inner progress up the pyramid in *On the Spiritual*. Like Kandinsky and Mondrian, Klee had a strong desire to ascend the metaphysical ladder and a concomitantly Platonic sense of the erotic.

Given the similarity between Klee's aesthetic credo and that articulated by both Mondrian and Kandinsky, it will come as no surprise that Klee also invokes the notion of purity when he seeks to define his goals and his relation to the nascent possibility of abstract expression. "To be an abstract painter [is] to distill pure pictorial relations.... Purity is an abstract realm. Purity is a separation of elements pictorially and within the picture."[14] We have seen Mondrian and Kandinsky define abstraction's purity in similarly formal terms, yet they subsume this formalism within a larger, transcendental project. Klee is equally disparaging about formalism, and there is no doubt that his work is driven by a transcendental urge, but it is in his references to the purity of abstraction – and of course in his sparing use of completely abstract compositions – that we can begin to see his critique of purity as the pioneering abstractionists had defined it. For Klee, purity referred almost exclusively to the means of pictorial composition. As early as July, 1905, he identifies this sort of purity as French and rejects it:

Things are not quite so simple with "pure" art as is dogmatically claimed. In the final analysis, a drawing simply is no longer a drawing, ... it is a symbol, and the more profoundly the imaginary

lines of projection meet higher dimensions, the better. In this sense I shall never be a pure artist.[15]

In this Klee agrees with the artists and theorists of essentialism from Aurier to Kandinsky. Like these ancestors, he is pleased to praise the "cultivation of . . . pictorial elements, their purification and their use in the pure state,"[16] but only as a means towards a deeper "content," which as he states at the beginning of his lecture, is the issue he really wants to address. But Klee does not take what was for Mondrian and Kandinsky the next steps prescribed by the rhetoric of purity. He seeks to transcend the formal, to make visible what is invisible, and he certainly believes that inner knowledge and striving is necessary. Yet he does not desire a union with any

13 Paul Klee, *Eros*, 1923. Watercolor on paper (cardboard mount), 33.3 × 24.5 cm (Lucerne: Collection Rosengart. © Paul Klee 1990/VIS★ART Copyright Inc.).

transcendent absolute or universal beyond the creative energies of art itself. It is these dynamic forces that Klee tries to understand through a perpetual "dialogue with nature,"[17] and the enlightenment he achieves is fed back into what he sees as an unending cycle of artistic experimentation. Klee has no nostalgia for the absolute but believes instead in constant change. His work is not teleological but morphological. As a result, he posits the unassailable need for an art that can make visible what the human mind discovers. In an important passage from his lecture notes in 1921, Klee explains that "knowledge . . . is of no use to us unless we have acquired the necessary equipment for representing it . . . the profoundest mind, the most beautiful soul, are of no use to us unless we have the corresponding forms to hand."[18] His search was for this plastic *discursiveness,* and he did not limit himself by looking only within the realm of pure abstraction, whether formal or metaphysical. Klee focused on and mirrored the unending dynamism of nature's creativity; inspired by Goethe,[19] he emphasized the cyclical change inherent in morphology rather than in a fixed end.

Two examples from Klee's work will reveal his departure from Mondrian's and Kandinsky's ideas of purity and also help to consolidate my own postmodern critique of their transcendentalism. Klee's comic watercolor *Metaphysical Transplant* of 1920 (Fig. 14) thematizes the notion of creation that he discusses in the "Creative Credo" with reference to genesis (and Genesis) in the Bible *and* in terms of gender. Both reference points bear comparison with Mondrian's invocation of Adam as the ultimate origin and with his concomitant condemnation of the female "element." In his writings and in this whimsical but not unphilosophical picture, Klee explores the essence of active formation. Here the male, eyes turned upward to a yet higher formative principle,[20] the "cosmic bond," generates and expresses a seed that the reclining and spatially subordinate female will receive. She looks out at us, rather surprised, perhaps, at her role in the creative process. In the "Creative Credo," Klee writes that "the Biblical story of Creation is a good parable for motion. The work of art, too, is first of all genesis; it is never experienced purely as a result."[21] *Metaphysical Transplant,* painted in the year that Klee published the "Creative Credo," pictures this form-giving genesis with what in this context can be read as an image of Adam and Eve.[22] In Genesis it is of course God who transmits the seed, but Klee chooses to elide this "original" act with its later and explicitly sexual

mechanism of continuity. Metaphysics is revealed through biology. He focuses on nature's irrepressible motion, and he *includes* the woman in a truly dialectical (though still hierarchical) process instead of equilibrating her out of existence in an hermaphroditic synthesis, as Mondrian does.[23] Both masculine and feminine, he says, are "principles of movement."[24] Klee is concerned with ongoing generation, not with a static result, with "forming" rather than "form." "Form must on no account ever be considered as something to be got over with," he writes in his lecture notes, "as a result, as an end, but rather as genesis, growth, essence."[25] Klee does not want to return to the absolute perfection of the origin: he sees all of life as a "circulatory process [in which] movement is of the very essence, and [in which] the question of a start thus becomes irrelevant."[26] In this he opposes a new definition of essence to the essentialist metaphysics of origin that we have examined.

Nowhere in his published writings does Klee refer to his principle of dynamism in opposition to Mondrian. But in addition to his deflection of the essentialist concern for origins, numerous passages in Klee's writing also function as explicit counterarguments to the common perception of

14 Paul Klee, *Metaphysical Transplant*, 1920. Watercolor oil transfer drawing on paper (cardboard mount), 27.3 × 43.8 cm (Illinois: Collection Helen Keeler Burke. © Paul Klee 1990/VIS★ART Copyright Inc.).

144

Mondrian's work as static and absolute. "Everything (the world)," Klee claims, "is of a dynamic nature." The "static" is an "exception."[27] "Straight lines are the quintessence of the static," because "flux, the subtle flow, takes certainty, gently but surely, away with it."[28] In Klee's terms, then, even the increased vocabulary and dynamism of Mondrian's New York work remains essentially static, in spite of Mondrian's claims to the contrary.

Klee also counters Kandinsky's yearning for the pure, crystalline state, and again he does so from inside this discourse. In Chapter 3, I described how Kandinsky, drawing on Worringer and Schopenhauer, employed the metaphor of crystallization to express the state of ontological purity that he claimed for his abstract art. Klee also describes himself as a crystal in his diary entries during the trip to Tunisia in 1914. The crystal is imaged as metaphysically clear[29] – permitting eidetic vision – and as both inviolable and eternal. Thinking of World War I,[30] he writes,

One deserts the realm of the here and now to transfer one's activity into the realm of the yonder where total affirmation is possible. Abstraction.
The cool Romanticism of this style without pathos is unheard of. The more horrible this world (as today, for instance), the more abstract our art, whereas a happy world brings forth an art of the here and now.
Today is a transition from yesterday. In the great pit of forms lie broken fragments to some of which we still cling. They provide abstraction with its material. A junkyard of unauthentic elements for the creation of impure crystals.
That is how it is today.
But then: the whole crystal cluster once bled. I thought I was dying, war and death, but how can I die, I who am crystal?
I, crystal . . .
crystalline formations, against which a pathetic lava is ultimately powerless.[31]

Klee clearly bases at least part of his notion of the crystal on Worringer, who defined the abstract and crystalline as a refuge from the horrors of the immediate world. To become crystal is to escape, and Klee admonished himself in his diary for not engaging sufficiently with the political world, for finding aesthetic control by "striving for a crystallization of the accidental," as he put it in a lecture note.[32] But Klee's attempt to become a pure crystal by purifying art's traditional means was not – like Kandinsky's – aimed beyond the material exigencies of his art. Through his artistic analysis of nature, he made himself into crystal and achieved what he

called a "cosmic" vantage point on creation itself. This process, however, was imminent, not transcendent. The more Klee discovers, the deeper he goes into art. We can see his dynamic crystallization at work in one of his most masterly paintings, *Fish Magic* of 1925 (Fig. 15).

Verdi has discussed this picture in detail and offered a convincing reading of one of its most unusual qualities, the two clearly separate yet integrated pieces of canvas that provide a picture within a picture.[33] I will not rehearse his argument but rather offer an alternative (and complementary) interpretation that seeks to understand Klee's self-characterization as crystal within his strategy of intervening critically in and with his paintings and thus to disrupt normalized aesthetic and philosophical procedures, in this case, the assumptions of the rhetoric of purity and its offspring, abstract painting. As Verdi shows, the superimposed canvas in this painting creates a second world within the frame. Some of Klee's magical creatures, especially the fish, seem to move unimpeded between these worlds; the head and upper torso of the human figure at the bottom of the painting, however, is bifurcated by the line dividing the inner frame from the rest of the canvas. This figure literally looks both ways. Presiding over the entire picture is a clown who peaks out from the lower left corner, setting the ludic tone. Within the inner frame is what Verdi identifies (very reasonably) as a clock tower and clockface somehow suspended on a line that allows it to float in the inner picture. I want to suggest that these important forms can also be read as a *crystal* that is being grown in solution, suspended on a string. The clock refers to the time that must elapse in the production of the crystal and, more metaphorically, to cyclical time itself, to time as perpetual. The celestial body just to the left of the clockface within this solution can refer, as Verdi suggests, to cosmic time, Klee's constant concern when he deals with quotidian temporality. This reading makes better sense than the clock-on-a-string proposed by Verdi, since a crystal has a reason to be immersed in this different world. Verdi also suggests that the red ellipse in the upper left corner of the inner world is "a dim reflection of the red curtain edge" that frames the outer part of the picture, and he thus sees the inner world as a mirror of the outer.[34] It is also plausible, however, that this red patch is a second curtain, another introduction to another and different world, the world of the crystal. Following this argument, it is Klee himself *as* the crystal who is immersed and growing within an inner, privileged medium, the aes-

15 Paul Klee, *Fish Magic*,
1925. Oil and watercol-
or on muslin (board
mount), 77.5 × 97.2
cm (Philadelphia Mu-
seum on Art. © Paul
Klee 1990/VIS★ART
Copyright Inc.).

thetic. He is at once cosmic and telluric (as he often suggested), but his crystalline existence – his art – is not transcendent. It is different from but contiguous with the other environment imaged by the outer canvas. *Fish Magic,* then, affirms what Klee saw as the magical and analytical powers of art itself. In its conscious rejection of the purity of abstraction, with its intimations of the end of art, Klee's work can also be seen to affirm the critical power of the aesthetic by insinuating its author's crystal voice into a discourse that tries to legislate silence.

By reading Klee's work against the rhetoric of purity, I have invoked three broad characteristics of what I would claim is a postmodern critical stance: historicality, play, and political critique. Understood in this context, Klee turns out to be decidedly impure, and outsider again. Transcendental purity, drawing on Hegel, may seek to establish a concrete universal with the material art object, but this instance really only performs a function for Spirit on its way to a higher and immaterial truth. Even though Klee's vision of constant morphology was influenced by the Hegelian philosopher Friedrich Hebbel,[35] his idea of history is quite different from Hegel's. Art's inevitable materiality is essential to Klee's notion of "creative power, [which]... must function in union with matter."[36] Essence is, for Klee, explicitly historical. In making visible the invisible, he seeks and pictures "the prehistory of the visible."[37] This visualization is what he calls "representation,"[38] and in representing (rather than abstracting) the strain of Modernism defined by eidetic purity, Klee is constructing an historical commentary. The whimsy of *Metaphysical Transplant* and *Fish Magic* contrasts sharply with the seriousness of Mondrian's work, its rigorous control. Kandinsky allows greater freedom of expression than his Dutch counterpart, but his messianic vision is equally exalted. Again, Klee seems impure. But the ludic tenor of his work has a philosophical dimension. He is bonded to both the cosmos and the earth and will deny neither by assuming the mantle of a transcendent viewpoint. As in *Fish Magic,* Klee habitually immerses himself in *individual* contexts or *games* that have rules determined only by the specific context. In his lecture notes, Klee explains the relative roles of different "voices" in the construction of a work: "as to the rank of these three voices... *it will depend on the point of view.*"[39] By focusing on the particular – and working in a small format, very much against the contemporary and especially the more recent "masculinist" pretensions of sublime scale found in

abstract painting – Klee inhabits what can be argued to be a "feminine" space, one that is hybrid in its interests and thus quintessentially impure,[40] and which is resistant to the hegemony of essentialism. As we have seen, in a cyclical system like art, there is no privileged origin, no absolute. Klee establishes a dynamic dialectic within each work, each game. The ruling principle is what he calls "metalogic," which "is concerned with the smile, the gaze, the scent, all the seductions between good and evil."[41] Klee revels in such seductions and varieties of viewpoint; he in no way seeks a stable, Archimedean point beyond the flux.

Klee's relation to contemporary politics was normally distant, though he certainly reflected plastically on the horrors of the Nazi takeover in particular, and his 1933 abstract drawings were seen by colleagues as "subversive denunciations of the new regime."[42] With respect to the immediate politics, then, Klee remained quite "pure" by ignoring or aestheticizing these events. But on another issue that is also political – art's relation to society – Klee demonstrates both his proximity to the neoplatonic discourse of Mondrian and Kandinsky and his ultimate departure from their views. He does not share their Platonic zeal for transforming society, but in practice, Klee's art cultivates the potential for commentary by refusing to blend seamlessly and quietly with a utopian society. By looking always for new representations, new discourses, Klee asserts art's ongoing place as a crystal in the surrounding world. "The approach, as the work's essential dimension, must not tire us. It must be refined, develop interesting offshoots, rise, fall, dodge, become more or less clearly marked, grow wider or narrower, easier or harder," depending on the immediate context.[43] In 1924, when he would certainly have been aware of Mondrian's work, Klee states his understanding but ultimate rejection of the flight to absolutes: "our need for orientation is expressed in a division and fixation into straight lines, precisely located; . . . this is done at the cost of reducing the wealth of possible nuances,"[44] nuances that are the lifeblood of art's place in society. Where Kandinsky and Mondrian finally give Plato what he wants by erasing art's latent role in the Republic, Klee denies the possibility of such censorship. Klee is a sophist whose playful aloofness prevents him from being persuaded by purity's rhetoric. His art is akin to what Richard Rorty has called "therapeutic" philosophy[45] in that it seeks to keep discourse going and resists the "traditional, Platonic, epistemologically-centered philosophy" that searches "for a way

AGLI UOMINI DEL FUTURO MCMLXXXVIII

16 Gerhard Merz, *ultra-marinblau (ultra marine blue), 1988*, 1988, pigment on canvas, 170.0 × 475.0 cm (Barbara Gladstone Gallery, New York. Photo: Art Gallery of Ontario).

in which one can avoid the need for conversation and deliberation and simply tick off the way things are."[46] In avoiding essentialism in this way, however, Klee does not leave himself open to the criticism of being conservatively apolitical leveled at Rorty's (and Lyotard's) versions of postmodernism.[47]

To cite a concluding example that has important implications for a wider political reality, Klee's implicit critique of Mondrian's static absolutism can again intervene when we look at a recent recollection of Neoplastic purity, Gerhard Merz's *ultramarinblau (ultra marine blue, 1988)*, (Fig. 16). Merz's immense work remembers Mondrian's primary blue pigment by framing a large field of this color within an even more expansive grey border. The painting makes Mondrian "present" simply by its scale, which invokes the dominant, male discourse of abstract painting. They grey background, a color rejected by Mondrian as impure, makes us wonder about Merz's message. If we register the work's inscription (which we can hardly help but do, given its scale) – Mondrian's dedication of his vision to his and future generations of men – through the filter of Klee's critique of absolutism and transcendence, however, the disturbing overtones of Mondrian's ideology flood back. Mondrian, Klee, and Merz all create explicitly through the use of memory.[48] For Mondrian and Kandinsky, this memory is eidetic and transcendent: it seeks to kill Mnemosyne (mother of the muses and thus of the arts) through union with the absolute. For Klee, memory is individual and practical, but as *we* remember his

work in its David and Goliath relationship to these larger than life abstractionists, we can see Merz's invocation of Mondrian as an admonition to recall critically the import of any dedication of an absolute set of values to the men of the future.

NOTES

PREFACE

1 I have drawn on a variety of sources to define and elaborate this term;
 some refer mainly to the philosophical tradition while others transfer
 the term to art, as I seek to do. Herbert Marcuse's historical critique
 of essence has been a prime inspiration ("The Concept of Essence"
 (1936), in *Negations: Essays in Critical Theory*, trans. Jeremy J. Shapiro
 (London: Penguin Press, 1968)), and though I don't subscribe to all of
 his views on Plato, I have also learned from Karl R. Popper's *The Open
 Society and Its Enemies*, Vol. 1: *Plato*, 5th ed. (Princeton: Princeton
 University Press, 1971). For connections between art and essentialism,
 see especially Jonathan Dollimore, *Radical Tragedy: Religion, Ideology
 and Power in the Drama of Shakespeare and His Contemporaries* (Chicago:
 University of Chicago Press, 1984), pp. 255 ff., Michael Fried's remarks
 on Clement Greenberg in the discussion titled "Theories of Art after
 Minimalism and Pop," in *Discussions in Contemporary Culture* No. 1,
 ed. Hal Foster (Seattle: Bay Press, 1987), p. 57, and Yve-Alain Bois,
 "Painting: The Task of Mourning," in *Endgame: Reference and Simulation
 in Recent Painting and Sculpture* (Boston: Institute of Contemporary Art,
 1986, exhibition catalogue), p. 30.
2 Plato's importance in modern art has not gone unremarked, but I shift
 the emphasis away from those (like the Purists and the Stieglitz circle)
 who responded mainly to his intimation in the *Philebus* (51 C) of an
 art of pure, geometrical solids. On this topic, see Linda D. Henderson,
 The Fourth Dimension and Non-Euclidean Geometry in Modern Art (Prince-
 ton: Princeton University Press, 1983), pp. 310 ff.; p. 215, and (for a
 passing remark on the significance of this part of Plato's thinking)
 Herbert Read, *Art Now: An Introduction to the Theory of Modern Painting
 and Sculpture* (New York: Harcourt, Brace & Co., 1933), p. 101. Pierre
 Guéguen also refers to this interest in Plato in "Platon et L'Art Ab-
 strait," *XXe siecle*, Nouvelle série, 1 (195), pp. 19–20. Bernard Berenson
 – not noted for his support of abstract art – found Plato's Phileban
 solids of negative importance (see *Aesthetics and History in the Visual
 Arts* (New York: Pantheon), p. 83).
 My emphasis on abstract art (which, according to the artists on
 whom I focus, does not include Cubism, Orphism, or Purism) takes
 me instead to Plato's remarks on mimesis and his (apparent) condem-
 nation of art. As I have mentioned, my main inspiration for this em-

phasis is the textual work of the central founders of abstract painting, but I do want to record those allusions to the ideas of purity and Platonism in connection with abstraction that exist in relevent studies. All of these references are passing, and I take them more as corroborations than inspirations for my own analyses. H. L. C. Jaffé refers to Neoplasticism's goal of "the total purification of the plastic arts" and discusses this theme in his pioneering study *De Stijl/1917–1931* (Cambridge: Belknap/Harvard, (1956), reprint, 1986), p. 5. Clearly I agree with Frederick R. Karl's assertion that one "could plan entire treatises on purification as a key aspect of modernism," (*Modern and Modernism: The Sovereignty of the Artist 1885–1925* (New York: Atheneum, 1985), p. 163) and I hope that the present study – though not focused primarily on Modernism – goes a few steps in this direction by tracing (among other phenomena) what Frances Bradshaw Blanshard has called the "*sub voce* dialogue with Plato" that has characterized the beginnings of abstract painting (see *Retreat From Likeness in the Theory of Painting,* 2nd ed., (New York: Columbia University Press, 1949), p. 32). "In Mondrian's ideas . . . we can detect a Platonic . . . absolutism," according to Arthur Chandler in *The Aesthetics of Piet Mondrian* (New York: MSS Information Corporation, 1972), p. 42. Again I would agree, as I do with Poggioli who – with somewhat different reference points – talks about the "modern mystique of purity" (*The Theory of the Avant-Garde,* trans. Gerald Fitzgerald (Cambridge: Belknap/Harvard, 1968), p. 201), and with Karsten Harries when he discusses the danger to the materiality of art inherent in the Platonic emphasis on purity (*The Meaning of Modern Art: A Philosophical Interpretation* (Evanston: Northwestern University Press, 1968), p. 5). Although Platonism and Neoplatonism remain central throughout my study, I broaden what I see as the core of these doctrines' thinking on art with the term essentialism (I explain this shift in terminology more fully in the latter part of Chapter 1).

3 See Richard A. Lanham, *The Motives of Eloquence: Literary Rhetoric in the Renaissance* (New Haven: Yale University Press, 1976).

4 On this crucial side of abstract art, see *The Spiritual in Art: Abstract Painting 1890–1985* (New York: Abbeville Press, 1986) and the *Art Journal* 46, 1 (Spring 1987), which is dedicated to these issues.

5 In many ways this is also what could be called a "deconstructive" reading, but given this term's relative unfamiliarity in the visual arts and the controversy surrounding the relation of poststructuralism and postmodernism, I prefer to use the broader notion of "postmodernism," as defined in my Postscript, where this issue is raised again.

6 Paul de Man, *Allegories of Reading: Figural Language in Rousseau, Nietzsche, Rilke, and Proust* (New Haven: Yale University Press, 1979), p. 118. David Carroll discusses this form of rigor in *Paraesthetics: Foucault. Lyotard. Derrida* (New York: Methuen, 1987), p. 15.

7 On this phenomenon, see especially Norman Bryson's "Introduction" in Norman Bryson, ed., *Calligram: Essays in New Art History from France* (Cambridge: Cambridge University Press, 1988), *The New Art History,* ed. A.L. Rees and F. Borzello (London: Camden Press, 1986), and Serge Guilbaut, "Art History after Revisionism: Poverty and Hopes" *Art Criticism,* 2, 1 (1986), pp. 39–50.

8 Thomas Crow, in opening remarks to his paper in the "Art & Society" session at the College Art Association annual meeting in Los Angeles,

February 1985. The proceedings of this important session have been published in *Representations* 12 (Fall 1985).

CHAPTER I. SECTION I

1 Unpublished letter from Gauguin to van Gogh, September 1888, cited in John Rewald, *Post-Impressionism from Gauguin to Van Gogh,* 3rd. ed. (New York: The Museum of Modern Art, 1978), p. 186.

2 Translation from Hershel B. Chipp, *Theories of Modern Art* (Berkeley: University of California Press, 1968), p. 67.

3 Terminology presents problems in this context because of the very free and unsystematic use of ancient philosophy in the late nineteenth century. I refer to "neoplatonism" and its cognates with a lower case "n" in order to signal that Gauguin, Sérusier, Aurier, and the many others who employed neoplatonic doctrines, made their own singular mix (to paraphrase Maurice Denis) of this body of theory. They were not always referring to what we now call *Neoplatonism,* that is, the philosophies of Plotinus, Porphyry, Proclus and others, seen both as discrete entities and in terms of the traditions they began. Within the term *neoplatonism,* I also include interpretations of Plato's thought crucial to the advent of abstract painting. Artists and theorists around 1900 drew freely from this broad range of philosophy, so it is frequently difficult to pinpoint exact sources. In any case, my aim is to demonstrate that essentialist thinking – of which neoplatonism is a prime example – with its characteristic anti-materialism, sense of a transcendent absolute, and focus on the self, underlies the move to abstraction that we see beginning in Synthetism.

 Two authors in particular have noted the general importance of Neoplatonism to the art history and theory of the late nineteenth century. See H. R. Rookmaaker, *Gauguin and Nineteenth-Century Art Theory* (Amsterdam: Swets and Zeitler, 1972) and Patricia Mathews, "Aurier and Van Gogh: Criticism and Response" *Art Bulletin,* 68, 1 (March, 1986), p. 96; and *idem, G.-Albert Aurier's Symbolist Art Criticism and Theory* (Ann Arbor, Mich.: UMI Research Press, 1986).

4 Critics disagree about the possibility of a direct connection between "abstraction" as the Synthetists used the term and its development in the early twentieth century. A summary of recent arguments pro and con can be found in Carol Donnell-Kotrozo, *Critical Essays in Postimpressionism* (London and Toronto: Associated University Presses, 1983), pp. 22, 41 n. 22. I contend that the essentialism common to experiments with abstraction before and after 1900 provides both an historical and a conceptual link between the Synthetists in the 1880s and the early twentieth-century abstractionists.

5 Vojtech Jirat-Wasiutynski, *Paul Gauguin in the Context of Symbolism* (New York: Garland, 1978), pp. 320 ff.

6 Gauguin's description of the Impressionist as one who "portant toujours une chaine pour le monde" calls to mind the conventional French translation of Plato's characterization of the prisoners whose legs and necks are "pris dans les chaines" (*La Republic,* trans. E. Chambry (Paris: 1921), Bk. VII, 514a). A literal translation of Gauguin's words might omit the verb "shackled" and read "who always carries a chain

for the world." This enigmatic phrase certainly gives the sense of the artist as a social and economic outcast, like Jean Valjean, but the crucial reference to "chain" has additional implications that I want to draw out.

All subsequent references to the *Republic* are to the Francis MacDonald Cornford translation (Oxford: Oxford University Press, 1941) and appear in the text.

7 For an excellent account of myth's role in Plato's thought, see Julius A. Elias, *Plato's Defence of Poetry* (Albany: State University of New York Press, 1984). I will return to what he calls the "methodological" function of the allegory of the cave.

8 Ibid., p. 135.

9 Cited in Wladyslaw Jaworska, *Gauguin and the Pont-Aven School*, trans. Patrick Evans (Greenwich, CT: New York Graphic Society, 1972), p. 68.

10 Ibid.

11 *Diverse Choses* exists as an unpublished ms., selections of which are translated in Chipp and in Daniel Guérin, ed., *The Writings of a Savage: Paul Gauguin* (New York: Viking, 1978). This reference is to Chipp, *Theories*, p. 65.

12 Chipp, p. 65.

13 Cited in René Huyghe, *Gauguin*, trans. Helen C. Slonim (New York: Crown Publishers, 1959), p. 41.

14 I will discuss this collaboration later in this section of Chapter 1.

15 Chipp, p. 65.

16 The so-called Turkish Painter's Manual, lent by Gauguin to Seurat under the pretext that it was an authentic Near Eastern manuscript, is discussed by Robert L. Herbert in "Seurat in Chicago and New York," *Burlington Magazine* 100, 662 (May 1958), p. 151.

17 Plotinus, *Enneads*, trans. Stephen Mackenna, 2nd ed., (London, Faber and Faber, 1956), V, 5,7. Subsequent references appear in the text.

18 For a discussion of this widespread visual metaphor, see Jirat-Wasiutynski, *Paul Gauguin*, p. 316.

19 Merete Bodelson, *Gauguin's Ceramics: A Study in the Development of His Art* (London: Faber and Faber, 1964), p. 112.

20 Ibid.

21 Cited in Huyghe, *Gauguin*, p. 90. Memory, of course, was also a focal point for academic pedagogy of the sort that Gauguin abhorred. Here the artist's eye was trained to copy what Gauguin the essentialist would have considered the superficial details of nature. For an example of this tradition, see Lecoq de Boisbaudran, *The Training of the Memory in Art*, trans. L.D. Luard (London: Macmillan and Co., 1911).

22 Plotinus's discussion is, of course, an early moment in a long history of apologies to Plato's disparagement of art. As I will argue more fully below, Gauguin and the other abstractionists discussed in this book can be fruitfully understood as apologists in this line.

23 Elias, *Plato's Defence*, p. 184.

24 Cited in Jean Pierrot, *The Decadent Imagination, 1880–1900*, trans. Derek Coltman (Chicago: University of Chicago Press, 1981), p. 24, n. 57.

25 See, for example, the introduction to the section on Symbolism in Chipp, *Theories*, pp. 51–3. Huyghe rightly notes Gauguin's caution regarding literary theory but concludes, against the evidence of Gau-

guin's considerable output as a writer, that he therefore saw painting as "creation" and writing as parasitic (*Gauguin,* p. 29, n.1). Jaworska is more generous about Gauguin's abilities as a theorist, but the following passage reverts to the conventional, negative attitude: "certain of Gauguin's writings . . . are full of remarkable and *unexpected* theoretical formulations" (*Gauguin and the Pont-Aven School,* pp. 26, 29; my emphasis). Balancing these views, Bogomila Welsh-Ovcharov points to Gauguin's considerable interest in art theory (*Vincent van Gogh and the Birth of Cloisonism* (Toronto: Art Gallery of Ontario, exhibition catalogue, 1981), p. 47). Georges Wildenstein holds open the possibility of significant theorizing by stating that "despite appearances, Gauguin, more than many artists, desired to introduce his ideas and his philosophizing into his work" ("L'idédologie et l'ésthetique dans deux Tableaux-clés de Gauguin" in Wildenstein, ed., *Gauguin: Sa Vie, Son Oeuvre, Re-Union de Textes, d'Etudes, de Documents* (Paris: Busson, 1958), p. 139). Gauguin's own words suggest that he did theorize and that he was open to the influence of what he read. "When a painter is in action he must be moved, but prior to that he thinks. Who is to say that something I have thought, or read, or enjoyed did not influence one of my works several years later?" (*Diverse Choses,* Guérin, *Paul Gauguin,* p. 129).

26 Guérin, *Paul Gauguin,* p. 230.

27 Denis, *Théories, 1890–1910* (1920) in Chipp, *Theories,* p. 102.

28 Ibid.

29 Guérin, *Paul Gauguin,* p. 231.

30 The French reads "du Platon plastiquement interprété par un sauvage de génie"; it was first published in Aurier's "Le Symbolism en peinture: Paul Gauguin," *Mercure de France* II (1891), pp. 159–64, and again in his article "Les Symbolistes, *Revue Encyclopédique* (1892), p. 482, from which I quote.

31 Guérin, *Paul Gauguin,* p. 253.

32 As Ronald Pickvance calls them in *Van Gogh in Arles* (New York: Metropolitan Museum of Art, 1984), p. 216.

33 Cited in Rewald, *Post-Impressionism,* p. 198.

34 Chipp, *Theories,* p. 43.

35 Cited in Rookmaaker, *Gauguin and 19th Century Art Theory,* p. 142.

36 Ibid., p. 165.

37 See the facsimilie edited by Suzanne Damiron (Paris: Université de Paris, 1963). This ref.: Damiron, n.p.

38 *Mercure de France,* Février, 1895, p. 222. My translation.

39 Letter to Schuffenecker, August, 1888. See Chipp, *Theories,* p. 60.

40 Inge Jonsson, *Emanuel Swedenborg,* trans. Catherine Djurklov (New York: Twayne, 1971), pp. 191–2.

41 See Robert P. Welsh, "Sacred Geometry: French Symbolism and Early Abstraction" in *The Spiritual in Art,* p. 67, for a discussion of the difficulties in determining the extent and chronology of Gauguin's knowledge of Theosophy.

42 Verkade, *Yesterdays of an Artist-Monk,* trans. John L. Stoddard (New York: P.J. Kennedy & Sons, 1930), p. 102.

43 For discussions of these connections, see especially Rewald, *Post-Impressionism,* and Sven Loevgren, *The Genesis of Modernism: Seurat, Gauguin, van Gogh and French Symbolism in the 1880s,* revised ed. (Bloomington: Indiana University Press, 1971).

44 See Pierrot, *The Decadent Imagination*, p. 77.

45 Richard Shiff, *Cézanne and the End of Impressionism: A Study of the Theory, Technique, and Critical Evaluation of Modern Art* (Chicago: University of Chicago Press, 1984), p. 5.

46 Julius Kaplan, *The Art of Gustav Moreau: Theory, Style, and Content* (Ann Arbor: UMI Research Press, 1982), p. 12. See also A.G. Lehmann, *The Symbolist Aesthetic in France 1885–1895* (Oxford: Basil Blackwell, 1950), p. 38.

47 Frederic Will, *Flumen Historicum: Victor Cousin's Aesthetic and Its Sources,* University of North Carolina Studies in Comparative Literature, No. 36 (Chapel Hill: North Carolina University Press, 1965), p. 14.

48 I will consider the attractions of essentialism further in Chapter 4.

49 Will, *Flumen*, p. 21.

50 Ibid., p. 6.

51 Ibid., p. 24. My translation.

52 Pierrot, *The Decadent Imagination*, pp. 55–6.

53 Ibid., p. 59.

54 Cited in Réne-Pierre Colin, *Schopenhauer en France: Un mythe naturaliste* (Lyon: Presses Universitaires, 1979), p. 207.

55 Lehmann, *The Symbolist Aesthetic*, p. 40.

56 On Schopenhauer and Plato, see Hilde Hein, "Schopenhauer and Platonic Ideas," *Journal of the History of Philosophy* 4 (1966), pp. 133–44. See also J.P. Stern, *Reinterpretations: Seven Studies in Nineteenth-Century German Literature* (London: Thames and Hudson, 1964).

57 Schopenhauer, *The World As Will And Representation*, trans. E.F.J. Payne, 2 vols. (New York: Dover, 1969), vol. I, p. 233. Subsequent references appear in the text with the volume number preceding the page reference.

58 Schopenhauer held these two ultimate realities to be "absolutely the same" (I, 173).

59 Cited in Pierrot, *The Decadent Imagination*, p. 58.

60 Gauguin, for example, described his painting *Pape Moe* ("Mysterious Water") as a "form which materializes a pure idea." (*Diverses Choses,* Guérin, *Paul Gauguin,* p. 139).

61 Guérin, *Paul Gauguin,* p. 39.

62 Ibid., p. 137.

63 See Rewald, *Post-Impressionism,* p. 177.

64 Ibid., pp. 502–04.

65 This interpretation would, for example, add extra resonance to Jirat-Wasiutynski's statement that "It is Gauguin's adoption of Bernard's ideas about working from memory that mark the major . . . departure . . . and Gauguin's debt to Bernard." (*Paul Gauguin,* p. 92).

66 Guérin, *Paul Gauguin,* p. 68.

67 Gauguin was interested in the South Seas well before his trip to Panama and Martinique with Laval in 1887.

68 These observations were made by Roger Mesely in a talk on Gauguin at the Universities Art Association of Canada meeting, in November, 1984. Welsh-Ovcharov is, I believe, mistaken in seeing this space as an open door (*Vincent van Gogh,* p. 174).

69 Pierrot, *The Decadent Imagination,* p. 212.

70 Mark Roskill, *Van Gogh, Gauguin and the Impressionist Circle* (London: Thames and Hudson, 1970), p. 239.

71 Welsh-Ovcharov (*Vincent van Gogh*, pp. 46–7) and Jirat-Wasiutynski (*Gauguin*, p. 17) agree on this dating. Chipp; following Rewald, opts for 1888 on the grounds that the ideas expressed in this text are Synthetist.

72 Chipp, *Theories*, p. 61.

73 Aurier, *Oeuvres Posthumes* (Paris: Mercure de France, 1893), pp. 212–13; cited in Chipp, *Theories*, p. 90.

74 Aurier read Plotinus and Plato, but his ideas were also inspired directly by Schopenhauer. See Loevgren, *The Genesis of Modernism*, p. 156.

75 On the importance of the senses and matter in Plato, see Elias, *Plato's Defence*, pp. 3, 194, 197, 223.

76 Guérin, *Paul Gauguin*, p. 69.

77 Cited in Huyghe, *Gauguin*, p. 29 (emphasis mine).

78 Rookmaaker, *Gauguin*, p. 124; Rewald, *Post-Impressionism*, p. 175.

79 Aurier, *Oeuvres*, p. 31.

80 Aurier's formulation was not unique. In his *Traite du Narcisse* (1891), for example, André Gide referred to "chaste Eden, jardin des Idées." See Lehmann, *The Symbolist Aesthetic*, pp. 68–9. As we will see in Chapter 2, Mondrian also relies on the authority of Eden.

81 Debora Leah Silverman, "Nature, Nobility, and Neurology: The Ideological Origins of 'Art Nouveau' in France, 1889–1900," Ph.D. dissertation (Princeton University, 1983), p. 149.

82 Aurier, *Ouevres*, p. 269; cited in Chipp, *Theories*, p. 94.

83 It should be remembered in this regard that the 1880s were also years of economic hardship throughout Europe. Gauguin lost his job as a result, and there was a common feeling of insecurity.

84 Chipp, *Theories*, p. 88.

85 Aurier, *Ouevres*, p. 215.

86 Ibid., p. 262.

CHAPTER I. SECTION II

1 Quoted from Sérusier's *A B C de la Peinture* in Jaworska, *Gauguin and the Pont-Aven School*, p. 84, n. 46. My translation. I cite Jaworska because this quotation does not appear in the now more readily available 1950 edition of the *A B C* to which I refer in the balance of this book.

2 Denis, "The Influence of Paul Gauguin," (1903), in Chipp, *Theories*, p. 101. The most detailed discussion of Sérusier's painting lesson is Caroline Boyle-Turner "Sérusier's Talisman," *Gazette des Beaux-Arts*, 105 (May-June 1985), pp. 191–6. On Sérusier in general, see Boyle-Turner, *Paul Sérusier* (Ann Arbor: UMI Research Press, 1983).

3 Quotations are from the *Plato's Phaedrus*, trans. R. Hackforth (Cambridge: Cambridge University Press, 1952, rpr. 1979).

4 The implications of Plato's privileging of speech over writing are taken up by Jacques Derrida in *Dissemination*, trans. Barbara Johnson (Chicago: University of Chicago Press, 1981). See also Gregory L. Ulmer, *Applied Grammatology: Post(e)-Pedagogy from Jacques Derrida to Joseph Beuys* (Baltimore: Johns Hopkins University Press, 1985). On "copies," "simulacra," and "models" in Plato, see Gilles Deleuze, trans.

Rosalind Krauss, "Plato and the Simulacrum," *October* 27, (Fall 1984), pp. 44–56.

5 Derrida, *Dissemination*, p. 135.

6 Published in 1921, this is a late text that came out of Sérusier's teaching; most of its ideas were nonetheless formulated in the 1890s. References are to the Librarie Floury ed., (Paris, 1950). Translations are my own.

7 Sérusier, *A B C*, pp. 13, 13, 8.

8 "Sérusier," in Denis, *Théories, 1890–1910*, 4th ed., (Paris: Rouart et Watelin, 1920), p. 147. My translation.

9 Marcel Guicheteau, *Paul Sérusier*, (Paris: Side, 1976), p. 9.

10 As we have seen, he was not alone in this, since Aurier, Bernard, and Gauguin were all moving in the same direction. Sérusier, however, was acknowledged (by Denis especially) to have codified Synthetist ideas and practices philosophically. I am more concerned in any case to illuminate the existence and ramifications of Platonism in the advent of abstract painting than to ascribe chronological priority to any individual member of the Synthetist circle. Following Heidegger's distinctions, I am using "Platonism" and "Neoplatonism" as historicized doctrines, that is, as philosophies as they were construed in a particular context. See Martin Heidegger, *Nietzsche*, Vol. I, *The Will to Power as Art*, trans., David F. Krell (London: Harper and Row, 1979), p. 151. It should also be noted that Sérusier and those around him responded to mystical and religious teachings that, while analogous with Platonism, were also separate. I am not claiming that Platonism was their sole inspiration.

11 In the late nineteenth century, alchemy was a common image for aesthetic purification. See Mathews, *Aurier*, p. 26.

12 Verkade, *Yesterdays*, p. 77.

13 Ibid., p. 79.

14 Sérusier's interest in various aspects of mysticism was extensive. He read Swedenborg, the mystic "Papus" (Gerard Encausse), and even composed illustrations for Edouard Schuré's immensely influential book *Les Grands Initiés* (1889). (See Verkade, *Yesterdays*, pp. 77, 102.) Both Papus and Schuré emphasized the neoplatonic foundations of their work. The former claimed that " 'the path that has led us to our present concepts . . . stretches back to ideas taught . . . as early as 2600 B.C., ideas that later formed the basis of Platonism and . . . Neoplatonism' " (Pierrot, *The Decadent Imagination*, p. 116). Schuré related the inspiration for his mystical philosophy as follows: "one day, lost in the labyrinth of the mysterious contained in the pages of Plato and Porphyry, Iamblichus and Apuleius, my inner vision suddenly extended its bounds beyond the horizon." (Schuré, *The Ancient Mysteries of the East* (Blauvelt, New York: Rudolf Steiner Publications, 1971), p. 17). Sérusier's commitment to a mathematical mysticism – in which pure geometrical forms embody Reality – is evident in his *A B C de la peinture*, even the title of which relies on the belief that the first letters of the alphabet stand for fundamental geometrical principles. One immediate source for this thinking was Papus's *Traite Elementaire de Science Occulte* (1888), where we read that "the circle . . . represents the eternal cycle. The triangle, the form of the number three, signifies the idea, and when directed upward . . . multiplicity moving towards unity" (Cited in George Mauner, "The Nature of Nabi Symbolism" *Art Journal* XXIII (Winter 1963–4), p. 101). Sérusier said that "syn-

thesis consists in containing all possible forms within the small number of forms which we are capable of conceiving: straight lines, the several angles, arcs of circles, and ellipses. Outside of these we become lost in an ocean of varieties" (Denis, *Théories*; cited in Chipp, *Theories*, p. 105). This comment confirms Verkade's claim that Sérusier "spoke frequently . . . of the mysteries of numbers" (Verkade, *Yesterdays*, p. 79). The ultimate source for the mystical interpretation of geometry is Plato in the *Meno, Phaedo,* and *Timeaus,* who, along with Plotinus, also stressed the all-important notion of unity to which Sérusier refers. Sérusier's interest in mathematical absolutes was also inspired by Didier Lenz's ideas, as taught at the Beuron monastery in Germany, where Sérusier studied in the 1890s. See Boyle-Turner, *Sérusier,* Chap. 8.

15 W.D. Woodhead trans., in Hamilton, Cairns, eds., *The Complete Dialogues of Plato,* (Princeton: Princeton University Press, 1973).

16 See Stanley Fish, *Self-Consuming Artifacts: The Experience of Seventeenth-Century Literature* (Berkeley: University of California Press, 1972), and Derrida, *Dissemination,* pp. 124–5.

17 Van Gogh to Theo, autumn 1888. *The Complete Letters of Vincent van Gogh,* 3 Vols., (London: Thames and Hudson, 1959), No. 607.

18 As I have mentioned, Sérusier did have doubts until he saw the Volpini show, but his adoption of Gauguin's ideas was then fanatical. For a chronology of these events, see Welsh-Ovcharov, *Vincent van Gogh,* pp. 370–2.

19 I will discuss the issue of gender in the advent of abstract painting in Chapter 4.

20 Welsh-Ovcharov, *Vincent van Gogh,* p. 371.

21 Boyle-Turner, *Sérusier,* p. 14.

22 Welsh-Ovcharov, for example, states the case thus: "although this painting was painted from nature rather than memory and contains an identifiable landscape setting, those who wish to interpret it as the first small step leading to the abstract art of the twentieth century will continue to do so, little deterred by a knowledge of its actual circumstances of origin" (*Vincent van Gogh,* p. 372). My claim, elaborated later, is that Sérusier did use memory in its Platonic sense to execute other works similar to the *Talisman* and that the Platonic premises necessary for and embodied in these paintings do filiate them, both historically and conceptually, with the abstract art of the early twentieth century. For a review of the debate surrounding the significance of Sérusier's *Talisman,* see *Post-Impressionism: Cross-Currents in European Painting* (London: Royal Academy, exhibition catalogue, 1979–80), p. 128.

23 Chipp, *Theories,* p. 94.

24 Ibid., p. 89.

25 Ibid., p. 93.

26 Ibid., p. 89.

27 Ibid., p. 93.

28 Cited in Rewald, *Post-Impressionism,* p. 255.

29 Sérusier, *A B C de la Peinture,* p. 72. This emphasis on hierarchy is central in the development of essentialist abstraction, as we will see in Chapter 2 especially. For Denis as well as Sérusier, to synthesize is "to put in hierarchic order" (Denis, *Theories,* in Chipp, p. 105).

30 See Derrida, *Dissemination,* p. 99.

31 See Derrida, *Dissemination,* p. 105, and Heidegger, *Nietzsche,* Vol. 1, for these connections.

32 Richard Rorty, *Consequences of Pragmatism: (Essays: 1972–1980)* (Minneapolis: University of Minnesota Press, 1982), p. xix.

33 Like so many late nineteenth- and early twentieth-century artists, Sérusier ultimately transcended art in religion. He ends the passage (cited above) about rejecting the Bretons and other motifs in his painting by pledging to restrict himself to an art "plus sévère et sacré."

34 Sérusier, *A B C,* p. 33. Emphasis mine.

35 See Derrida, *Dissemination,* p. 112.

36 Elias, *Plato's Defence,* p. 9.

37 See Heidegger's explication of this point in *Nietzsche,* vol. 1, Chap. 20.

38 Erwin Panofsky, *Idea: A Concept in Art Theory,* trans. J.S. Peake (New York: Harper & Row, 1968), p. 5. I will discuss this paradox in Chapter 4.

39 On the nature and history of the apology and defense as a form, see Margaret W. Ferguson, *Trials of Desire: Renaissance Defenses of Poetry* (New Haven: Yale University Press, 1983).

40 Maurice Tuchman, "Hidden Meanings in Abstract Art," in *The Spiritual in Art,* p. 20.

41 Derrida, *Dissemination,* p. 191.

42 Marcuse, "The Concept of Essence," in J. J. Shapiro, trans., *Negations: Essays in Critical Theory* (London: Penguin Press, 1968), p. 43.

43 Heidegger, *Nietzsche,* vol. 1, p. 201.

44 Elias argues that Plato's myths are vehicles to truths from which dialectic itself is barred.

45 This would substantiate W. J. T. Mitchell's provocative claim that "behind every theory of imagery is some form of the fear of imagery." *Iconology: Image, Text, Ideology* (Chicago: University of Chicago Press, 1986), p. 159.

46 In making this transition from one art to another, it is worth reiterating the point that Plato's views on poetry are largely interchangeable with his opinions of the other arts, especially painting. See Elias, *Plato's Defence,* p. 2.

47 There can be little doubt that both artists knew writings by Plato, Plotinus, and other "essentialist" thinkers. Both Mondrian and Kandinsky were familiar with the theosophical texts that credited Plato with the claim that "God geometrizes," (see Sixten Ringbom, "Transcending the Visible: The Generation of the Abstract Pioneers," *The Spiritual in Art: Abstract Painting 1890–1985,* pp. 138, 147) and with Schuré's *Grandes initiés,* where Plato is acclaimed as a mystical leader. Kandinsky even noted Plato in this regard in a sketchbook reference to Schuré's book (see Jonathan Fineberg, *Kandinsky in Paris 1906–1907* (Ann Arbor: UMI Research Press, 1984), p. 41. n. 13). More important to my project than specific allusions to sources, however, is the allegiance these artists had to the essentialist metaphysics proclaimed by the Platonic tradition.

48 It is true that many of Mondrian's writings are retrospective in the sense that they presuppose his pictorial experiments and try to codify them. The best example, discussed by Welsh, is his use of early landscape paintings as the basis for some of the scenes he sets in "Natural Reality and Abstract Reality," 1919–20. (See Robert P. Welsh, *Piet*

Mondrian's Early Career: The 'Naturalistic' Periods (New York: Garland,
1977), pp. 106, 110, 114.) This is a crucial maneuver on the artist's
part, and I will return to it in the context of his self-purification in
Chapter 2. Other authors have emphasized the priority of Mondrian's
practice (see, for example, the essays by James and by Holtzman in
their edition of Mondrian's writings), or, in the case of another em-
inent commentator, H. L. C. Jaffé, the primacy of "conception" over
"execution." (*De Stijl 1917–1931: Visions of Utopia* (Minneapolis:
Walker Art Center, 1982), p. 12). See also Kermit Swiler Champa,
Mondrian Studies (Chicago: University of Chicago Press, 1985, p. xiii).
By discussing Mondrian's overall aesthetic endeavour as an apology
for art, however, I wish to demonstrate the common purpose and
productive integration of these two aspects of his work and thus
provide a clearer understanding of its overall importance.

CHAPTER 2

1 See Erwin Panofsky, *Idea: A Concept in Art Theory,* Joseph J. S. Peake,
 trans. (New York: Harper and Row, 1968). Mondrian's essentialism
 is conceptually close to that of Bellori, who argued that the artist's
 idea is not *a priori* but exists only after purification, though it is unlikely
 that Mondrian drew directly on this source. The philosophical tra-
 dition he did employ will be considered later in this chapter.

2 This is certainly true of Mondrian's early naturalistic work, though
 it could be argued that during World War I – when he was in the
 Netherlands and concerned to formulate the theory of his painting –
 he articulated the essentialist position that came to direct his practical
 experiments. As his letter to the critic Querido (discussed below)
 suggests, he was moving in this direction by 1909.

3 I am of course aware that this view of Mondrian is controversial and
 I am not in any way suggesting that the case is closed (rather, that
 this side of the issue should be heard). In a recent article that is im-
 pressive in its detailed discussion of Mondrian's New York work, for
 example, Yve-Alain Bois argues that this late work had as its "goal
 . . . to prohibit any stasis or fixing of perception in a systematic as-
 surance" ("Piet Mondrian: *New York City,*" *Critical Inquiry* 14 (Winter
 1988), p. 252). While I agree that this was Mondrian's *purpose,* and
 that (as his conversations with Carl Holty, which are discussed in
 Chapter 4, show) he was very aware of immanent dynamism versus
 transcendent "repose," I will argue that, even allowing for the changes
 in Mondrian's thinking and plastic expression discussed by Bois, Mon-
 drian habitually worked towards a fixed absolute that ultimately en-
 tailed the abrogation of art itself.

4 Mondrian was well versed in Hegelian thinking. He refers in several
 essays to the Dutch philosopher C. J. P. J. Bolland, and we know
 that Van Doesburg advised Mondrian to read Hegel's own texts (see
 J. Baljeu, "The Problem of Reality with Suprematism, Constructiv-
 ism, Proun, Neoplasticism and Elementarism," *Lugano Review,* 1, 1,
 1965, p. 119). I will return to the Hegelian subtext later in this chapter
 and to the question of abrogation in Chapter 4.

5 Cited in Carl Holty, "Mondrian in New York: A Memoir," *Arts Digest* 31, 10 (September 1957), p. 21.

6 Here and in my subsequent uses of this central passage, I have substituted Seuphor's translation "mirror" for the now-standard translation's "reflection," because this rendering better maintains the metaphysical implications of Mondrian's assertion.

7 On the importance of Mondrian's response to Querido's discussion of his work, see Carel Blotkamp, "Annunciation of the New Mysticism: Dutch Symbolism and Early Abstraction," *The Spiritual in Art*, p. 98. For the text of the letter, see Robert Welsh and J. M. Joosten, trans., eds., *Two Mondrian Sketchbooks 1912–1914* (Amsterdam: Meulenhoff International, 1969), p. 10.

8 I will discuss the gender implications of Mondrian's ideology of pure abstraction in Chapter 4.

9 It should be clear from what I have said so far about Mondrian's painting that I do not subscribe to the notion that his work can best be understood in terms of its (admittedly complex and fascinating) formal problems. The most outspoken proponent of this view is Champa. He claims in *Mondrian Studies* to attend only to "the paintings themselves" (xiii). Thus, when he writes of Mondrian's passion for right angle intersections, for example, he describes the radical purity of these means only in terms of their formal implications. Here and in Chapter 4, I hope to show that this sort of reading – notwithstanding how illuminating it can be for individual works – is blind to the theoretical foundations and import that largely determined Mondrian's Neoplasticism and that certainly inform our assessment of his work today.

10 Mondrian's response to Querido, 1909, in *Two Mondrian Sketchbooks*, p. 10.

11 Ibid.

12 Ibid.

13 Plato makes the same assertion in the *Symposium* (211).

14 J. Baljeu, "The Problem of Reality," 115. It is likely that Brouwer in turn derived this idea from Hegel, who, in the *Phenomenology*, describes truth as "simple repose." (Hegel, *The Phenomenology of Spirit*, trans. A. V. Miller (New York: Oxford University Press, 1977), p. 27.

15 See especially Robert P. Welsh, "Mondrian and Theosophy," in *Piet Mondrian 1872–1944: A Centennial Exhibition* (New York: Solomon R. Guggenheim Museum, exhibition catalogue, 1971), pp. 35–52, and Sixten Ringbom, "Transcending the Visible: The Generation of the Abstract Pioneers," in *The Spiritual in Art*, pp. 131–53.

16 See Henkels, "Mondrian in His Studio," p. 235.

17 For Mondrian's relationship to Symbolism, see Martin S. James, "Mondrian and the Dutch Symbolists," *Art Journal*, XXIII, (1963–4), pp. 103–11, and Robert Welsh, "Sacred Geometry: French Symbolism and Early Abstraction," *The Spiritual in Art*, pp. 63–87.

18 Cited in Jaffé, *De Stijl*, p. 113.

19 Ibid.

20 Ibid., p. 55. Van Doesburg presents a fascinating parallel to this metaphysic in his story "The Legend of Bimbisara," of 1916. As Hedrick writes, in this tale "the Buddha himself delivers Van Doesburg's opinion of the invalidity of representational art by telling the artist that the relationship of the outline of his reflection [a *shadow* cast on cloth]

is the same as the relationship of . . . knowledge to true knowledge . . . of 'art and that which is created by man to the Eternal Life and that which is not created'." Hannah L. Hedrick, *Theo Van Doesburg: Propagandist and Practitioner of the Avant-Garde, 1905–1923* (Ann Arbor: UMI Research Press, 1980), pp. 22–3.

21 This is especially true with regards to Hegelianism, because as one critic suggests, Theosophy "can be considered as a mystical offshoot of Hegelian historicism that stresses the evolution of 'spirit' rather than culture." See Lucian Krukowski, "Hegel, 'Progress,' and the Avant-Garde" *Journal of Aesthetics and Art Criticism* XLIV, 3 (Spring 1986), p. 279, n.2. Theosophy also explicitly traced its roots to Plato. See n.22, below.

22 Welsh, "Mondrian and Theosophy," p. 37. See also Els Hoek, "Piet Mondrian," *De Stijl: The Formative Years,* trans. C. and A. Loeb (Cambridge, Mass.: MIT Press, 1986), p. 59.

23 Welsh, "Mondrian and Theosophy," p. 48.

24 Henkels, "Mondrian in His Studio," p. 238. Henkels substantiates his claim with a passage from Mondrian's "Realist and Superrealist Art (Morphoplastic and Neo-Plastic)" of 1930, in which the discourse on light metaphysics as an image of truth is reminiscent of Plato's discussion of the cave in the *Republic.* Typical of this link is Mondrian's fragmentary image "Absence of certainty. Waiting for daylight" (228). See Henkels, pp. 255–565. On Superville, see Barbara M. Stafford, *Symbol and Myth: Humbert de Superville's Essay on Absolute Signs In Art* (New Jersey: Associated University Presses, 1979). As Stafford points out, Superville drew on Plato's *Philebus* for the theory of absolute geometric forms, and his ideas were popularized through Charles Blanc's color theory, which Mondrian would have known.

25 Welsh, "Mondrian and Theosophy," p.45. I will discuss this painting further in Chapter 4.

26 Ibid., pp. 43, 40. The eyes in this work should be compared with those in pieces by Gauguin and Sérusier discussed in Chapter 1, (Figs. 1 and 2). If we follow Steiner's theory, where the open eyes indicate a higher form of spirituality, then we could see Mondrian's work as an evolution from that of Gauguin and Sérusier. Such a view would certainly accord with Mondrian's teleological thinking, but there is no reason to suggest that he consciously developed these earlier images of the turn inward.

27 Henkels, "Mondrian in His Studio," p. 245.

28 Ibid., p. 246; my emphasis. The connection with Plato's prisoner as examined in Chapter 1 stems, I believe, from artists' use of a common philosophical source.

29 Welsh, "De Stijl: A Reintroduction," in *De Stijl 1917–1931: Visions of Utopia,* p. 26.

30 See Martin S. James, "Piet Mondrian: Art and Theory to 1917," p. 18. On dialectic, see Baljeu, "The Problem of Reality."

31 On Van Doesburg's intellectual proclivities, see J. Baljeu, *Theo Van Doesburg* (New York: Macmillan, 1974).

32 Cited in Jaffé, *De Stijl,* p. 54.

33 Ibid., p. 55.

34 On this topic, see William Desmond, *Art and the Absolute: A Study of Hegel's Aesthetics* (Albany: State University of New York, 1986).

35 G. W. F. Hegel, *Aesthetics: Lectures on Fine Art,* trans. T. M. Knox, 2 vols. (Oxford: Clarendon, 1975), vol. 1, p. 31.

36 Hegel's is the fullest articulation of this fundamental teleolgy, though Mondrian, as usual, could well have developed aspects of the idea from other texts, particularly those of Theosophy, where there is a considerable imbrication with Hegel's concept of consciousness's evolution. In a letter of 1914 to his friend the Dutch Cubist L. Schelfhout, for example, Mondrian confided that he found the teaching of "Theosophy valid [in that] it leads towards clarity in the spiritual evolution. ...It seems to me that the attainment of conscious knowledge is the primary goal of everyone." Cited in Welsh, Joosten, eds., trans., *Two Mondrian Sketchbooks,* n.49. Though an exact date for these interests is difficult to determine, it is likely that Mondrian was familiar with Theosophy before he read Hegel. He joined the Dutch Theosophical Society in 1909; Van Doesburg's advice to read Hegel came almost a decade later.

37 As Welsh puts it, "it is difficult not to think of [the dusk works of c. 1905–07] when reading the first two scenes." *Piet Mondrian's Early Career: The "Naturalistic" Periods* (New York: Garland, 1977), p. 106.

38 Desmond, *Art and the Absolute,* p. 28.

39 The sense that we are looking at a picture when we are "really" seeing a natural landscape provides a fascinating, though historically unconnected, reversal of Diderot's slight of hand when he discusses six of Joseph Vernet's painted landscapes from the Salon of 1767 by pretending to walk through them as he could physical nature. See Michael Fried, *Absorption and Theatricality: Painting and Beholder in the Age of Diderot* (Berkeley: University of California Press, 1980), pp. 122–7.

40 Hegel, *Aesthetics,* vol, 1, p. 55.

41 I will discuss issues arising from art's potential for self transcendence – another consequence of Mondrian's teleology – more fully in Chapter 4.

42 Desmond, *Art and the Absolute,* p. 1.

43 Hegel, *Aesthetics,* vol. 1, p. 22.

44 Hegel, *Aesthetics,* vol. 1, pp. 141–2.

45 Cited in *The New Art – The New Life: The Collected Writings of Piet Mondrian,* p. 82. The editors of course note the parallel between this description and the third scene in "Natural Reality and Abstract Reality."

46 On this topic, see Robert P. Welsh, "The Birth of De Stijl, Part I: Piet Mondrian: The Subject Matter of Abstraction," *Artforum* 11 (April 1973), p. 53.

47 Michael Podro, *The Manifold in Perception: Theories of Art from Kant to Hildebrand* (Oxford: Clarendon Press, 1972), p. 92. Given Schopenhauer's importance, it is odd that relatively little has been written about his relationship with the visual arts. One notable exception is Reed Way Dasenbrock's *The Literary Vorticism of Ezra Pound and Wyndham Lewis: Towards the Condition of Painting* (Baltimore: Johns Hopkins University Press, 1985).

48 Schopenhauer's philosophy is replete with references to both the Eastern and Western mystical traditions.

1 Nina Kandinsky, *Kandinsky und Ich* (Munich: Kindler, 1976), p. 202. Cited in Christian Derouet, "Kandinsky and Paris: 1934–1944," *Kandinsky in Paris, 1934–1944* (New York: Solomon R. Guggenheim Museum; exhibition catalogue, 1985), p. 44.

2 Ibid.

3 Ibid., Letter of April 24, 1931. The "form" to which Kandinsky refers is undoubtedly Mondrian's Neoplastic relation of orthogonal lines, which, as we have seen, Mondrian was only too willing to claim as absolute.

4 See for example Mondrian's comment that Kandinsky's "work remained predominantly an expression of natural feeling" (p. 64, n. "a").

5 Sixten Ringbom, for example, argues that Mondrian "sought objective truths and immutable generalities, a reality independent of individual feeling, whereas Kandinsky . . . invoked a 'cosmos of spiritually active beings' " ("Transcending the Visible," p. 146). As we will see, however, Kandinsky also tried to transcend the vagaries of the individual in the hope of arresting absolute truth.

6 Kandinsky's answer to Zervos's queries was published as "Reflexions sur l'art abstrait" in *Cahiers d'art*, 1, nos. 7–8, 1931.

7 Kandinsky, "Reflections on Abstract Art," Kenneth C. Lindsay, Peter Vergo, eds., trans., *Kandinsky: Complete Writings on Art*, 2 vols. (Boston: G. K. Hall & Co., 1982), vol. II, p. 756. Subsequent references to Kandinsky's writings are to this edition and will appear in my text as a volume number followed by a page number.

8 For these questions, see *Kandinsky: Complete Writings*, II, pp. 755–6.

9 Cited in Beeke Sell Tower, *Klee and Kandinsky in Munich and at the Bauhaus*, Studies in the Fine Arts: The Avant-Garde, No. 16 (Ann Arbor: UMI Research Press, 1981), p. 178. Italics removed.

10 Kandinsky's reference to the object's "pulse" suggests a link with the German mystic Jakob Boehme, as Hariett Watts has argued in "Arp, Kandinsky, and the Legacy of Jakob Boehme." "In the Boehme-Romantic mystical tradition," she writes, "the idea of a universal pulse created by the oscillation between contraries is a crucial bridge between the ideas of divinity as unknowable pure spirit and divinity as made manifest in matter" (*The Spiritual in Art*), p. 252.

11 Harold Osborne, *Abstraction and Artifice in Twentieth-Century Art*, p. 111.

12 Ibid., p. 137.

13 For a discussion of the publication details of this text, see Kandinsky, *Complete Writings*, pp. 114–18.

14 This topic has been very thoroughly and expertly examined, so while not wanting to underestimate the importance of these influences on Kandinsky, I do (as with Mondrian) want to emphasize somewhat different aspects of Kandinsky's work by broadening the scope of this inquiry. On Kandinsky's debt to Theosophy, see especially Sixten Ringbom, *The Sounding Cosmos*. On his religious imagery, see Rose-Carol Washton-Long, *Kandinsky: The Development of an Abstract Style* (Oxford: Clarendon Press, 1980) and Reinhold Heller, "Kandinsky

and Traditions Apocalyptic," *Art Journal* 43, 1 (Spring 1983), pp. 19–26.

15 Beeke Sell Tower has argued convincingly that Kandinsky came closer and closer to Klee's vision of the formative power and laws of nature through their association at the Bauhaus. Kandinsky furthered these interests in his late Paris work. See Tower, *Klee and Kandinsky*. On Kandinsky's final stay in Paris, see *Kandinsky in Paris, 1934–1944*.

16 See Peter Vergo, "Music and Abstract Painting: Kandinsky, Goethe and Schoenberg" in *Abstraction: Towards a New Art. Painting 1910–1920* (London: Tate Gallery, 1980; exhibition catalogue), pp. 41–63. Kandinsky discusses the *Generalbass* in *On the Spiritual* (I, p. 162) and quotes in the *Almanac* from Goethe's reference to this topic (I, p. 112).

17 On the important issue of abstraction's status as a "language," see Stephen Bann, "Abstract art – a language?" in *Abstraction: Towards a New Art*, pp. 125–45.

18 The discussion of law is central to Kuspit's "Utopian Protest in Early Abstract Art" *Art Journal* 29, 4 (Summer 1970), pp. 430–7, and he also takes up the issue of Kandinsky's transcendental aspirations in "The Illusion of the Absolute in Abstract Art" *Art Journal*, 31, 1 (Fall 1971), pp. 26–30. As these articles focus on many of the same issues that concern me in this book, and because I agree with Kuspit's overall criticism of early abstraction's metaphysical longings (though not with his reasons for this criticism), I feel obliged to record the fact that I constructed my arguments before becoming aware of Kuspit's ideas. In "The Illusion of the Absolute," Kuspit even uses the phrase "the rhetoric of purity" in passing (p. 30). Although I take this as corroboration for my emphasis on the importance of purity to the development of abstract painting, I want to emphasize that we coined this phrase independently, and that Kuspit uses it to describe Kandinsky's putative stress on the formal grammar of painting, an emphasis that I see as subsumed by the very metaphysical strivings in abstract painting that Kuspit is, in "Utopian Protest," keen to deny.

19 "Utopian Protest," p. 436.

20 Ibid., p. 431.

21 "Illusion of the Absolute," p. 28.

22 Letter to Will Grohmann, 1925. Cited in Tower, *Klee and Kandinsky*, p. 151. As early as 1910, Kandinsky expressed the same idea: "in art the end determines the means" (I, p. 75).

23 As Ringbom has remarked, "it is one of the ironies of the history of art that the abstract idiom which its founders intended as a vehicle for communicating an essential content actually came to be regarded as a play with forms." See *The Sounding Cosmos*, p. 113.

24 Fineberg states that Munich's "intellectual climate [was] saturated with Idealist philosophy." *Kandinsky in Paris*, p. 25.

25 See Washton-Long, *Kandinsky*, 10, and Peg Weiss, *Kandinsky in Munich*, 7, n.25.

26 Karsten Harries, *The Meaning of Modern Art: A Philosophical Interpretation* (Evanston, Ill.: Northwestern University Press, 1968), p. 106.

27 Worringer, *Abstraction and Empathy: A Contribution to the Psychology of Style*, trans. Michael Bullock (New York: International Universities Press, 1963), p. 133.

28 For example, Tower, *Klee and Kandinsky*, p. 115; Washton-Long,

Kandinsky, p. 113; Sixten Ringbom, "Transcending the Visible," p. 144.

29 Kandinsky's creation of an indirect mode of communication is a major focus in Washton-Long, *Kandinsky*.

30 Alwynne Mackie, "Kandinsky and Problems of Abstraction," *Artforum*, November 1978, 59. Harriet Watts corroborates this point: during Kandinsky's association with Arp in Paris during the thirties, she claims, Kandinsky "declared every true work of art to constitute a unique instance of materialization." Kandinsky, she writes later, is "presenting a world in the process of materialization rather than dematerialization." See "Arp, Kandinsky, and the Legacy of Jakob Boehme," 239, 242.

31 Washton-Long, *Kandinsky*, pp. 112–13.

32 Ibid., plates 139, 140.

33 See Ringbom, *The Sounding Cosmos*, p. 117.

34 I do not mean to suggest that these traditions are the only parallels to or inspirations for Kandinsky's essentialism. On the contrary, as we saw in Chapter 1, Symbolist theory worked within the same philosophical coordinates; Kandinsky, in fact, is best understood as part of the Symbolist generation (see especially Fineberg, *Kandinsky in Paris*; Weiss, "Kandinsky and the Symbolist Heritage," *Art Journal* 45, 2 (Summer 1985), pp. 137–45). In *Kandinsky in Munich*, Weiss also stresses that the Stefan George circle was an outgrowth of Symbolism that had a great effect in turn of the century Munich. Kandinsky seems also to have been cognizant of Eastern mysticism (see Laxmi P. Sidhare, "Oriental Influences on Wassily Kandinsky and Piet Mondrian 1907–1917," Ph.D. diss., New York University, 1967). He was in addition a devout, orthodox Christian, and many of his notions of a higher reality that is "made flesh" in art were doubtless encouraged by this background. As we have seen, Goethe's search for "Ur" phenomena was also embraced by Kandinsky, and Worringer equated the abstract with a longing for absolute values. As I have argued, what these and other "sources" have in common is an essentialist metaphysic that is applied to art, and that finds its originary discourse in Platonic and neoplatonic texts. It is this common ground that I wish to explore.

35 Washton-Long, *Kandinsky*, p. 34.

36 Ringbom, *Sounding Cosmos*, p. 154. This emphasis on the directness of the sense of hearing – and thus also on music – underlines the search for metaphysical "presence" that typifies essentialism. Kandinsky's resonant "Klang" gives access to an exhalted realm of essence because its immateriality harmonizes with that of the absolute. Hegel also emphasizes the priority of hearing for this reason. See Derrida, "The Pit and the Pyramid: Introduction to Hegel's Semiology," in *Margins of Philosophy*, trans. Alan Bass (Chicago: University of Chicago Press, 1982), pp. 69–108.

37 John Gage makes this assertion in "The Psychological Background to Early Modern Colour: Kandinsky, Delaunay and Mondrian" in *Abstraction: Towards the New Art*, p. 26, n. 3. As I argue later in this chapter, however, Schopenhauer is an equally probable inspiration, perhaps for both Steiner and Kandinsky.

38 Fineberg, *Kandinsky in Paris*, 41. Fineberg remarks that, before he owned Schuré's book, Kandinsky made notes from it to the effect that "Plato" and "Jesus," among others, were initiates (p. 41, n. 13).

39 See Washton-Long, *Kandinsky*, p. 16, n. 27; Fineberg, *Kandinsky in Paris*; Weiss, *Kandinsky in Munich.*

40 Mark C. Taylor, *Journeys to Selfhood: Hegel and Kierkegaard* (Berekeley: University of California Press, 1980), pp. 89–90.

41 Itten, "Analysen alter Meister" in *Utopia: Dokumente der Wirklichkeit* (Weimar, 1921), pp. 28–78.

42 *Almanac*, p. 252. This passage comes from a prospectus for the publication written by Marc in early 1912, but we may assume that it represented Kandinsky's views as well.

43 Poling, "Kandinsky: Russian and Bauhaus Years," pp. 42–3.

44 Hegel, *Aesthetics*, vol. 1, p. 99.

45 Ibid., p. 292.

46 Ibid., pp. 99–100. My emphasis.

47 See Desmond, *Art and the Absolute*, p. 96. This definition of the absolute is analogous to the Platonic and Neoplatonic melding of the knower with the known in absolute knowledge, and thus forges yet another link with the essentialist tradition in general.

48 Hegel, *Aesthetics*, vol. 1, p. 75.

49 Schopenhauer's focus throughout his writings is very much on the inner self, the locus of "will." See Podro, *The Manifold in Perception*, p. 105.

50 See Kandinsky, *Complete Writings*, I, p. 116, n. 8.

51 Schoenberg in his essay "The Relationship to the Text" (*Almanac*, I, pp. 90, 92); Marc in "Die konstruktiven Ideen der neuen Malerei."

52 Schopenhauer draws conspicuously on Kant as well as Plato and is properly thought of as a Neo-Kantian. For our purposes, however, Plato, Kant, and Schopenhauer share a fundamental essentialism that Kandinsky subsequently adopts. Indeed, Schopenhauer is himself concerned to bring Kant and Plato as closely together as possible (see *The World As Will and Representation*, I, 173). The Kantian flavor of his Platonism is the emphasis on the subject, the inner, and on this subject's resulting creativity. Kandinsky also stresses what M. H. Abrams, with reference to these philosophical legacies, calls "the lamp" as opposed to "the mirror," which is one of Plato's images for the greater importance of the object. Abrams argues in this context that the lamp imagery stems from Plotinus's emanating One, and thus that there is a split between Plato and the Neoplatonics on the creative role of the artist. I would suggest further that this distinction is an early example of the apology for art's power, an apology, as I have contended, that Plato invites. See Abrams, *The Mirror and the Lamp: Romantic Theory and the Critical Tradition* (Oxford: Oxford University Press, 1979), pp. 58–9.

53 Cited in Harries, *The Meaning of Modern Art*, p. 104.

54 For a discussion of this relationship, see Harries, *The Meaning of Modern Art*, pp. 95–6.

55 Ibid., p. 96.

56 Washton-Long, "Kandinsky and Abstraction: The Role of the Hidden Image," *Artforum* 10 (1972), pp. 42–50, and *Kandinsky.*

57 Tower, *Klee and Kandinsky*, p. 113.

58 It is possible that Kandinsky borrowed this image from Schopenhauer's reference to the magic lantern, discussed above.

59 See Hans K. Roethel, Jean K. Benjamin, *Kandinsky: Catalogue Raisonné*

of the Oil Paintings, 2 vols., (Ithaca: Cornell University Press, Vol. 1, 1982; Vol. 2, 1984), vol. 1, cat. nos., 459, 465.

60 See Roethel, Ibid., vol. 2, nos. 665, 673, 680, 684, and 685 respectively.

61 Ibid., no. 895.

62 The following quotation is taken from the Russian version of this text, written in 1918 (five years after the German essay), and published under the title "Stupeni" ("Steps").

63 Roethel, no. 711.

64 Roethel, no. 466.

65 Roethel, no. 765.

66 See for example Roethel, nos. 347–50.

67 Roethel, no. 802.

68 Roethel, no. 715.

69 Roethel, no. 746.

70 See Weiss, *Kandinsky in Munich,* pp. 147ff.

71 Weiss, "Kandinsky and the Symbolist Heritage," p. 140.

72 Ibid., p. 143.

73 Fineberg, *Kandinsky in Paris,* pp. 19; 65–6. Steven A. Mansbach also points to slightly earlier nineteenth-century inspirations for this social consciousness: the work of Ruskin and William Morris. See *Visions of Totality: Laszlo Moholy-Nagy, Theo Van Doesburg, and El Lissitzky,* Studies in the Fine Arts: The Avant-Garde, No. 6 (Ann Arbor: UMI Research Press, 1980), p. 4.

74 Washton-Long discusses Kandinsky's attempts "to find ways to change the direction of society" in terms of contemporary notions of anarchism. See "Occultism, Anarchism, and Abstraction: Kandinsky's Art of the Future," *Art Journal* 46, 1 (Spring 1987), p. 39.

75 Lankheit, ed., *The Blaue Reiter Almanac,* p. 251.

76 William Fowkes has argued that "it is necessary to distinguish that from which something is abstracted from that function . . . served by abstraction (abstraction *from* versus abstraction *for* . . .), "mere abstraction" versus "spiritual abstraction." See *An Hegelian Account of Contemporary Art,* (Ann Arbor: UMI Research Press, 1981), p. 47.

CHAPTER 4

1 Derrida, "White Mythology: Metaphor in the Text of Philosophy," in *Margins of Philosophy,* trans. Alan Bass (Chicago: University of Chicago Press, 1982), p. 230.

2 Althusser, "Ideology and Ideological State Apparatuses," in *Lenin and Philosophy and Other Essays,* trans. Ben Brewster (New York: Monthly Review Press, 1971), p. 161.

3 Ibid., p. 170.

4 Ibid., p. 166.

5 Mitchell, *Iconology: Image, Text, Ideology* (Chicago: University of Chicago Press, 1986), p. 164. Subsequent references appear in the text.

6 Cited in Jaffé, *De Stijl,* p. 131.

7 Marcuse, "The Concept of Essence," in *Negations: Essays in Critical Theory.* Trans. Jeremy J. Schapiro (London: Penguin, 1968), p. 53.

8 Cited in Jaffé, *De Stijl,* p. 107.

9 See Peter Bürger, *Theory of the Avant-Garde*. Trans. Michael Shaw (Minneapolis: University of Minnesota Press, 1984).

10 Cited in Jaffé, *De Stijl*, p. 86.

11 Plato, for example, although well aware of the need for change as a means of achieving his utopian political and social ideals, clearly seeks an immaterial absolute. As he argues with respect to the impediment of the corporeal self, "by keeping ourselves uncontaminated by the follies of the body, we shall . . . gain direct knowledge of all that is pure . . . that is, presumably, of truth" (*Phaedo*, 67 A-B, trans. Hugh Tredennick; *The Collected Dialogues of Plato*, ed. Edith Hamilton and Huntington Cairns (Princeton: Princeton University Press, 1973)). Hegel also tends to favor a transcendental absolute, despite his elaborate machinery for its historical evolution. As Hilary Putnam suggests with respect to the closely related concept of rationality, for Hegel, "what is rational is measured by the level to which Spirit has developed in the historical process at a given time. . . . And there is a limit notion of rationality . . . the notion of that which is destined to be stable, the final self-awareness of Spirit which will not itself be transcended." (*Reason, Truth and History* (Cambridge University Press, 1981), p. 158.

12 It is not my intention to rehearse what has been written about Mondrian's use of the diagonal but rather to examine this innovation as a touchstone for his ideas on the dynamic and static in his metaphysics of art. For detailed discussions of the so-called diamond paintings, see E. A. Carmean, Jr., *Mondrian: The Diamond Compositions* (Washington: National Gallery of Art, 1979; exhibition catalogue); H.L.C. Jaffé, "The Diamond Principle in the Works of Van Doesburg and Mondrian," *The Structurist*, 9 (1969), pp. 14–21; Carel Blotkamp, "Mondrian's First Diamond Compositions," *Art Journal*, XVIII, 4 (December, 1979), pp. 33–9; Erik Saxon, "On Mondrian's Diamonds," *Art Journal*, XVIII, 4 (December 1979), pp. 40–5; Champa, *Mondrian Studies*, Chapter 8.

13 For concise accounts of these discussions, see Hoek, "Piet Mondrian," pp. 59ff, and Blotkamp, "Theo Van Doesburg," in *De Stijl: The Formative Years 1917–1922*.

14 Cited in Hoek, Ibid., p. 72.

15 On this topic, see Nancy J. Troy, "Figures of the Dance in De Stijl," *The Art Bulletin* LXVI, 4 (December, 1984), pp. 645–56.

16 Holtzman, "Piet Mondrian: The Man and His Work," in *The New Art – The New Life*, p. 2.

17 Carl Holty, "Mondrian in New York: A Memoir," *Arts Digest*, 31, 10 (September 1957), pp. 17–21. In "Piet Mondrian, *New York City*," Bois discusses Holty's conversations with Mondrian, though not this exact passage. It seems to me that in believing Mondrian's protests that he does obviate stasis – and finding evidence in his work – Bois is taking him too much at his word.

18 See Blotkamp, "Mondrian's First Diamond Compositions," pp. 35–8.

19 See Hoek, p. 61.

20 Van Doesburg, "Painting and Plastic Art: Elementarism," published in *De Stijl*, VIII, 1926–27. In Baljeu, *Theo Van Doesburg* (New York: Macmillan, 1974), pp. 165–6. Subsequent references appear in the text.

21 Blotkamp suggests that it was Van Doesburg's claim to have surpassed Neoplasticism that finally precipitated Mondrian's departure from De

Stijl, not – as is popularly held – the use of diagonal lines in itself. See "Mondrian's First Diamond Compositions," p. 39.

22 Cited in Jaffé, *De Stijl*, p. 149.
23 George Steiner, *Nostalgia for the Absolute* (Toronto: CBC Enterprises, 1974).
24 On this subject, see John Dewey, *The Quest for Certainty: A Study of the Relation of Knowledge and Action* (New York: Minton, Balch & Co., 1929), pp. 14–16.
25 Steiner, *Nostalgia,* p. 48.
26 Ibid., p. 2.
27 See *Kandinsky: Complete Writings,* I, pp. 251, 169. We should recall too that Worringer removed all negative connotations from the notion of the primitive and even saw this state as the basis for abstraction via purity: primitive peoples' "most powerful urge," he argued, was "to wrest the object of the external world out of its natural context, out of the unending flux of being, to purify it of all its dependence upon life, i.e. of everything about it that was arbitrary, to render it necessary and irrefragable, to approximate it to its *absolute* value" (*Abstraction and Empathy,* p. 17). On Mondrian's interest in the "primitivism" of music and dance, see Nancy J. Troy, "Figures of the Dance in De Stijl," p. 646.
28 Mondrian felt that religion had largely outworn its usefulness, that it was usually oppressive like all tradition, and had to be surpassed by Neoplasticism. See his discussions in *The New Art – The New Life,* pp. 81, 256, 269, 318–19.
29 Dewey, *The Quest for Certainty,* pp. 17, 29–30.
30 See Richard Rorty, *Consequences of Pragmatism (Essays: 1972–1980)* (Minneapolis: University of Minnesota Press, 1982), pp. xix, xxxix, and Monique Canto, "Arts of Fake: The Icon in Platonic Thought," trans. Betsy Wing, *Representations* 10 (Spring 1985), pp. 124–45. See also Harries, *The Meaning of Modern Art,* p. 96 (as discussed in Chapters 2 and 3) for the continuation of the metaphysics of the return in German Idealism.
31 This is Kandinsky's favored term for abstract art late in his career. See *Kandinsky: Complete Writings on Art,* II, p. 785.
32 Susan R. Bordo, *The Flight to Objectivity: Essays on Cartesianism and Culture* (Albany: State University of New York Press, 1987), p. 17.
33 On Descartes, see Bordo, *The Flight to Objectivity.* Edgar Wind argues that the rapid change and fragility of Greek society during Plato's lifetime figured in this philosopher's search for secure values: Edgar Wind, *Art and Anarchy,* 3rd ed. (Evanston, Ill.: Northwestern University Press, 1985), p. 4. On this topic, see also Eric E. Havelock, *Preface to Plato* (Cambridge: Belknap/Harvard, 1963). Plato reveals this insecurity in his seventh letter (343 B). Nietzsche, of course, offered a stinging critique of all metaphysics as "means of comfort," and his crticism stands historically and conceptually behind the comments of the authors cited here and my own project vis-à-vis the rhetoric of purity. See Friedrich Nietzsche, *The Will to Power,* trans. Walter Kaufmann and R. J. Hollingdale (New York: Vintage Books, 1968), p. 510.
34 Bordo, *Flight to Objectivity,* p. 76.
35 Mary Douglas, *Purity and Danger: An Analysis of the Concepts of Pollution and Taboo* (1966) (London: Ark Paperbacks, 1984), p. 4.

36 Worringer, *Abstraction and Empathy*, p. 15.

37 This is perhaps an appropriate point at which to offer a comparison
between my argument and those of Yve-Alain Bois in "Painting: The
Task of Mourning" (in *Endgame: Reference and Simulation in Recent
Painting and Sculpture* (Boston: Institute of Contemporary Art, exhi-
bition catalogue, 1986, pp. 29–49)), an article that I only discovered
after finishing this book, and which I greatly admire but also take
issue with in significant ways. Bois speaks of the "essentialism" of
Mondrian's and Malevich's abstraction, "its idea that something like
the essence of painting existed, veiled somehow, and waiting to be
unmasked" (30). He suggests, as I do, that this essentialism means
that "abstract painting could not but understand its birth as a calling
for its end" (30). And Bois also attempts to find historical causes for
this approach to painting. He concludes that "it is *necessary* to interpret
this essentialism as the effect of a large historical crisis . . . industrial-
ization," (30; my emphasis) which, if I understand him, posed the
"threat of the collapse of art's special status [its autonomy, in the terms
I use] into a fetish or a commodity" (32). It seems to me that Bois is
very close here to Clement Greenberg: both define art's essence in
largely formal terms but also contextualize this focus on what we
might call immanent purity in terms of historical necessity, and Bois
makes his debts to Greenberg explicit in "Piet Mondrian, *New York
City*." It is not that I think that these ideas are wrong so much as
incomplete and certainly not "necessary" (as I argue further below).
Thus my description of the nature of essentialism, the way it entails
painting's end, and the reasons for the adoption of this enterprise to
begin with, differ quite fundamentally from Bois's analyses. But we
could perhaps agree on the need to keep the discussion of these issues
open.

38 See Nancy J. Troy, *The De Stijl Environment* (Cambridge, Mass.:
M.I.T. Press, 1983).

39 Henkels has identified this passage as distinctly Platonic in "Mondrian
in his Studio," p. 256.

40 It would be interesting to investigate to what extent those early ab-
stractionists like Kandinsky and Klee, who were teachers in the formal
sense, also adopted the Socratic goal of educating the soul in a mystical/
philosophical way. It is certainly true that these artists as well as Itten
were at odds with the more technological directions of Bauhaus Con-
structivism, and that they criticized their colleagues' methods as spir-
itually superficial. Kandinsky's pedagogical priorities were also seen
as atavistic by the younger Constructivist generation in the Soviet
Union shortly after the revolution.

41 See for example "Art without Subject Matter" (1938), p. 302.

42 On the social and political details of this period, see Peter Gay, *Weimar
Culture: The Outsider as Insider* (New York: Harper & Row, 1968).
On the interaction between this society and its art forms, see Rose-
Carol Washton Long, "Expressionism, Abstraction, and the Search
for Utopia in Germany," in *The Spiritual in Art*, pp. 201–17.

43 Long, "Expressionism," p. 207. Emphasis mine.

44 Clark V. Poling, "Kandinsky: Russian and Bauhaus Years, 1915–
1933," p. 26.

45 "Reductionism in modernist thinking, that is, the urge to simplify
down to basics, . . . is very much a twentieth-century preoccupation."

George Rochberg, "Can the Arts Survive Modernism? (A Discussion of the Characteristics, History, and Legacy of Modernism)" *Critical Inquiry* 11, 2 (December 1984), p. 322.

46 Terminology presents problems when discussing Modernism, especially when the term avant-garde is also used. Many writers equate the two, or reduce Modernism to their definition of the avant-garde. On these difficulties, see Jochen Schulte-Sasse, "Theory of Modernism versus Theory of the Avant-Garde," in Bürger, *Theory of the Avant-Garde*. In what follows, I will maintain the term Modernism as an overarching period designation, as – to borrow a phrase from T. J. Clark – "a set of contexts for art," and specifically that art that we in the later twentieth century now construe as "progressive" in the century from roughly 1860–1960. See Clark, "Clement Greenberg's Theory of Art," *Critical Inquiry* 9, 1 (September 1982), p. 152. What tends to count as progressive is either the subset of art that focuses on its own media – often labeled modernist – and that work which "aimed to intervene in social reality" (Schulte-Sasse, p. xxxix): the avant-garde. Needless to say, there are crossovers between these definitions.

47 On Greenberg's theories, see Clark, "Clement Greenberg's Theory of Art"; Michael Fried, "How Modernism Works: A Response to T. J. Clark," *Critical Inquiry* 9, 1 (September, 1982), pp. 217–34; Stephen W. Melville, *Philosophy Beside Itself: On Deconstruction and Modernism*, Theory and History of Literature, vol. 27 (Minneapolis: University of Minnesota Press, 1986). My references to Greenberg are from *Clement Greenberg: The Collected Essays and Criticism*, ed. John O'Brian, 2 vols. (Chicago: University of Chicago Press, 1986) and appear in the text with the volume number followed by the page.

48 See Fried, "How Modernism Works," p. 222.

49 "Modernist Painting," in Gregory Battcock, ed. *The New Art* (New York: Dutton, 1973), p. 68.

50 Bürger, *Theory of the Avant-Garde*, p. 49.

51 See Fried, "How Modernism Works," for a discussion of negation in Modernism, where he claims that Clark's emphasis on "practices of negation" as constitutive of modernism is "false" (p. 217). Instead he argues "that the deepest impulse or master convention of what I called 'mainstream' modernism has never been to overthrow or otherwise break with the pre-modernist past but rather to attempt to equal its highest achievements" (pp. 224–5). Using the evidence of the particular sort of purity sought by early abstract painting, I would claim that both these views are correct when applied to certain works or traditions within what we would want to call Modernism. At the same time, neither position can adequately explain either the radical negation (which turns into the metaphysical affirmation of security) or the oddly historicized search for an ahistorical absolute that characterize the projects of both Kandinsky and Mondrian. Against Clark, pure abstraction of this type would claim not to be a negation; against Fried, it would claim to be building on past art but also offering a new non-mimetic art that far outstrips any historical achievements.

52 Poling notes the widespread belief that "geometry provided a universal language" ("Kandinsky," p. 49). The mathematics and geometry of the fourth dimension were also explored by artists seeking the essential. See Linda D. Henderson, *The Fourth Dimension and Non-Euclidean Geometry in Modern Art* (Princeton: Princeton University Press, 1983).

See also Robert P. Welsh, "Sacred Geometry: French Symbolism and Early Geometry," in *The Spiritual in Art,* pp. 63–87.

53 Christopher Norris, *Contest of Faculties: Philosophy and Theory After Deconstruction* (London: Methuen, 1985), p. 99. Similar arguments are presented by Dewey in *The Quest for Certainty* and by Richard Rorty in *Philosophy and the Mirror of Nature* (Princeton: Princeton University Press, 1979) and *Consequences of Pragmatism.*

54 Norris, *Contest,* p. 100.

55 Marcuse, "The Struggle Against Liberalism in the Totalitarian View of the State," in *Negations,* p. 7.

56 Quotations are from Joosten, Welsh, trans., eds., *Two Mondrian Sketchbooks.* This ref., p. 19.

57 Throughout *Idols of Perversity: Fantasies of Feminine Evil in Fin-de-Siècle Culture* (Oxford: Oxford University Press, 1986), Bram Dijkstra shows the extreme lengths to which all-too-numerous members of late nineteenth- and early twentieth-century European culture went to remove what they saw as the disquieting spectre of female sexuality. Elements of Mondrian's personal life would provide an excellent example (his apparent preference for pre-pubescent girls as dancing partners, for example). More important to this study is Dijkstra's recounting of Auguste Comte's suggested "exploration of artificial insemination as a means of keeping women as close to the madonna ideal as possible, while still allowing them to fulfill their function as mothers" (19). Plato and Mondrian hit on an even "purer" solution: the hermaphrodite.

58 Plato equates matter and the feminine in the *Symposium* (190 B) and *Menexenus* (238 A). For a more detailed analysis of the feminine in ancient Greek culture, see Lloyd, *The Man of Reason,* pp. 2–9. Carolyn G. Heilbrun traces the history of androgyny in *Toward a Recognition of Androgyny* (1964) (New York: Norton, 1982). On pictorial depictions of the androgyne, see Edgar Wind, *Pagan Mysteries in the Renaissance* (London: Penguin Books, 1967), pp. 212 ff.

59 Hoek, "Piet Mondrian," p. 44.

60 *Symposium,* trans. Michael Joyce, in Hamilton, Cairns, eds., *The Collected Dialogues of Plato.* References appear in the text.

61 Mitchell, "Ut Pictura Theoria: Abstract Painting and the Repression of Language," *Critical Inquiry,* 15 (Winter 1989), 348.

62 Mitchell, "Ut Pictura Theoria," 367.

63 I have developed this contention further in "Purity or Danger: Mondrian's Exclusion of the Feminine and the Gender of Abstract Painting" in *Women and Reason,* ed. Elizabeth Harvey and Kathleen Okruhlik (Ann Arbor: University of Michigan Press, 1991).

64 "If we are to keep our flock at the highest pitch of excellence, there should be as many unions of the best of both sexes, and as few of the inferior, as possible, and . . . only the offspring of the better unions should be kept. . . . No one but the rulers must know how all this is being effected; otherwise our herd of Guardians may become rebellious" (*Republic,* 459).

65 In the *Timaeus* (50 C-D; 51 E ff.), Plato also identifies the Forms as the father of all reality. On male inheritance in Plato, see Norris, *Derrida,* p. 30, and Deleuze, "Plato and the Simulacrum," pp. 46, 51.

66 See Derrida's analysis in *Dissemination,* pp. 142 ff.

67 Bordo's phrase for the seventeenth-century conception of science. See *The Flight to Objectivity*, p. 5.

68 Welsh has mentioned the androgynous appearance of these figures in "Mondrian and Theosophy," (p. 47), and of course androgyny was a widespread ideal around the turn of the twentieth century (see Pierrot, *The Decadent Imagination*). My aim is to take these general observations further by showing how central androgyny was to Mondrian's notion of purity.

69 See Welsh, "Mondrian and Theosophy," and Blotkamp, "Annunciation of the New Mysticism: Dutch Symbolism and the Early Abstraction."

70 There was a tradition in fourth-century art to portray Hermaphroditus "as a beautiful youth with developed breasts" (*The Oxford Classical Dictionary*, 2nd. ed., ed. N. G. L. Hammond, H. H. Scullard (Oxford: Clarendon Press, 1970, p. 502) but even if Mondrian did know these sources (and there is no indication that he did), it seems more likely that he had a conceptual rather than stylistic reason for using the female figure in *Evolution*.

71 "'Degenerate' Art – A Look at a Useful Myth," in *German Art of the 20th Century: Painting and Sculpture 1905–1985* (London: Royal Academy, exhibition catalogue, 1985), pp. 113–24. Subsequent references appear in the text.

72 Klaus Theweleit, trans. Stephen Conway, *Male Fantasies, Vol. 1: Women, Floods, Bodies, History* (Minneapolis: University of Minnesota Press, 1987), p. 227.

73 *Idols of Perversity*, p. vii.

74 Cited in *The New Art – The New Life*, p. 320.

75 Cited in Poling, "Kandinsky: Russian and Bauhaus Years," p. 13.

76 Ibid.

77 Adolf Hitler, *The Speeches of Adolf Hitler: April 1922–August 1939*, trans. Norman H. Baynes, 2 vols., (New York: Howard Fertig, 1969), vol. 1, p. 588. Subsequent references appear in the text. This quotation is from Hitler's speech opening the House of German Art in Munich, July 18, 1937.

78 Cited in *The New Art – The New Life*, p. 320.

79 *Male Fantasies*, p. 35. Subsequent references appear in the text.

80 Lacoue-Labarthe, "Philippe Lacoue-Labarthe Responds," in *ICA Documents 4 Postmodernism* (London: Institute of Contemporary Arts, 1985), p. 9.

81 Donald Marshal, "Foreword" to Melville, *Philosophy Beside Itself,* Theory and History of Criticism, vol. 27. (Minneapolis: University of Minnesota Press, 1986), p. xix.

82 Chipp, *Theories,* p. 482.

83 Marcuse, "The Concept of Essence," *Negations,* p. 63.

84 Grosshanns, " 'Degenerate Art,' " p. 52.

85 Nolde saw Germans as the master race. Interestingly for the ideology of abstract art, so did Wilhelm Worringer, who wrote in *Abstraction and Empathy* that only in Northern Europe were the people sufficiently pure to produce abstract art.

86 On this aspect of modern art, see Carol Duncan, "Virility and Domination in Early Twentieth-Century Vanguard Painting," *Feminism and Art History: Questioning the Litany,* ed. Norma Broude and Mary D. Garrard (New York: Harper & Row, 1982), pp. 293–313. We should

recall in this context the debate within the Nazi upper ranks about the possibility of having Expressionism work as *the* new German art form, as Nolde for one suggested it could.

87 The phrase is Berel Lang's; see "Postmodernism in Philosophy: Nostalgia for the Future, Waiting for the Past," *New Literary History* 18, 1 (Autumn, 1986), p. 223.

88 On the search for social and political stability as fundamental to the ideology of National Socialism, see G. L. Mosse, *The Crisis of German Ideology: Origins of the Third Reich* (New York: Grosset & Dunlap, 1964), p. 3.

89 G. L. Mosse, "The Mystical Origins of National Socialism," *Journal of the History of Ideas* 22, 1 (1961), p. 82.

90 Ibid., p. 84.

91 Ibid., p. 85.

POSTSCRIPT

1 Giulio Carlo Argan, for example, writes in the "Preface" to volume one of the English edition of Klee's *Notebooks* that "it is well-known that Klee, more than any other artist of our century, was consciously detached from the main stream of modern art and its theoretical assumptions" (Klee, *Notebooks: Vol. 1: The Thinking Eye,* ed. Jürg Spiller, trans. Ralph Mannheim (London: Lund Humphries, 1961), p. 11). This view was echoed recently by Ann Temkin in her essay for the MOMA Klee retrospective of 1987 ("Klee and the Avant-Garde 1912–1940," in *Paul Klee,* ed. Carolyn Lanchner (New York: MOMA, 1987), p. 13). Klee's independence is easily overstated, however, as Richard Verdi argues in *Klee and Nature* (New York: Rizzoli, 1985), p. 211, with respect to Klee's relation to nature study, and as I will claim in the context of Klee's interest in abstraction, essence, and purity.

2 See Tower, *Klee and Kandinsky.*

3 On Klee's relation to Neoplatonism, see Karen C. Adams, "Platonic/ Neoplatonic Aesthetic Tradition in Art Theory and Form: Relationship of Sense Object to Idea in Selected Works of Hindemith and Klee," Ph.D. Dissertation, Ohio State University, 1975.

4 Bürger, *Theory of the Avant-Garde,* p. 15.

5 See David Carroll, *Paraesthetics,* p. xvi.

6 A postscript is not the place to begin a detailed account and defense of the much-debated term "postmodern," so I will only mention those critics with whom I have the greatest sympathy on this topic: Carroll, *Paraesthetics;* Derrida (and here I disagree with Stephen Melville's characterization of Derrida as a "modern," (in *Philosophy Beside Itself*)); Jonathan Arac in his "Introduction" to *Postmodernism and Politics,* Theory and History of Literature, Vol. 28 (Minneapolis: University of Minnesota Press, 1986); Linda Hutcheon, *A Poetics of Postmodernism: History, Theory, Fiction* (New York and London: Routledge, 1988); Andreas Huyssen, *After the Great Divide: Modernism, Mass Culture, Postmodernism* (Bloomington and Indianapolis: Indiana University Press, 1986); and Christopher Norris in all his books, even though I see the postmodern in terms of what he calls "deconstruction."

I examine the term and its attendant issues fully in *Remembering Post-modernism: The Past, the Subject, and Society in Recent Canadian Art* (Oxford and Toronto: Oxford University Press, 1991).

7 Like Kandinsky and Mondrian, Klee sought to bring "theory" and "practice" together. He wrote extensively, yet "protested forcefully against the notion of theory in itself" (Klee, *The Diaries of Paul Klee, 1898–1918,* ed. Felix Klee (Berkeley, University of California Press, 1968), no. 961).

8 See Jörg Spiller's "Introduction" to Klee, *Notebooks,* vol. 1, p. 26, and Tower, *Klee and Kandinsky,* p. 124.

9 "Creative Credo," in *Notebooks,* vol. 1, p. 76. Unless otherwise noted, references to Klee's writings are from the versions contained in the English edition of the *Notebooks.*

10 Klee, "Ways of Nature Study," p. 63.

11 Ibid., p. 66.

12 Ibid., p. 67.

13 Klee, "Exact Experiments in the Realm of Art," p. 69.

14 Ibid., pp. 72–3.

15 *Diaries,* No. 660.

16 Klee, Jena lecture of 1924, later published as "On Modern Art," p. 95.

17 *Notebooks,* vol. 1, p. 63.

18 Ibid., p. 100.

19 On the oft-remarked relationship between Klee and Goethe, see Verdi, *Klee and Nature.*

20 Here too Klee reveals his neoplatonism, for as he puts it in the "Creative Credo," "In the beginning is the act; yes, but above it is the idea" (p. 78).

21 "Credo," p. 78.

22 *Metaphysical Transplant* in fact looks like a parodic and benevolent revision of William Blake's 1795 color print *Elohim Creating Adam.* Klee did know Blake's work (see Gualtieri Di San Lazzaro, trans. Stuart Hood, *Klee* (New York: Praeger, 1964), p. 35). For a color reproduction of the Blake, see Martin Butlin, *William Blake* (Tate Gallery, 1978, exhibition catalogue), plate 85.

23 I do not want to make Klee seem particularly "liberated" in comparison with other male artists of the period. My analysis is, rather, part of what I take to be a typically postmodern concern for "difference," especially of gender, though I would also like to think that my interests have a more personal dimension. On these issues, see Huyssen, *After the Great Divide,* Chapter 3, and Hutcheon, *A Poetics of Postmodernism,* Chapter 4.

24 *Notebooks,* vol. 1, p. 354.

25 Klee, *Notebooks, Volume 2: The Nature of Nature,* ed. Jürg Spiller, trans. Heinz Norden (London: Lund Humphries, 1973), p. 269.

26 Ibid., p. 255.

27 *Notebooks,* vol. 1, p. 5.

28 Ibid., pp. 101; 9.

29 See *Diaries,* No. 945.

30 Klee's relation to world events was at once removed and engaged, though he did not, like Kandinsky and Mondrian, adopt the "pure" role of a social and political reformer. On his relations with politics, see Michèle Vishny, "Paul Klee and War: A Stance of Aloofness" *Gazette Des Beaux Arts* XCII (Décembre 1978), pp. 233–43, and O.K.

Werckmeister, "From Revolution to Exile," in *Paul Klee* (MOMA, 1987), pp. 39–63.

31 *Diaries,* No. 951; the final sentence is from No. 953.

32 *Notebooks,* Vol. 1, p. 444.

33 See Verdi, *Klee and Nature,* pp. 171 ff., and "Paul Klee's *Fish Magic;* An Interpretation," *Burlington Magazine* CXVI (March 1974), pp. 147ff.

34 Verdi, *Klee and Nature,* p. 178.

35 Tower, *Klee and Kandinsky,* pp. 104 ff.

36 *Notebooks,* Vol. 2, p. 63.

37 *Notebooks,* Vol. 1, p. 69.

38 Representation is a prime concern in postmodern theories of the visual arts. See, for example, *Art After Modernism: Rethinking Representation,* ed. Brian Wallis (Boston: David R. Godine, Publisher, 1984).

39 *Notebooks,* Vol. 1, p. 343. My emphasis.

40 On this topic, see Naomi Schor, *Reading in Detail: Aesthetics and the Feminine* (New York and London: Methuen, 1987). Theweleit has connected the avoidance of the small or of detail (as signs of the feminine) with the fascist mentality of the soldier-male. See *Male Fantasies,* p. 88.

41 Ibid., p. 60.

42 Werckmeister, "From Revolution to Exile," p. 51.

43 *Notebooks,* Vol. 2, p. 269.

44 Ibid., p. 352.

45 Rorty, *Consequences of Pragmatism,* p. 73.

46 Ibid., p. 164.

47 See Norris, *The Contest of Faculties,* pp. 141 ff.

48 See James D. Campbell, *Mnemosyne Or The Art of Memory: Gerhard Merz* (Toronto: Art Gallery of Ontario/Cold City Gallery, 1988).

SELECTED BIBLIOGRAPHY

Adams, Karen. "Platonic/Neoplatonic Aesthetic Tradition in Art Theory and Form: Relationship of Sense Object to Idea in Selected Works of Hindemith and Klee." Ph.D. dissertation. University of Ohio, 1975.

Adelman, Lucy, and Michael Compton. "Mathematics in Early Abstract Art," 64–89. In *Abstraction: Towards a New Art, Painting, 1910–1920,* 90–124. London: Tate Gallery, 1980; exhibition catalogue.

Althusser, Louis. "Ideology and Ideological State Apparatuses." In *Lenin and Philosophy and Other Essays*. Trans. Ben Brewster. New York: Monthly Review Press, 1971.

Apollinaire, G. *Apollinaire on Art: Essays and Reviews 1902–1918.* Ed. Leroy C. Breunig, trans. Susan Suleiman. New York: Viking, 1972.

Arac, Jonathan. Ed. *Postmodernism and Politics.* Theory and History of Literature, vol. 28. Minneapolis: University of Minnesota Press, 1986.

Argülles, José A. *Charles Henry and the Formation of a Psychophysical Aesthetic.* Chicago: University of Chicago Press, 1972.

Aurier, Albert. *Ouevres Posthumes de G.-Albert Aurier.* Paris: Mercure de France, 1893.

"Les Symbolistes." *Revue Encyclopédique* 32 (1892): 474–86.

Baillot, Alexandre. *Influence de la Philosophie de Schopenhauer en France (1860–1900).* Paris: Librairie Philosophique J. Vrin, 1927.

Baljeu, Joost. *Theo Van Doesburg.* New York: Macmillan, 1974.

"The Problem of Reality with Suprematism, Constructivism, Proun, Neoplasticism and Elementarism." *The Lugano Review* 1,1 (1965): 105–24.

Bann, Stephen. "Abstract art – a language?" In *Abstraction: Towards a New Art, Painting, 1910–1920,* 125–45. London: Tate Gallery, 1980; exhibition catalogue.

Barnett, Vivian Endicott. "Kandinsky and Science: The Introduction of Biological Images in the Paris Period." In *Kandinsky in Paris: 1934–1944.* New York: Solomon R. Guggenheim Museum, 1985.

Beckett, Jane. "The Abstract Interior." In *Abstraction: Towards a New Art, Painting, 1910–1920,* 90–124. London: Tate Gallery, 1980; exhibition catalogue.

Blanshard, Frances Bradshaw. *The Retreat From Likeness in the Theory of Painting.* 2nd ed. New York: Columbia University Press, 1949.

Blotkamp, Carel. "Theo Van Doesburg." In *De Stijl: The Formative Years 1917–1922.* Trans. Charlotte I. Loeb. Cambridge: M.I.T. Press, 1986.

"Annunciation of the New Mysticism: Dutch Symbolism and Early

Abstraction." In *The Spiritual in Art: Abstract Painting 1890–1985*, 89–111. New York: Abbeville Press, 1986.

"Mondrian's First Diamond Compositions." *Artforum* XVIII, 4 (December, 1979): 33–9.

Bodelson, Merete. *Gauguin's Ceramics: A Study in the Development of His Art*. London: Faber & Faber, 1964.

Bois, Yve-Alain. "Painting: The Task of Mourning." In *Endgame: Reference and Simulation in Recent Painting and Sculpture*. Boston: Institute of Contemporary Art, 1986: 29–49.

"Piet Mondrian, *New York City*." *Critical Inquiry* 14 (Winter 1988): 244–77.

Bordo, Susan. *The Flight to Objectivity: Essays on Cartesianism and Culture*. Albany: State University of New York Press, 1987.

Boyle-Turner, Carolyn. "Sérusier's *Talisman*." *Gazette Des Beaux-Arts* 105 (May–June 1985): 191–6.

Paul Sérusier. Ann Arbor: UMI Research Press, 1983.

Bryson, Norman. Ed. *Calligram: Essays in New Art History from France*. Cambridge University Press, 1988.

Bürger, Peter. *Theory of the Avant-Garde*. trans. Michael Shaw. Minneapolis: University of Minnesota Press, 1984.

Burnett, David. "Paul Klee: The Romantic Landscape." *Art Journal* XXXVII/4 (Summer 1977): 322–6.

Bussmann, Georg. " 'Degenerate Art' – A Look at a Useful Myth." In *German Art in the 20th Century: Painting and Sculpture 1905–1985*. London: Royal Academy, exhibition catalogue, 1985: 113–24.

Cahoone, Lawrence E. *The Dilemma of Modernity: Philosophy, Culture, and Anti-Culture*. Albany: State University of New York Press, 1988.

Calinescu, Matei. *Faces of Modernity: Avant-Garde, Decadence, Kitsch*. Bloomington: Indiana University Press, 1977.

Canto, Monique. "Acts of Fake: The Icon in Platonic Thought." Trans. Betsy Wing. *Representations* 10, (Spring, 1985): 124–45.

Carroll, David. *Paraesthetics: Foucault . Lyotard . Derrida*. New York & London: Methuen, 1987.

Chandler, Arthur. *The Aesthetics of Piet Mondrian*. New York: MSS Information Corporation, 1972.

Chassé, Charles. *Gauguin et Le Groupe De Pont-Aven: Documents inédits*. Paris: Henry Floury, 1921.

The Nabis and Their Period. Trans. Michael Bullock. New York: Praeger, 1969.

Cheetham, Mark A. "Mystical Memories: Gauguin's Neoplatonism and 'Abstraction' in Late-Nineteenth-Century French Painting." *Art Journal* 46, 1 (Spring 1987): 15–21.

Chipp, Herschel B. *Theories of Modern Art: A Source Book by Artists and Critics*. Berkeley; University of California Press, 1968.

Colin, René-Pierre. *Schopenhauer en France: Un mythe naturaliste*. Lyon: Presses Universitaires, 1979.

Dasenbrock, Reed Way. *The Literary Vorticism of Ezra Pound and Wyndham Lewis: Towards the Condition of Painting*. Baltimore: Johns Hopkins University Press, 1985.

Deleuze, Gilles. "Plato and the Simulacrum." Trans. Rosalind Krauss. *October* 27: 45–56.

De Man, Paul. "The Resistance to Theory" (3–20). Barbara Johnson, ed., *The Pedagogical Imperative: Yale French Studies* 63, 1982.

Allegories of Reading: Figural Language in Rousseau, Nietzsche, Rilke, and Proust. New Haven: Yale University Press, 1979.

Denis, Maurice. *Théories, 1890–1910.* 4th ed. Paris: Rouart et Watelin, 1920.

Derouet, Christian. "Kandinsky in Paris: 1934–1944." In *Kandinsky in Paris: 1934–1944.* New York: Solomon R. Guggenheim Museum, 1985; exhibition catalogue.

Derrida, Jacques. *Margins of Philosophy.* Trans. Alan Bass. Chicago: University of Chicago Press, 1982.

 Dissemination. Trans. Barbara Johnson. Chicago: University of Chicago Press, 1981.

Desmond, William. *Art and the Absolute: A Study of Hegel's Aesthetics.* Albany: State University of New York Press, 1986.

Dewey, John. *The Quest for Certainty: A Study of the Relation of Knowledge and Action.* New York: Minton, Balch & Co., 1929.

Dollimore, Jonathan. *Radical Tragedy: Religion, Ideology and Power in the Drama of Shakespeare and His Contemporaries.* Chicago: University of Chicago Press, 1984.

Donnell-Kotrozo, Carol. *Critical Essays on Postimpressionism.* London/Toronto: Associated University Presses, 1983.

Douglas, Mary. *Purity and Danger: An Analysis of the Concepts of Pollution and Taboo* (1966). London: Ark Paperbacks, 1984.

Duncan, Carol. "Virility and Domination in Early Twentieth-Century Vanguard Painting." In *Feminism and Art History: Questioning the Litany.* Ed. Norma Broude and Mary D. Garrard. New York: Harper & Row, 1982: 293–313.

Elias, Julius A. *Plato's Defence of Poetry.* Albany: State University of New York Press, 1984.

Ferguson, Margaret W. *Trials of Desire: Renaissance Defenses of Poetry.* New Haven: Yale University Press, 1983.

Fineberg, Jonathan David. *Kandinsky in Paris 1906–1907.* Studies in the Fine Arts: The Avant-Garde, No. 44. Ann Arbor: UMI Research Press, 1984.

Fish, Stanley. *Self-Consuming Artifacts: The Experience of Seventeenth-Century Literature.* Berkeley: University of California Press, 1972.

Foucault, Michel. *Language, Counter-Memory, Practice: Selected Essays and Interviews.* Trans. Donald F. Bouchard, Sherry Simon. Ithaca: Cornell University Press, 1977.

 The Archaeology of Knowledge & the Discourse on Language. Trans. A. M. Sheridan Smith. New York: Harper & Row, 1972.

Fowkes, William. *An Hegelian Account of Contemporary Art.* Ann Arbor: UMI Research Press, 1981.

Franciscano, Marcel. "Paul Klee in the Bauhaus: The Artist as Lawgiver." *Arts Magazine* 52, 1 (September 1979): 122–7.

French Symbolist Painters: Moreau, Puvis de Chauvannes, Redon and their followers. London: Arts Council of Great Britain: 1972; exhibition catalogue.

Friedman, Martin. "Echoes of De Stijl." In *De Stijl 1917–1931: Visions of Utopia.* Ed. Mildred Friedman. Minneapolis: Walker Art Center, 1982; exhibition catalogue.

Frisby, David. *Fragments of Modernity: Theories of Modernity in the Work of Simmel, Kracauer and Benjamin.* Cambridge: M.I.T. University Press, 1986.

Fry, Edward F. *Cubism*. New York: Mcgraw Hill, 1966.

Gage, John. "The psychological background to early modern colour: Kandinsky, Delaunay and Mondrian." In *Abstraction: Towards a New Art, Painting, 1910–1920*, 23–40. London: Tate Gallery, 1980; exhibition catalogue.

Gauguin, Paul. *The Writings of a Savage*. Ed. Daniel Guérin, trans. Eleanor Levieux. New York: Viking, 1978.

Gauguin, Paul. *Cahier Pour Aline*. Facsimilie ed. Ed. Suzanne Damiron. Paris: Société des Amis de la Bibliothèque d'Art et d'Archéologie de l'Univerité de Paris, 1963.

Gauss, Charles E. *The Aesthetic Theories of French Artists: 1885 to the Present*. Baltimore: Johns Hopkins University Press, 1949.

Gee, Malcolm. *Dealers, Critics, and Collectors of Modern Painting: Aspects of the Parisian Art Market Between 1910 and 1930*. New York: Garland, 1981.

Glaesemer, Jürgen. "Klee and German Romanticism." In *Paul Klee*. New York: MOMA, 1987.

Gourmont, Remy de. *Decadence and Other Essays on the Culture of Ideas*. Trans. W. A. Bradley. New York: Harcourt, Brace and Co., 1921.

Green, Christopher. "Cubism and the Possibility of Abstract Art." In *Abstraction: Towards a New Art, Painting, 1910–1920*, 156–77. London: Tate Gallery, 1980; exhibition catalogue.

Grosshans, Henry. *Hitler and the Artists*. New York: Holmes and Meier, 1983.

Guicheteau, Marcel. *Paul Sérusier*. Paris: Editions Side, 1976.

Guilbaut, Serge. "Art History After Revisionism: Poverty and Hopes." *Art Criticism* 2, 1 (1986): 39–50.

Hamlyn, D.W. *Schopenhauer*. London: Routledge & Kegan Paul, 1980.

Harmsen, Ger. "De Stijl and the Russian Revolution." In *De Stijl 1917–1931: Visions of Utopia*. Ed. Mildred Friedman. Minneapolis: Walker Art Center, 1982; exhibition catalogue.

Harries, Karsten. *The Meaning of Modern Art: A Philosophical Interpretation*. Evanston: Northwestern University Press, 1968.

Havelock, Eric A. *Preface to Plato*. Cambridge: Belknap/Harvard, 1963.

Hedrick, Hannah L. *Theo Van Doesburg: Propagandist and Practitioner of the Avant-Garde, 1905–1923*. Studies in the Fine Arts: The Avant-Garde, No. 5. Ann Arbor: UMI Research Press, 1980.

Hegel, G. W. F. *Aesthetics: Lectures on Fine Art*. Trans. T. M. Knox. Oxford: Clarendon Press, 1975.

Heidegger, Martin. *Nietzsche*. Vol. 1, *The Will to Power as Art*. Trans. David Farrell Krell. London: Routledge & Kegan Paul, 1979.

Heller, Reinhold. "Kandinsky and Traditions Apocalyptic." *Art Journal* 43, 1 (Spring 1983): 19–26.

Henderson, Linda Dalrymple. "Mysticism, Romanticism, and the Fourth Dimension." In *The Spiritual in Art: Abstract Painting 1890–1985*, 219–37. New York: Abbeville Press, 1986.

The Fourth Dimension and Non-Euclidean Geometry in Modern Art. Princeton: Princeton University Press, 1983.

Henkels, Herbert. "Mondrian in his Studio." In *Piet Mondrian Centennial Exhibition*. New York: Solomon R. Guggenheim Museum, 1971.

Herbert, Robert. "Seurat in Chicago and New York." *Burlington Magazine* 100 (May 1958): 146–53.

Hinz, Berthold. *Art in the Third Reich.* Trans. Robert and Rita Kimber. New York: Pantheon, 1979.

Hitler, Adolf. *The Speeches of Adolf Hitler April 1922 – August 1939.* Ed. Norman H. Baynes, 2 vols. New York: Howard Fertig, 1969.

Hoek, Els. "Piet Mondrian." In *De Stijl: The Formative Years 1917–1922.* Trans. Charlotte I. Loeb. Cambridge: M.I.T. Press, 1986.

Holty, Carl. "Mondrian in New York: A Memoir." *Arts Digest* 31, 10 (September 1957): 17–21.

Holtzman, Harry. "Piet Mondrian: The Man and His Work." In *The New Art – The New Life: The Collected Writings of Piet Mondrian,* 1–10. Ed., trans. Harry Holtzman and Martin S. James. Boston: G.K. Hall & Co., 1986.

Hutcheon, Linda. *A Poetics of Postmodernism: History, Theory, Fiction.* New York and London: Routledge, 1988.

Huyghe, René. *Gauguin.* Trans. Helen C. Slonim. New York: Crown Publishers, 1959.

Huyssen, Andreas. *After the Great Divide: Modernism, Mass Culture, Postmodernism.* Bloomington and Indianapolis: Indiana University Press, 1986.

Isaak, Jo Anna. *The Ruin of Representation in Modernist Art and Texts.* Studies in the Fine Arts: Art Theory, No. 13. Ann Arbor: UMI Research Press, 1986.

Jaffé, H. L. C. "The Diagonal Principle in the Works of Van Doesburg and Mondrian." *The Structurist* 9 (1969): 14–21.

De Stijl 1917–1931: The Dutch Contribution to Modern Art. (1956). Reprint. Cambridge: Belknap/Harvard, 1986.

James, Martin S. "Piet Mondrian: Art and Theory to 1917." In *The New Art – The New Life: The Collected Writings of Piet Mondrian.* Ed., trans. Harry Holtzman and Martin S. James. Boston: G. K. Hall & Co., 1986.

"Mondrian and the Dutch Symbolists." *Art Journal* XXIII/2 (Winter 1963–64): 103–11.

Jaworska, Wladyslawa. *Gauguin and the Pont-Aven School.* Trans. Patrick Evans. Greenwich, Connecticut: New York Graphic Society, 1972.

Jirat-Wasiutynski, Vojtech. "Paul Gauguin's Paintings, 1886–91: Cloisonism, Synthetism and Symbolism." *RACAR* IX, 1–2 (1982): 35–46.

Paul Gauguin in the Context of Symbolism. New York: Garland, 1978.

Johnson, Ron. "Vincent Van Gogh and the Vernacular: The Poet's Garden." *Arts Magazine* 53 (February 1979): 98–104.

Jonsson, Inge. *Emmanuel Swedenborg.* Trans. Catherine Djurklov. New York: Twayne Publishers, 1971.

Joosten, Joop. "Painting and Sculpture in the Context of De Stijl." In *De Stijl 1917–1931: Visions of Utopia.* Ed. Mildred Friedman. Minneapolis: Walker Art Center, 1982; exhibition catalogue.

"Mondrian: Between Cubism and Abstraction." In *Piet Mondrian Centennial Exhibition.* New York: Solomon R. Guggenheim Museum, 1971.

Jordan, Jim M. *Paul Klee and Cubism.* Princeton: Princeton University Press, 1984.

Kagan, Andrew. *Paul Klee/Art & Music.* Ithaca: Cornell University Press, 1983.

Kandinsky, Vasily. *Complete Writings on Art.* 2 vols. Ed., trans. Kenneth

C. Lindsay and Peter Vergo. The Documents of Twentieth Century Art. Boston: G. K. Hall, 1982.

Kaplan, Julius. *The Art of Gustav Moreau: Theory, Style, and Content.* Ann Arbor: UMI Research Press, 1982.

Karl, Frederick R. *Modern and Modernism: The Sovereignty of the Artist 1885–1925.* New York: Atheneum, 1985.

Klee, Paul. *Notebooks Volume 2: The Nature of Nature.* Ed. J. Spiller. Trans. Heinz Norden. London: Lund Humphries, 1973.

 The Diaries of Paul Klee 1898–1918. Berkeley: University of California Press, 1964.

 Notebooks Volume 1: The Thinking Eye. Ed. J. Spiller. Trans. Ralph Mannheim. London: Lund Humphries, 1961.

Knott, Robert. "Paul Klee and the Mystic Center." *Art Journal* XXXVIII/2 (Winter 1978–79): 114–17.

Knox, Israel. "Schopenhauer's Aesthetic Theory." In *Schopenhauer: His Philosophical Achievement.* London: Harvester Press, 1980.

Krukowski, Lucian. "Hegel, 'Progress,' and the Avant-Garde." *Journal of Aesthetics and Art Criticism* XLIV, 3 (Spring 1986): 279–90.

Kruskopf, Erik. *Shaping the Invisible: A Study of the Genesis of Non-Representational Painting, 1908–1919.* Helsinki: Karkkilan Kirjapaino Ky, 1976.

Kuspit, Donald. "Philosophy and Art: Elective Affinities in an Arranged Marriage." *Artforum* XXIII, 3 (November 1984): 44.

 "Delaunay's Rationale for Peinture Pure, 1909–15." *Art Journal* 34, 2 (Winter 1974–75): 108–14.

 "The Illusion of the Absolute in Abstract Art." *Art Journal* XXXI, 1 (Fall 1971): 26–30.

 "Utopian Protest in Early Abstract Art." *Art Journal* XXIX, 4 (Summer 1970): 430–7.

Lanham, Richard A. *The Motives of Eloquence: Literary Rhetoric in the Renaissance.* New Haven: Yale University Press, 1976.

Lehmann A. G. *The Symbolist Aesthetic in France 1885–1895.* Oxford: Basil Blackwell, 1950.

Lloyd, Genevieve. *The Man of Reason: "Male" and "Female" in Western Philosophy.* Minneapolis: University of Minnesota Press, 1984.

Loevgren, Sven. *The Genesis of Modernism: Seurat, Gauguin, Van Gogh & French Symbolism in the 1880s.* Revised ed. Bloomington: Indiana University Press, 1971.

Long, Rose Carol Washton. "Occultism, Anarchism, and Abstraction: Kandinsky's Art of the Future." *Art Journal* 46, 1, (Spring 1987): 38–45.

 "Expressionism, Abstraction, and the Search for Utopia in Germany." In *The Spiritual in Art: Abstract Painting 1890–1985,* 201–17. New York: Abbeville Press, 1986.

 "Kandinsky's Vision of Utopia as a Garden of Love." *Art Journal* 43, 1 (Spring 1983): 50–60.

 Kandinsky: The Development of an Abstract Style. Oxford: Clarendon Press, 1980.

 "Kandinsky and Abstraction: The Role of the Hidden Image." *Artforum* 10 (1972): 42–50.

Luthi, Jean-Jacques. *Emile Bernard: Catalogue raisonné de l'oeuvre peint.* Paris: Editions Side, 1982.

Lynton, Norbert. "The New Age: primal work and mystical nights." In

Abstraction: Towards a New Art, Painting, 1910–1920, 9–21. London: Tate Gallery, 1980; exhibition catalogue.

Mackie, Alwynne. "Kandinsky and Problems of Abstraction." *Artforum* (November 1978): 58–63.

Mansbach, Steven A. *Visions of Totality: Laszlo Moholy-Nagy, Theo Van Doesburg, and El Lissitzky*. Studies in the Fine Arts: The Avant-Garde, No.6. Ann Arbor: UMI Research Press, 1980.

Manuel, Frank E., and Fritzie P. *Utopian Thought in the Western World*. Cambridge: Belknap/Harvard, 1979.

Marcuse, Herbert. *Negations: Essays in Critical Theory*. Trans. Jeremy J. Shapiro. London: Penguin Press, 1968.

Mathews, Patricia Townley. *Aurier's Symbolist Art Criticism and Theory*. Studies in the Fine Arts: Criticism, No. 18. Ann Arbor: UMI Research Press, 1986.

 "Aurier and Van Gogh: Criticism and Response." *Art Bulletin* 68, 1 (March 1986): 94–104.

Mauner, George L. *The Nabis: Their History and Their Art 1888–1896*. New York: Garland, 1978.

 "The Nature of Nabi Symbolism." *Art Journal*. XXIII (Winter 1963– 64): 96–103.

Melville, Stephen W. *Philosophy Beside Itself: On Deconstruction and Modernism*. Theory and History of Criticism, Vol. 27. Minneapolis: University of Minnesota Press, 1986.

Meyerson, Ake. "Van Gogh and the School of Pont-Aven." *Konsthistorisk Tidskrift* 15, 3–4 (1946): 135–49.

Mitchell, W. J. T. *Iconology: Image, Text, Ideology*. Chicago: University of Chicago Press, 1986.

Mondrian, Piet. *The New Art – The New Life: The Collected Writings of Piet Mondrian*. Ed., trans. Harry Holtzman and Martin S. James. Boston: G. K. Hall & Co., 1986.

Moravasik, Julius, and Philip Temko. Eds. *Plato on Beauty, Wisdom, and the Arts*. New Jersey: Rowman & Allenheld, 1982.

Mosse, G. L. *The Crisis of German Ideology: Intellectual Origins of the Third Reich*. New York: Grosset & Dunlap, 1964.

 "The Mystical Origins of National Socialism." *Journal of the History of Ideas* 22, 1 (1961): 81–96.

Nochlin, Linda. *Impressionism and Post-Impressionism 1874–1904*. Sources and Documents in the History of Art. New Jersey: Prentice-Hall, 1966.

Norris, Christopher. *Derrida*. Cambridge: Harvard University Press, 1987.
 Contest of Faculties: Philosophy and Theory After Deconstruction. New York & London: Methuen, 1985.
 Deconstruction: Theory and Practice. New York & London: Methuen, 1982.

Osborne, Harold. *Abstraction and Artifice in Twentieth-Century Art*. Oxford: Clarendon Press, 1979.

Panofsky, Erwin. *Idea: A Concept in Art Theory*. 1924. Trans. Joseph J. S. Peake. New York: Harper & Row, 1968.

Pierrot, Jean. *The Decadent Imagination 1880–1900*. Trans. Derek Coltman. Chicago: University of Chicago Press, 1981.

Plato. *The Collected Dialogues of Plato*. Ed. Edith Hamilton and Huntington Cairns. Bollingen Series LXXI. Princeton: Princeton University Press, 1973.

Plotinus. *The Enneads*. 2nd ed. Trans. Stephen Mackenna. London: Faber
& Faber, 1956.

Podro, Michael. *The Critical Historians of Art*. New Haven: Yale University
Press, 1982.

The Manifold in Perception: Theories of Art from Kant to Hildebrand. Oxford:
Clarendon Press, 1972.

Poling, Clark V. "Kandinsky: Russian and Bauhaus Years, 1915–1933."
In *Kandinsky: Russian and Bauhaus Years 1915–1933*. New York: Sol-
omon R. Guggenheim Museum, 1983.

Popper, Karl R. *The Open Society and Its Enemies*. Vol 1, *The Spell of Plato*.
5th ed. Princeton: Princeton University Press, 1971.

Post-Impressionism: Cross-Currents in European Painting. London: Royal
Academy, 1979–80; exhibition catalogue.

Priebe, Evelin. *Angst und Abstraktion: Die Funktion der Kunst in der Kun-
sttheorie Kandinskys*. Frankfurt am Main: Peter Lang, 1986.

Rajchman, John. "Foucault's Art of Seeing." *October* 44 (Spring 1988): 89–
117.

Read, Herbert. *Art Now: An Introduction to the Theory of Modern Painting
and Sculpture*. New York: Harcourt, Brace & Co., 1933.

Rees, A. L., and Borzello, F. Eds. *The New Art History*. London: Camden
Press, 1986.

Rewald, John. *Post-Impressionism from Van Gogh to Gauguin*. 3rd. ed. New
York: MOMA, 1978.

Gauguin Drawings. New York: Thomas Yoseloff, 1958.

Ringbom, Sixten. "Transcending the Visible: The Generation of the Ab-
stract Pioneers." In *The Spiritual in Art: Abstract Painting 1890–1985*,
131–53. New York: Abbeville Press, 1986.

"Paul Klee and the Inner Truth to Nature." *Arts Magazine* 52, 1 (Sep-
tember 1977): 112–17.

*The Sounding Cosmos: A Study in the Spiritualism of Kandinsky and the
Advent of Abstract Painting*. Acta Academiae Aboensis, Ser. A. Finland:
Abo Akademi, 1970.

Rist, J.M. *Plotinus: The Road to Reality*. Cambridge University Press, 1967.

Robinson, Alan. *Poetry, Painting and Ideas, 1885–1914*. London: Macmillan,
1985.

Rookmaaker, H. R. *Gauguin and 19th Century Art Theory*. Amsterdam:
Swets & Zeitlinger, 1972.

Rorty, Richard. *Consequences of Pragmatism (Essays:1972–1980)*. Minne-
apolis: University of Minnesota Press, 1982.

Philosophy and the Mirror of Nature. Princeton: Princeton University Press,
1979.

Rosenthal, Deborah. "Paul Klee: The Lesson of the Master." *Arts Magazine*
52, 1 (September 1977): 158–60.

Roskill, Mark. *Van Gogh, Gauguin and the Impressionist Circle*. London:
Thames & Hudson, 1970.

Rowell, Margit. "Interview with Charmion von Wiegand." In *Piet Mon-
drian Centennial Exhibition*. New York: Solomon R. Guggenheim Mu-
seum, 1971.

Sandström, Sven. "The Dream of a Pure Art." *Aris* 2 (1969): 36–48.

Saxon, Erik. "On Mondrian's Diamonds." *Artforum* XVIII, 4 (December,
1979): 40–5.

Schiebinger, Londa. "Feminine Icons: The Face of Early Modern Science."
Critical Inquiry 14 (Summer 1988): 661–91.

Schopenhauer, Arthur. *The World as Will and Representation*. 2 vols. Trans. E. F. J. Payne. New York: Dover, 1969.

Schor, Naomi. *Reading in Detail: Aesthetics and the Feminine*. New York and London: Methuen, 1987.

Sérusier, Paul. *ABC de la Peinture/Correspondance*. (1921) Paris: Librairie Floury, 1950.

Seuphor, Michel. *Piet Mondrian: Life and Work*. New York: Abrams, 1956.

Shiff, Richard. *Cézanne and the End of Impressionism: A Study of the Theory, Technique, and Critical Evaluation of Modern Art*. Chicago: University of Chicago Press, 1984.

Silverman, Debora Leah. "Nature, Nobility, and Neurology: The Ideological Origins of 'Art Nouveau' in France, 1889–1900." Ph.D. Dissertation, Princeton University, 1983.

Spate, Virginia. *Orphism: The Evolution of Non-figurative Painting in Paris 1910–1914*. Oxford: Clarendon Press, 1979.

Stein, Susan Alyson. "Kandinsky and Abstract Stage Composition: Practice and Theory, 1909–12." *Art Journal* 43, 1 (Spring 1983): 61–66.

Steiner, George. *Nostalgia for the Absolute*. Toronto: CBC Enterprises, 1974.

Stern, J.P. *Reinterpretations: Seven Studies in Nineteenth-Century German Literature*. London: Thames & Hudson, 1964.

Sutton, Denys. "The Paul Gauguin Exhibition." *Burlington Magazine* XCI (October, 1949): 283–6.

Taylor, Mark C. *Journeys to Selfhood: Hegel and Kierkegaard*. Berkeley: University of California Press, 1980.

Temkin, Ann. "Klee and the Avant-Garde 1912–1940." In *Paul Klee*. New York: MOMA, 1987.

Theweleit, Klaus. *Male Fantasies Vol. 1: Women, Floods, Bodies, History*. Trans. Stephen Conway. Minneapolis: University of Minnesota Press, 1987.

Tower, Beeke Sell. *Klee and Kandinsky in Munich and at the Bauhaus*. Studies in the Fine Arts: The Avant-Garde, No. 16. Ann Arbor: UMI Research Press, 1981.

Troy, Nancy J. "Figures of the Dance in De Stijl." *The Art Bulletin* LXVI, 4 (December 1984): 645–56.

The De Stijl Environment. Cambridge: M.I.T. Press, 1983.

Tuchman, Maurice. "Hidden Meanings in Abstract Art." In *The Spiritual in Art: Abstract Painting 1890–1985*, 17–61. New York: Abbeville Press, 1986.

Ulmer, Gregory. *Applied Grammatology: Post(e)-Pedagogy from Jacques Derrida to Joseph Beuys*. Baltimore: The Johns Hopkins University Press, 1985.

"OP Writing: Derrida's Solicitation of *Theoria*" (29–58). In *Displacement: Derrida and After*, ed. Mark Krupnick. Bloomington: Indiana University Press, 1983.

Van Doesberg, Nelly. "Some Memories of Mondrian." In *Piet Mondrian Centennial Exhibition*. New York: Solomon R. Guggenheim Museum, 1971.

Verdi, Richard. *Klee and Nature*. London: A. Zwemmer, 1984.

Vergo, Peter. "Music and Abstract Painting: Kandinsky, Goethe, and Schoenberg." In *Abstraction: Towards a New Art, Painting, 1910–1920*, 41–63. London: Tate Gallery, 1980; exhibition catalogue.

Verkade, Dom Willibrord. *Yesterdays of an Artist-Monk*. Trans. John L. Stoddard. New York: P.J. Kenedy & Sons, 1930.

Vishny, Michèle. "Paul Klee and War: A Stance of Aloofness." *Gazette Des Beaux Arts* XCII (Décembre 1978): 233–43.

Watts, Harriet. "Arp, Kandinsky, and the Legacy of Jakob Böhme." In *The Spiritual in Art: Abstract Painting 1890–1985*, 239–55. New York: Abbeville Press, 1986.

Weiss, Peg. "Kandinsky and the Symbolist Heritage." *Art Journal*. 45, 2 (Summer 1985):137–45.

Kandinsky in Munich: The Formative Jugendstil Years. Princeton: Princeton University Press, 1979.

Welsh, Robert P. "Sacred Geometry: French Symbolism and Early Abstraction." In *The Spiritual in Art: Abstract Painting 1890–1985*, 63–87. New York: Abbeville Press, 1986.

"Mondrian as Draftsman." In *Mondrian: Drawings Watercolours New York Paintings*. Stuttgart: Staatsgalerie, 1980; exhibition catalogue.

"Theo Van Doesburg and Geometric Abstraction." In Francis Bulhof, ed., *Nihoff, Van Ostaijen, "De Stijl": Modernism in the Netherlands and Belgium in the First Quarter of the 20th Century*, 76–94. The Hague: Martinus Nijhoff, 1976.

"Mondrian and Theosophy." In *Piet Mondrian Centennial Exhibition*. New York: Solomon R. Guggenheim Museum, 1971.

Piet Mondrian's Early Career: The "Naturalistic" Periods. New York: Garland, 1977.

Welsh, Robert P., and J. M. Joosten. Eds., trans. *Two Mondrian Sketchbooks, 1912–1914*. Amsterdam: Meulenhoff International, 1969.

Welsh-Ovcharov, Bogomila. *Vincent van Gogh and the Birth of Cloisonism*. Toronto, Art Gallery of Ontario, 1981; exhibition catalogue.

Werckmeister, O. K. "From Revolution to Exile." In *Paul Klee*. New York: MOMA, 1987.

Wiedmann, August K. *Romantic Roots in Modern Art: Romanticism and Expressionism: A Study in Comparative Aesthetics*. Surrey: Gresham Books, 1979.

Wildenstein, Georges. Ed. *Gauguin: sa vie, son oeuvre, re-union de textes, d'études, de documents*. Paris: Busson, 1958.

Will, Frederic. *Flumen Historicum: Victor Cousin's Aesthetic and its Sources*. University of N. Carolina Studies in Comparative Literature, No. 36. Chapel Hill: University of North Carolina Press, 1965.

Wilm, E. L. *Henri Bergson: A Study in Radical Evolution*. New York: Sturgis & Walton, 1914.

Wind, Edgar. *Art and Anarchy*. 3rd ed. Evanston: Northwestern University Press, 1985.

Worringer, Wilhelm. *Abstraction and Empathy: A Contribution to the Psychology of Style*. (1908) Trans. Michael Bullock. New York: International Universities Press, 1963.

INDEX